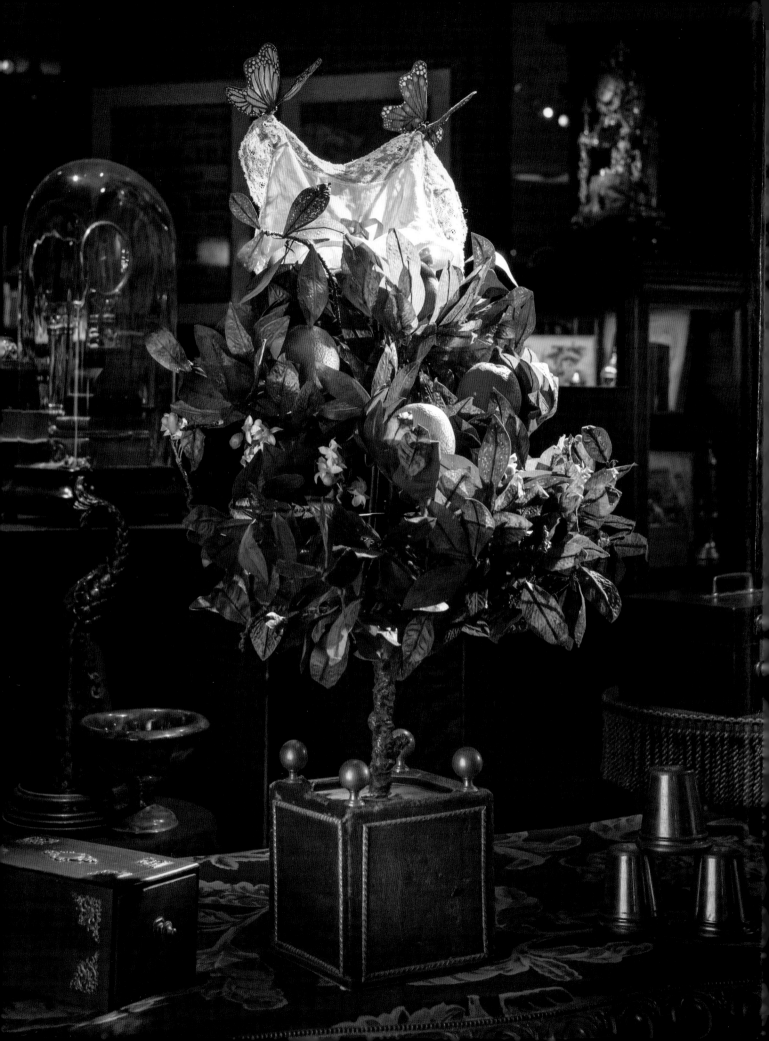

DAVID COPPERFIELD'S

History of Magic

❧ —————————————— ❧

DAVID COPPERFIELD

RICHARD WISEMAN

DAVID BRITLAND

Photographs by

HOMER LIWAG

Simon & Schuster

NEW YORK LONDON TORONTO SYDNEY NEW DELHI

Simon & Schuster
1230 Avenue of the Americas
New York, NY 10020

First Simon & Schuster hardcover edition October 2021

SIMON & SCHUSTER and colophon are registered trademarks
of Simon & Schuster, Inc.

For information about special discounts for bulk purchases,
please contact Simon & Schuster Special Sales at 1-866-506-1949
or business@simonandschuster.com.

The Simon & Schuster Speakers Bureau can bring authors to your
live event. For more information or to book an event, contact
the Simon & Schuster Speakers Bureau at 1-866-248-3049
or visit our website at www.simonspeakers.com.

Interior design by Paul Dippolito

Manufactured in China

1 3 5 7 9 10 8 6 4 2

Library of Congress Cataloging-in-Publication Data

Names: Copperfield, David, 1956- author. | Liwag, Homer, photographer.
Title: David Copperfield's history of magic / David Copperfield, Richard
Wiseman, David Britland; photographs by Homer Liwag.
Other titles: History of magic
Description: First Simon & Schuster Hardcover Edition. | New York : Simon &
Schuster, [2021] | Includes bibliographical references and index. |
Identifiers: LCCN 2021016783 | ISBN 9781982112912 (Hardcover) |
ISBN 9781982112936 (eBook)
Subjects: LCSH: Magic tricks—History. | Magicians—History. |
Magic—History. | Magic—Pictorial works.
Classification: LCC GV1543 .C67 2021 | DDC 793.809—dc23
LC record available at https://lccn.loc.gov/2021016783

ISBN 978-1-9821-1291-2
ISBN 978-1-9821-1293-6 (ebook)

To my family, Chloe, Sky, Audrey, and Dylan
for their unwavering love, and for everyone searching for magic,
challenging the impossible, fighting for your dreams.

Contents

Introduction 1

CHAPTER 1

Secrets of the Conjurors Revealed

REGINALD SCOT'S *THE DISCOVERIE OF WITCHCRAFT*

— 9 —

CHAPTER 2

The Pastry Chef

ROBERT-HOUDIN'S MAGICAL AUTOMATA

— 15 —

CHAPTER 3

Prestidigitation and the Presidency

WYMAN THE WIZARD'S CAP AND PENCE

— 27 —

CHAPTER 4

Will, the Witch, and the Watchman

JOHN NEVIL MASKELYNE'S TRUNK

— 35 —

CONTENTS

CHAPTER 5

The Man Who Knows

ALEXANDER'S TURBAN

— 43 —

CHAPTER 6

"P" Is for Private

PROFESSOR HOFFMANN'S NOTEBOOK

— 51 —

CHAPTER 7

This Is My Wife

BUATIER DE KOLTA'S EXPANDING DIE

— 59 —

CHAPTER 8

We're Off to See the Wizard

HARRY KELLAR'S NEST OF BOXES

— 65 —

CHAPTER 9

The Queen of Magic

ADELAIDE HERRMANN'S DRESS

— 73 —

CONTENTS

CHAPTER 10

The Palace of Magic

MARTINKA'S THEATRE

— 81 —

CHAPTER 11

Author Unknown

THE EXPERT AT THE CARD TABLE

— 89 —

CHAPTER 12

Notes on Steam Engines, Pumps, Boilers Hydraulic, and Other Machinery

MAX MALINI'S PECULIAR PARAPHERNALIA

— 97 —

CHAPTER 13

Condemned to Death by the Boxers

CHUNG LING SOO'S GUN

— 105 —

CHAPTER 14

Escaping Mortality

THE HOUDINI COLLECTION

— 113 —

CONTENTS

CHAPTER 15

The Magician Who Made Himself Disappear

HOWARD THURSTON'S DISEMBODIED PRINCESS

— 123 —

CHAPTER 16

Lighter Than Air

OKITO'S FLOATING BALL

— 131 —

CHAPTER 17

Divided

DANTE'S SAWING ILLUSION

— 137 —

CHAPTER 18

Free Rabbits

THE HARRY BLACKSTONE COLLECTION

— 145 —

CHAPTER 19

The Suave Deceiver

CARDINI'S TUXEDO, MONOCLE, AND PLAYING CARDS

— 153 —

CONTENTS

CHAPTER 20

The Human Index

ARTHUR LLOYD'S GOWN, MORTARBOARD, AND CARDS

— 161 —

CHAPTER 21

If They Don't Know You, They Can't Book You

DELL O'DELL'S GUILLOTINE

— 167 —

CHAPTER 22

In Pursuit of Perfection

CHANNING POLLOCK'S VANISHING BIRD CAGE

— 175 —

CHAPTER 23

Blood on the Curtain

RICHIARDI'S BUZZ SAW

— 183 —

CHAPTER 24

The Man Who Fooled Houdini

DAI VERNON'S DEAD LIST

— 191 —

CONTENTS

CHAPTER 25

The Mystery Box

TANNEN'S MAGIC STORE

— 199 —

CHAPTER 26

The Magic in Your Mind

AL KORAN'S MEDALLION

— 207 —

CHAPTER 27

The Magician Who Believed in Real Magic

DOUG HENNING'S COSTUME AND METAMORPHOSIS TRUNK

— 215 —

CHAPTER 28

On the Shoulders of Giants

DAVID COPPERFIELD'S DEATH SAW

— 223 —

Sources and Further Reading 237

Acknowledgments 249

Image Credits 250

Index 251

DAVID COPPERFIELD'S

History of Magic

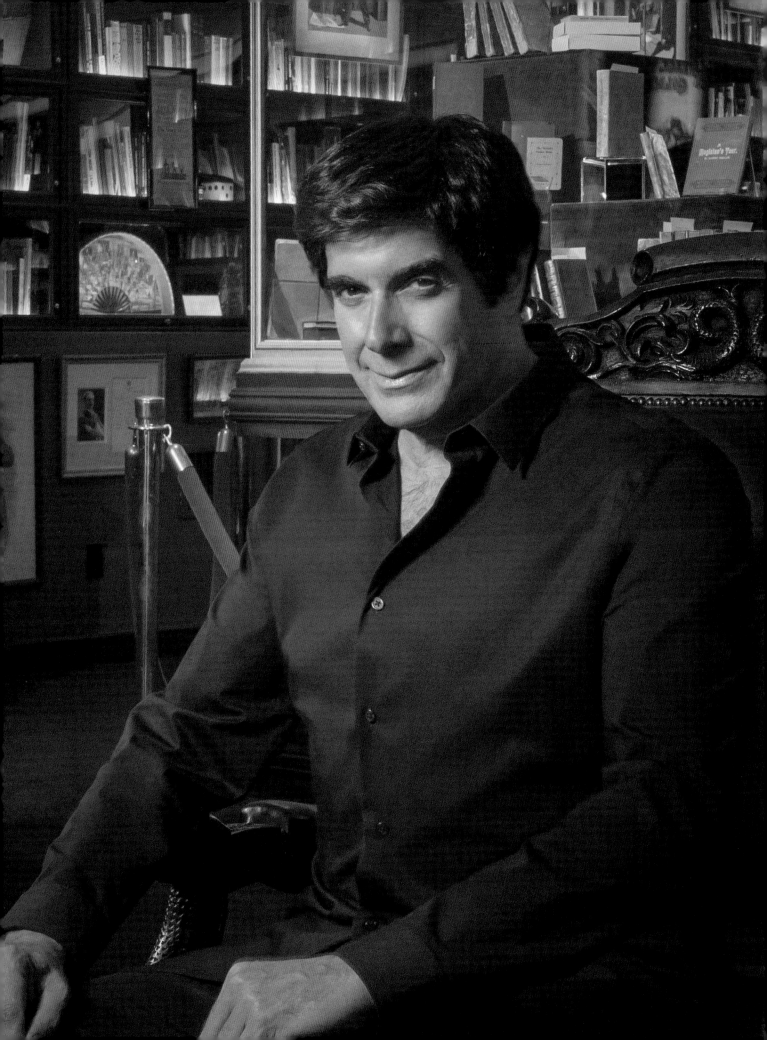

Introduction

Magic matters. It transports people into a world in which the impossible appears possible. Precious items appear out of nowhere, objects defy gravity, and people are sawed in half and magically restored. Watching a great magic show opens people's minds and inspires them to achieve the extraordinary in their everyday lives.

Magic has also changed the world. Throughout history, inventors, engineers, and scientists have been fascinated by the conjuring arts. For instance, Leonardo da Vinci frequently collaborated with Luca Pacioli, the fifteenth-century mathematician who helped to lay the foundations for modern-day accountancy. Pacioli created one of the earliest known European books to be largely devoted to magic (*De Viribus Quantitatis*) and described the secrets to several impressive miracles, including how to bathe your hands in molten lead and have an egg walk across a tabletop. Similarly, one of the pioneers of modern-day cinema, Georges Méliès, was a great stage illusionist, and drew heavily on his background in magic and storytelling to create his innovative and influential films. In 1902, Méliès made a film about traveling to the Moon and just over sixty years later that fantasy became fact. Over time, many other magicians have inspired visionaries and technologists to transform illusion into reality.

Magic can also reveal fascinating insights into the human mind. Every magic performance is a field experiment in psychology, and magicians have to know how to influence an audience's attention, awareness, and memory. Indeed, some of the founding figures in modern-day psychology—such as the French psychologist Alfred Binet and American Joseph Jastrow—worked with some of the most famous conjurors of their day in an attempt to understand the mysteries of perception.

In each generation, a group of people have devoted their lives to furthering the art of conjuring. I am proud to follow in their footsteps.

My real name is David Seth Kotkin and I was born in Metuchen, New Jersey. My mother worked in insurance and my father had a menswear store. I was a shy only child. From an early age I was a dreamer with a big imagination, and I was immersed in movies and television as they offered a tremendous sense of escape and hope. I was also a big fan of an innovative ventriloquist named Paul Winchell, and when I was around eight years old I received a vent puppet as a gift. I mastered the basics of ventriloquism and put together an act. It wasn't the greatest act in the world, but it got me in front of an audience.

I enjoyed performing and eventually asked my parents for a new ventriloquist figure. My mother took me to a magic store in New York City and the moment that I set foot in that special place I felt as if I had arrived home. I never did buy that new puppet but instead I became spellbound with magic. All these years later it's still the driving passion in my life.

When I was ten years old I adopted the stage name Davino the Boy Magician, and just two years later I became the youngest person to be accepted into the Society of American Magicians. Around the same time, I invented an illusion that was published in a classic series of magic books, the Tarbell Course in Magic. At the age of sixteen, I became a professor at New York University and was teaching a course on the art of magic. For some reason magic came naturally to me.

I eventually decided to have a career in the arts. A friend suggested that I take inspiration from the much-loved Charles Dickens novel and change my name to David Copperfield. My first major engagement came when I was offered the lead role in a musical comedy about a turn-of-the-century magician who exposed a fake psychic. The show was called *The Magic Man* and the producers at first wanted me to sing and perform magic. But after they heard my voice, many of my songs mysteriously vanished.

It was a great show and I thought that it was going to be the springboard to success. I was wrong. After the show closed I found it difficult to get work, and my girlfriend and I struggled to pay the bills. I used the downtime to think about how I could combine my love of magic with my passion for film and theatre. My heroes were creators like Orson Welles, Frank Capra, Gene Kelly, and Fred Astaire. All of them understood how to use their art to move an audience emotionally and I wanted to do the same through the medium of magic. I found that stories and

context added meaning to my work, and I devised illusions that focused on love, friendship, and acceptance. I levitated an assistant to Gershwin's "American in Paris" and created an imaginary game show called *Let's Burn a Deal*, where I appeared to destroy and restore money. Looking back, it was actually a surprisingly happy period of my life. I had no idea where the next dollar was coming from, but I enjoyed the blank page and had the freedom to create and develop.

Eager for work, I persistently knocked on doors until one of them opened. In 1977 I hosted a show for ABC, and the following year CBS offered me my own television special. I can remember my father putting up posters in his store window, saying, "Please watch our son. Make his mom happy." Fortunately, the show was a hit and became an annual event. I was just twenty-two years old.

One network television special followed another, and over the years I have appeared to walk through the Great Wall of China, escaped from Alcatraz, caused a jet to vanish, and made the Statue of Liberty disappear. Throughout it all, stories and meaning remained the bedrock of my magic. Vanishing the Statue of Liberty symbolized what the world would be like without freedom and democracy, and celebrated the opportunities that America has offered to those coming to the country to make a new life for themselves. Years later, people still talk about that event.

On the face of it, my job is to perform the impossible. But when I see audience members being moved by my magic, I am moved, too: magic has the power to redirect people away from their worries and concerns and, perhaps most important of all, to inspire and to provide hope. Creating my illusions takes hard work—I think of it as "glorious torture"—yet being able to bring a sense of wonder to people makes all of that effort worthwhile.

———————

For more than thirty years I've had a secret project. It all began with an American magician named John Mulholland. Born in 1898, Mulholland led an unconventional life that included him being recruited by the CIA in the 1950s and asked to write a training manual that taught spies how to use magical techniques in their covert work. Mulholland was also an avid historian and collector, amassing an impressive library of more than 20,000 magic books and journals. He died in 1970 and when his amazing library came up for sale in 1991, some magicians were worried that this important collection would be broken up. My friend, magician and historian Mike Caveney, suggested that I buy the collection and ensure that it remained intact.

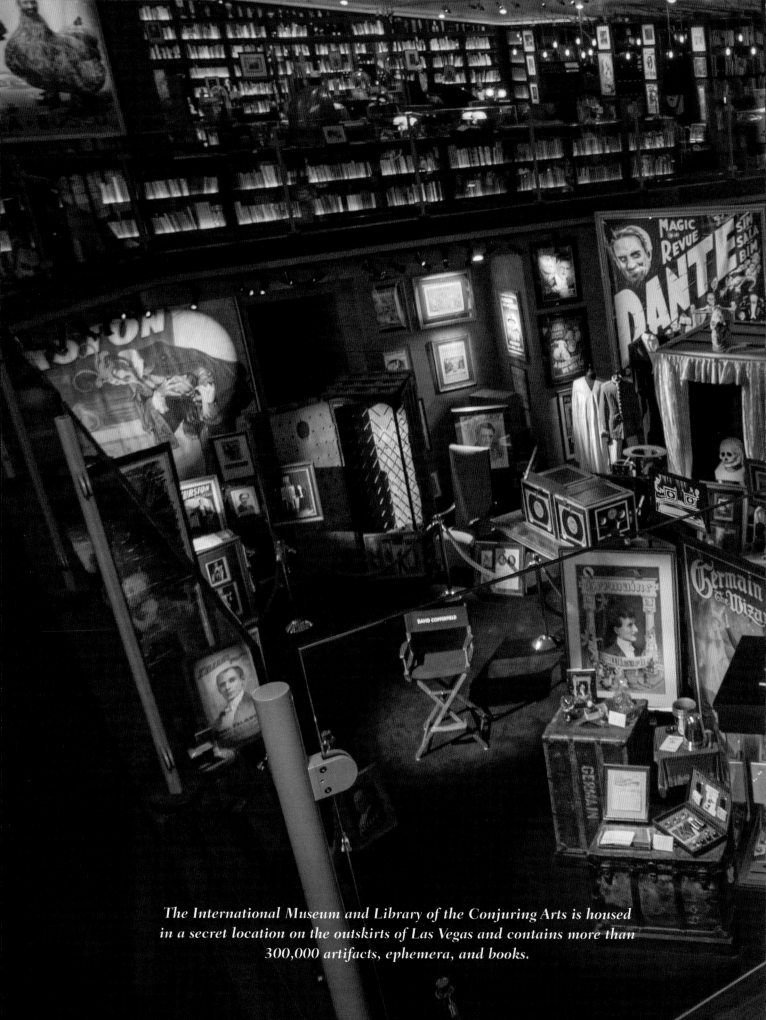

The International Museum and Library of the Conjuring Arts is housed in a secret location on the outskirts of Las Vegas and contains more than 300,000 artifacts, ephemera, and books.

At the time, I wasn't a collector or historian of magic. Instead, my focus was to invent and perform new illusions, and so I gave the matter a considerable amount of thought. The Mulholland collection is one of magic's greatest historical resources, and I knew that being its custodian would involve ensuring that it was properly housed and cared for. In the end, I took the plunge and acquired the collection. Since that time, I have collected historical material six times the original size of the Mulholland archive, creating a secret museum dedicated to preserving the history and art of magic for future generations. Now known as The International Museum and Library of the Conjuring Arts, this hidden treasure trove of illusion is home to countless books, posters, apparatus, and ephemera. This collection is housed in a gigantic building on the outskirts of Las Vegas. It's not open to the general public but researchers are always welcome and I regularly give tours to interested parties.

The tours often begin after my last show of the night and so I frequently arrange to meet visitors around midnight. The street address takes them to a men's clothing store called Korby's. Somewhat confused, they step inside and discover that it's a replica of the store once owned by my father. It's a small space with a decidedly vintage atmosphere, and they find themselves surrounded by jackets, pants, and shirts hanging on racks. We make our way into the store's changing room, and they see a shirt and tie hanging on the wall. I ask them to pull gently on the tie and suddenly a secret door swings open. They walk through it and find themselves in a wonderland.

The museum is massive and contains dozens of rooms on several levels. Every inch is packed with amazing props, dazzling posters, and fascinating photographs from history's greatest conjurors.

In this book, I am going to guide you through my magical world. When you see magic, you see only what the magician wants you to see, but I am about to take you backstage and uncover the reality behind the illusion. During our time together we will encounter the most historically important items in this vast collection along with a few of my personal favorites, including a sixteenth-century manual on sleight of hand, Houdini's straitjackets and handcuffs, mechanical wonders devised by one of France's greatest magicians, beautiful trunks and boxes from the huge touring shows of American illusionists Harry Kellar and Howard Thurston, and even some coins that may have magically passed through the hands of Abraham Lincoln.

Together, we will discover how magic influences popular culture, adapts to social change, reveals insights into the human mind, embraces the latest technological and scientific

discoveries, and alters the course of history. Perhaps most important of all, we will explore how each exhibit has helped satisfy humanity's seemingly endless appetite for wonder. Along the way we will encounter a colorful cast of characters, including the illusionist who believed in real magic, the man who fooled Houdini, and the performer who paid the ultimate price for his love of conjuring. They plied their entertainment in the streets, theatres, and palaces. Some of these master magicians found great fame and fortune, while others lived only for applause. Nevertheless, they all shared my passion for making the impossible seem possible.

We are about to encounter a series of astonishing objects that have made hearts beat faster, jaws drop, and eyes stare in disbelief. Each object has a tale to tell and together they provide an unprecedented insight into the history of wonder, magic, and illusion.

Welcome to my world.

Secrets of the Conjurors Revealed

➤ REGINALD SCOT'S *THE DISCOVERIE OF WITCHCRAFT* ⬱

In the sixteenth century, witch hunters scoured Europe in search of those who they believed were dabbling in the dark arts. In 1584, one man spoke out against this toxic mix of superstition, fear, and ignorance. In doing so, he helped shape history and also produced the first book in the English language to present detailed descriptions of magic.

Born in the 1530s, Reginald Scot appears to have come from a relatively afflu-
ent family and to have spent most of his life in southeast England. Although
little is known about his earlier years, many historians believe that Scot acted
as a justice of the peace and had probably spent time studying law. In 1574
he produced a book on how to grow hops. Around a decade later he turned his attention to a
much more serious and sober subject.

At the time, many people in Europe believed in the existence of witchcraft. According to
this worldview, witches were able to summon evil spirits and to carry out various supernatural
misdemeanors, including making people ill, rendering animals infertile, and causing crops
to fail. These beliefs allowed self-proclaimed "witch hunters" to travel from town to town
trying to eradicate this perceived threat to society. The late sixteenth century saw a surge in
witch hunting across England and Scotland, with governments in both countries passing laws
against witchcraft in 1563. Evidence of alleged wrongdoing often involved something as sim-
ple as an unusual birthmark, an unfortunate growth, or erratic behavior. Unperturbed, witch
hunters and others extracted false confessions, encouraged unreliable eyewitness testimony,
staged show trials, and were responsible for the deaths of hundreds of people. The majority
of those accused were women.

Scot investigated the matter and in 1584 published his contentious conclusions in a
book titled *The Discoverie of Witchcraft*. Containing over five hundred pages, Scot's book
displayed remarkable scholarship and drew upon the writings of more than two hundred
other authors.

At a time when many people supported witch hunts, Scot bravely argued that these events
were little more than the barbaric persecution of the vulnerable, old, and ill. His controversial
text frequently proposed more rational approaches to these seemingly supernatural phenom-
ena, arguing that those appearing to be witches might merely be superstitious or uneducated,
that the effects of seemingly magical potions were due to chemical causes, and that those
claiming to have been visited by nighttime demons were instead victims of a sleep disorder.

The Discoverie of Witchcraft was also the first work in the English language to present a
detailed description of sleight of hand and conjuring. Several chapters of the book contained
the secrets to illusions, including some principles that are still employed by modern-day
magicians.

Scot's book presented scientific and rational explanations
for many seemingly supernatural phenomena.

Many of the illusions described by Scot relied on sleight of hand with balls, coins, and playing cards, including "To make a little ball swell in your hand till it be verie great," "How to deliver out foure aces, and to convert them into foure knaves," and the ever-popular "To make a groat strike through a table, and to vanish out of a handkercher verie strangelie."

Other chapters explored the use of secret stooges and concealed verbal codes. For instance, Scot described how a conjuror might ask someone to go behind a door and arrange some coins into the shape of either a cross or a pile. The conjuror apparently listens to the sound of the coins clinking together and is able to reveal how they have been arranged. Scot revealed the secret of the illusion, noting that the person doing the arrangement of the coins was a confederate ("who must seeme . . . obstinatlie opposed against you") and how they used a subtle verbal code covertly to convey the arrangement of the coins to the conjuror. ("What is it?" signifies a cross and "What ist?" a pile.)

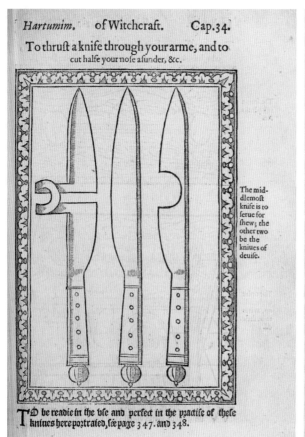

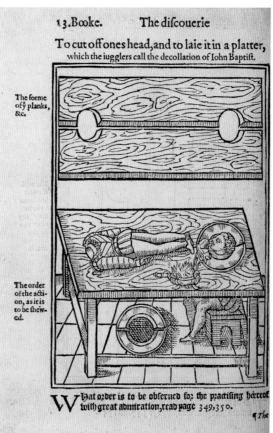

(Left) An illustration from The Discoverie of Witchcraft *showing the apparatus that allowed performers "to thrust a knife through your arme, and to cut halfe your nose asunder."*
(Right) Scot explains how "to cut off ones head, and to laie it in a platter, which the jugglers call the decollation of John Baptist."

Scot's final chapters on conjuring discussed several illusions using boxes with false bottoms before moving on to more gruesome and shocking stunts, including how to appear to thrust a bodkin needle into your head, place a knife through your arm, stab yourself in the stomach, and cut off your head and lay it on a platter ("The decollation of John Baptist"). Once again, all of the secrets to these illusions were described in considerable detail and sometimes accompanied by vivid woodcuts. When it came to placing a bodkin needle through your head, for instance, Scot recommended the use of a bodkin with a retractable needle and a small sponge soaked in red wine (if spectators discover the wine, Scot informed his readers that "you may saie you have drunke verie much"). Similarly, performers wishing to stage the chest-stabbing illusion were advised to place a protective plate on their chest,

followed by a bladder of blood, and then a flesh-colored pasteboard designed to resemble your actual chest. During the performance, the conjuror plunged a dagger through the pasteboard and bladder, but was protected from harm by the back plate. Performers were advised to make the pasteboard appear as realistic as possible (including the use of chest hair) and to use the blood of a calf or sheep ("but in no wise of an oxe or a cow, for that will be too thicke"). Scot warned readers that such feats may carry a genuine risk, describing how one performer became drunk, forgot to don the protective plate, stabbed himself in the stomach, crawled into a nearby churchyard, and died.

Scot's radical approach to witchcraft proved highly influential and resulted in him making several powerful enemies. In 1597, King James VI of Scotland produced his own book in which he passionately argued in favor of witch trials. At the start of his book, James explains that one of his main motivations for putting pen to paper was to argue against the "the damnable opinions of . . . the one called SCOT an Englishman," who James described as being "not ashamed in publike print to deny, that ther can be such a thing as Witch-craft."

Scot died in 1599, but his ideas lived on. Over time, the belief in witchcraft began slowly declining throughout Europe and the barbaric witch hunts eventually came to an end. Many historians have argued that *The Discoverie of Witchcraft* played a key role in making this possible.

Scot's book also had a tremendous impact on conjuring, with some of the material from *The Discoverie of Witchcraft* being reproduced in two later magic books: *The Art of Juggling or Legerdemain* (1612) and *Hocus Pocus Junior: The Anatomie of Legerdemain* (1634). The popularity of these works encouraged other authors to produce similar manuals and, over time, these manuscripts of magical secrets have come to form the bedrock of modern-day conjuring.

The Discoverie of Witchcraft is highly sought after by both book collectors and historians of magic, and I am proud to have a copy in my museum. It helped lay the foundations for magic and so provides the perfect starting point for our journey into the art of conjuring.

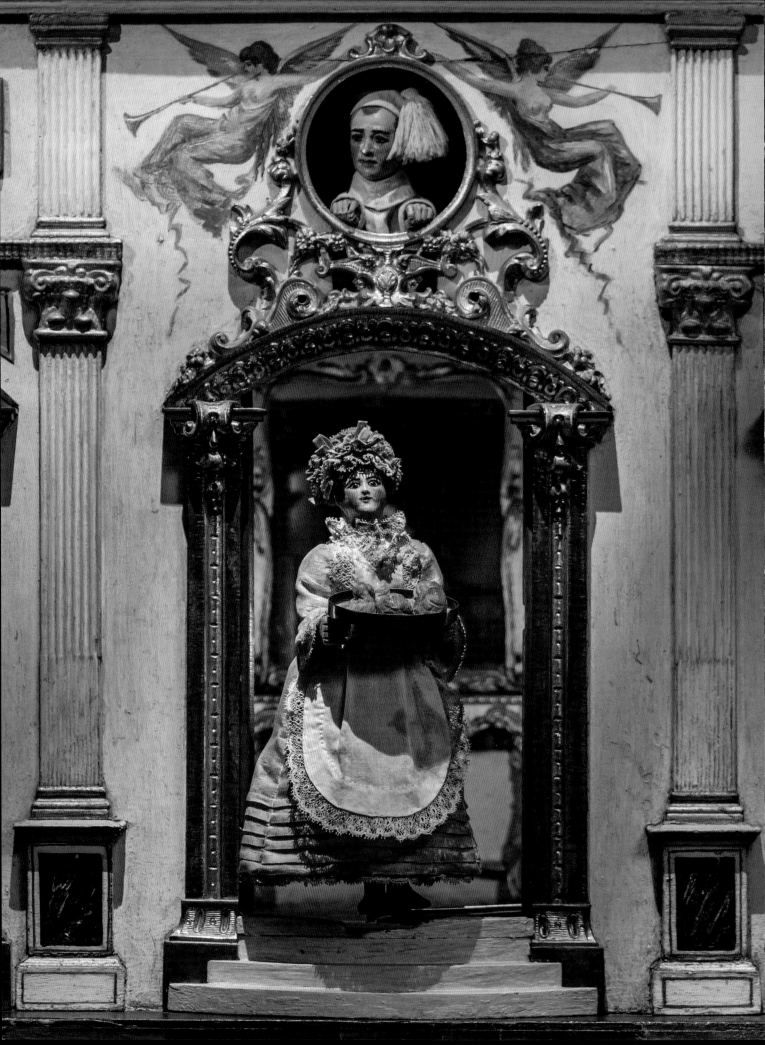

The Pastry Chef

➢ ROBERT-HOUDIN'S MAGICAL AUTOMATA ≪

This curious collection of mysterious clocks, a beautiful model orange tree, and a strange dollhouse-sized French bakery sit at the heart of my museum. Together they represent perhaps the most important seven years in the history of magic.

Jean-Eugène Robert was born in the French city of Blois in 1805. At the time, Blois was a major European center for clock making, and home to hundreds of artisans and craftsmen. In his twenties, Robert began to train as a watchmaker and became fascinated by finely engineered mechanisms. Although historians have struggled to discover exactly how Robert became interested in magic, in his memoirs he claims that during his apprenticeship he ordered a book on watchmaking (*Traité de l'Horlogerie*) but was mistakenly given a work on rational recreation (*Dictionnaire Encyclopédique des Amusements des Sciences Mathématiques et Physiques*). This two-volume encyclopedia of fun and games apparently revealed the secret to many magical illusions, including how to read minds and appear to decapitate a pigeon. Mesmerized by this trove of knowledge, Robert entered the world of magic.

In 1830, Robert married Josèphe Cecile Houdin, adopted her surname, and became Robert-Houdin. Around the same time, he moved to Paris to pursue his joint love affair with mechanism and magic. With the cogs and gears of his mind in full spin, Robert-Houdin patented a small clock that automatically produced a lit taper when the alarm sounded, thus preventing people from stumbling around in the dark when they woke up. He also created several "mystery clocks" that consisted of clock hands mounted on a transparent glass dial, and the dial sitting on a clear crystal pillar. Despite the lack of any apparent visible mechanism connected to the dials or hands, the clocks kept perfect time.

At the time, the French aristocracy and bourgeoisie were keen to find new ways of flaunting their considerable wealth, and one approach involved buying intricate and expensive automata to entertain their friends and visitors. Eager to make the most of this highly lucrative market, Robert-Houdin designed and built several highly complex automata, including his pièce de résistance, The Singing Lesson. This beautifully crafted item was mounted on a gilt base, stood about two feet high, and depicted a lady teaching a bird to sing. When wound up, the elegantly dressed woman and tiny bird came to life. As the woman turned the handle of a music box, the tiny bird twisted and turned, lifted its wings, opened its beak, and chirped away.

Robert-Houdin frequently visited the homes of the wealthy and demonstrated his ingenious automata, and slowly added some magical illusions to these intimate performances. In doing so, he sowed the seeds of an idea that would change magic forever.

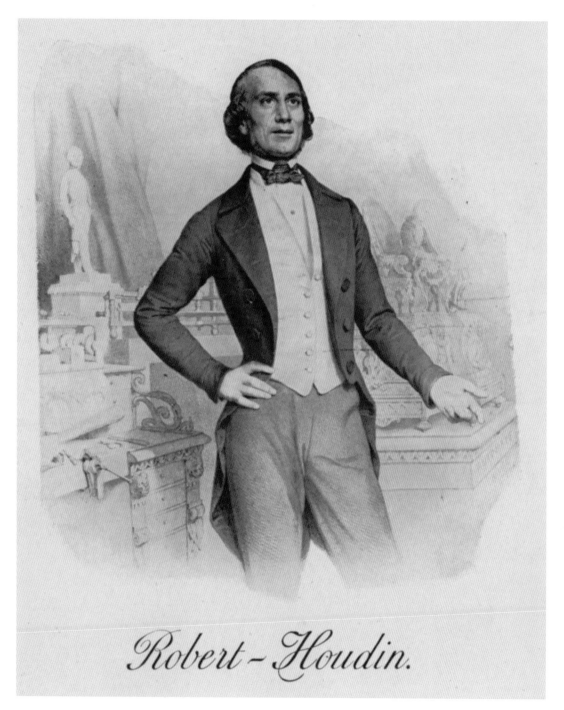

*Jean-Eugène Robert-Houdin is widely regarded
as the father of modern magic.*

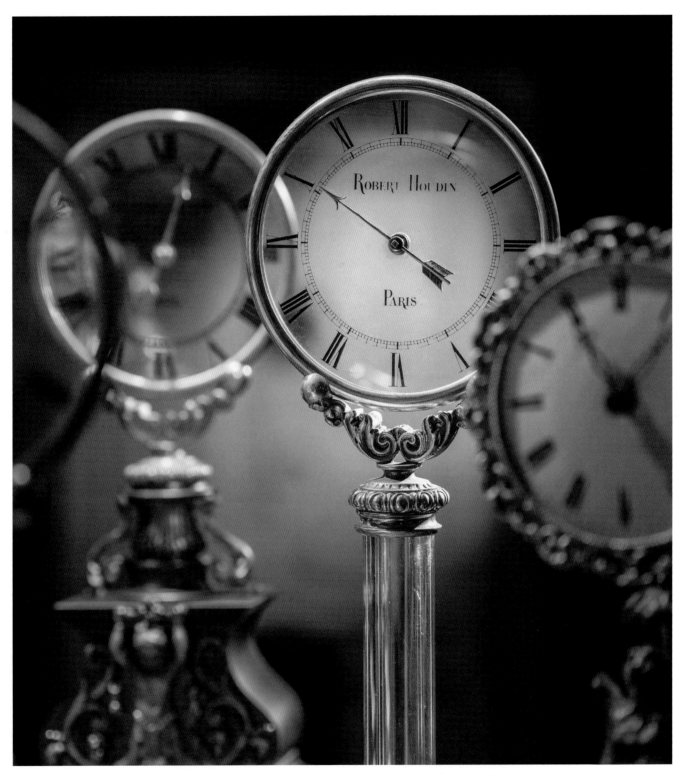

The hands on Robert-Houdin's "mystery clocks" didn't appear to be connected to any kind of mechanism, yet they kept perfect time.

For hundreds of years, wandering magicians had performed at markets and fairs across Europe, and conjuring had generally been considered a distinctly marginal and lowbrow affair. However, the nineteenth century saw some magicians come in from the cold, and start to stage their shows in small theatres, halls, and hired rooms. Enthused by the success of his parlor shows, Robert-Houdin decided to place his performances on a more permanent footing and in 1845, at the age of thirty-nine, he opened his dream theatre in Paris.

Robert-Houdin was keen to elevate conjuring by emphasizing elegance and simplicity. His theatre felt intimate and seated around two hundred patrons, and his stage resembled the type of stylish salon associated with the French aristocracy and middle classes. Eager to distance himself from more lowly performers, Robert-Houdin did away with strange-looking tables draped in suspiciously long cloths, and instead employed fashionable gilt-edged furniture designed in the style of Louis XV. Adopting the manner of a genial and respectful host, Robert-Houdin appeared in finely tailored evening dress, avoided poor puns, and made no mention of the supernatural.

During his Soirée Fantastique, Robert-Houdin presented an extraordinary array of magical illusions and amazing automata. The Marvellous Orange Tree began with him borrowing a woman's handkerchief and finger ring, attaching the ring to the middle of the handkerchief with a ribbon, and making both the ring and handkerchief magically vanish. Next, Robert-Houdin directed spectators' attention to a miniature model of an orange tree. Standing around three feet high, it resembled the type of plant that wealthy families carefully cultivated for the luxury of sampling the exotic citrus flavors. As spectators focused their attention on the tree, it slowly blossomed, with flowers mysteriously emerging from its leaves, followed by the appearance of several large oranges. The oranges were real and presented to members of the audience. One orange, however, remained perched at the top of the tree and, to gasps of astonishment from the audience, it slowly opened and out flew two clockwork butterflies with their wings fluttering. Between them, the butterflies held the woman's missing handkerchief, with her ring still attached to the center of it.

In another section of the show, Robert-Houdin brought forward a model of a classical French bakery. It was about the size of a dollhouse, and the illusionist declared that it was home to a tiny pastry chef who could bake anything the audience desired. A spectator was

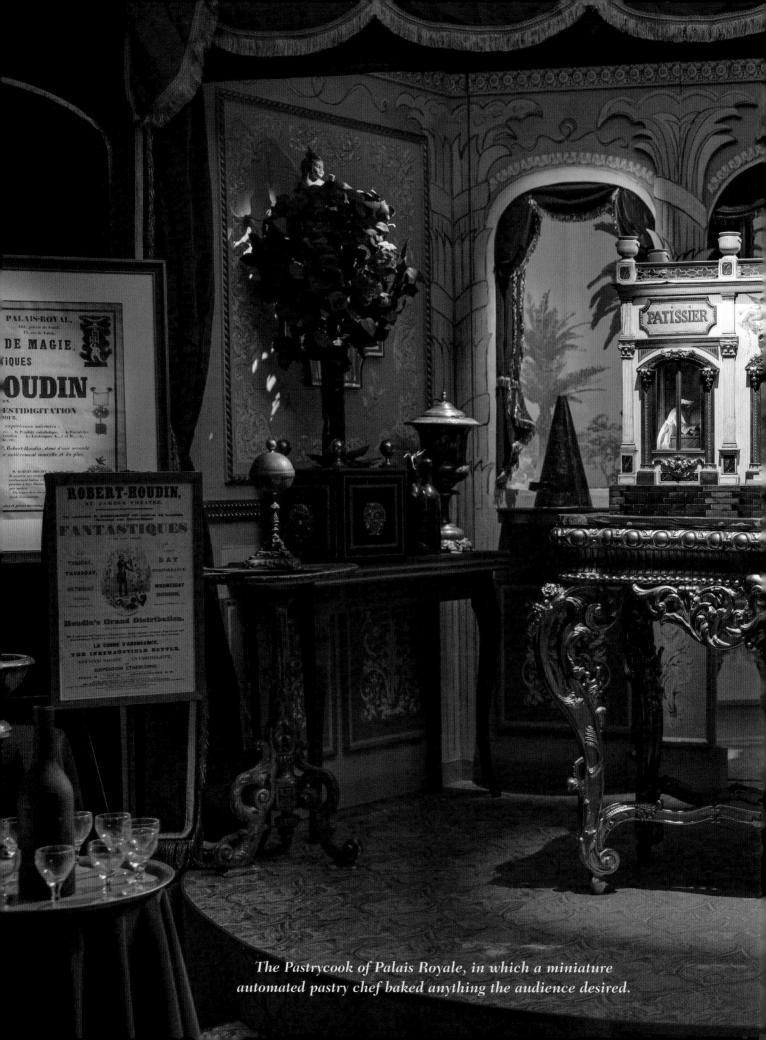

The Pastrycook of Palais Royale, in which a miniature automated pastry chef baked anything the audience desired.

asked to choose their favorite cake or pastry. Robert-Houdin then turned a crank on the side of the bakery and a small model of a pastry chef emerged from the front door to take the order. A few moments later, the inside of the bakery lit up and the audience saw additional model chefs working away. Finally, the pastry chef reappeared at the front door with dainty models of the desired cake or pastry. On occasion, another small figure emerged from the model bakery holding a little tray. Robert-Houdin borrowed a twenty-franc piece and placed it on the tray, and the figure made its way back into the bakery. Spectators were asked to call out an amount of money for the chef to deduct from the twenty francs and the model reemerged holding the change. A mixture of genuine automata and illusion, The Pastrycook of Palais Royale was both fascinating and fooling.

Robert-Houdin's evening of wonder also featured several magical illusions, including a demonstration of alleged mind reading, a bottle that seemed to contain an endless supply of wine, and the production of various items from an apparently empty folder, including two bonnets, four doves, three copper pots, and his young son.

The show was an enormous success, and attracted large numbers of wealthy and sophisticated theatregoers. When the 1848 French Revolution severely reduced audience numbers, Robert-Houdin made his way across the channel and presented his artful show in Britain. Once again, he was hugely successful and was invited to perform for Queen Victoria. After conquering Britain, he resumed his shows in France and then retired in 1852 at the peak of his success. Despite running his theatre for only seven years, Robert-Houdin had made a fortune and returned to Blois a wealthy man. He remained highly active, spending his retirement writing bestselling books about his life and magic, and transforming his house into a technological marvel. He designed and built remote-control doors, created a temperature-activated fire alarm, and added a security system that was automatically armed each night. In that sense, he created one of the world's first "smart" homes. Robert-Houdin's spring finally wound down in 1871, when he died of pneumonia at the age of sixty-five.

Robert-Houdin's mystery clocks, The Singing Lesson, The Marvellous Orange Tree, and The Pastrycook of Palais Royale now all reside in my museum. I have shown them to hundreds of visitors and they still continue to mystify modern minds. Each of these amazing items involves countless carefully crafted parts working together to produce a moment of

extraordinary perfection. In that sense, they perfectly symbolize Robert-Houdin's contribution to magic. Before Robert-Houdin, a few conjurors had appeared onstage in evening dress, others had decorated their stages with elegant furniture, and some had exhibited magical automata. However, in the same way that Robert-Houdin carefully crafted cogs and springs and then used them to create remarkable automata, so he took each of these elements to new heights and combined them into a single astonishing vision. His success ensured that the art of magic became a respectable and intelligent form of theatre. Little wonder then that Robert-Houdin is now widely considered to be the father of modern-day magic.

➤ *The Ethereal Suspension* ➤

One of the most important items in my collection belonged to Robert-Houdin. When I first held the item I was reduced to tears and it has had a similar emotional impact on many of the magicians who have visited the museum.

In the mid-1840s, scientists discovered that ether could act as a surgical anesthetic, and Robert-Houdin took advantage of the public's newfound enthusiasm for this mysterious substance. During his show, Robert-Houdin presented a serious scientific discourse on ether and offered to demonstrate how people became lighter than air by inhaling this curious chemical. His young son, Eugène, stood on a stool that was balanced on a plank set across two trestles. A wooden pole was carefully placed under each of Eugène's arms and acted as a kind of crutch against which he set his weight.

A vial of ether was opened and its unique odor filled the auditorium. Eugène inhaled the ether and appeared to lose consciousness. Robert-Houdin then removed the stool from under his son's feet, followed by the left-hand pole and stool. Appearing to be lighter than air, Eugène remained supported on the remaining pole, apparently in deviance of gravity. Finally, Robert-Houdin lifted his son into a horizontal position and he became suspended in midair.

Eugène's sensational illusion wasn't due to ether. In reality, the vial contained water and the strange smell in the auditorium was due to a backstage assistant pouring ether onto a hot metal plate and producing harmless fumes. Instead, it was the result of an incredibly ingenious, and cleverly crafted, secret mechanism.

I can still remember holding that mechanism for the first time: the apparatus symbolized everything that was innovative about Robert-Houdin's work. His mastery of the mechanics, his contemporary presentation style, his ability to take an effect and build it into a masterpiece. The Ethereal Suspension of Robert-Houdin is the foundation upon which many modern suspension illusions have been built.

It's not the only connection that I feel with Robert-Houdin. He incorporated the latest scientific and engineering marvels into his performances. Likewise, the illusions in my live show frequently involve modern-day technology, such as sending a

mass email to the entire audience that accurately predicts the decisions that spectators will make later on in the show, and conjuring up a thirty-five-foot animatronic dinosaur. Also, in the same way that Robert-Houdin jettisoned wizard-like robes and adopted the elegant evening wear that was popular at the time, so I wear fashionable and contemporary clothing onstage.

Robert-Houdin's Ethereal Suspension is now safely housed in a beautiful antique safe at the heart of my museum. All these years later, I still become emotional when I lead visitors into the safe and talk about the father of modern magic. Often, I am not the only one to shed a tear.

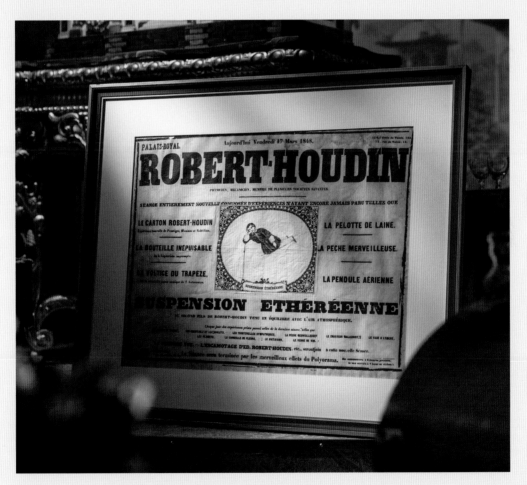

During Robert-Houdin's Ethereal Suspension, his son appeared to inhale ether and become lighter than air.

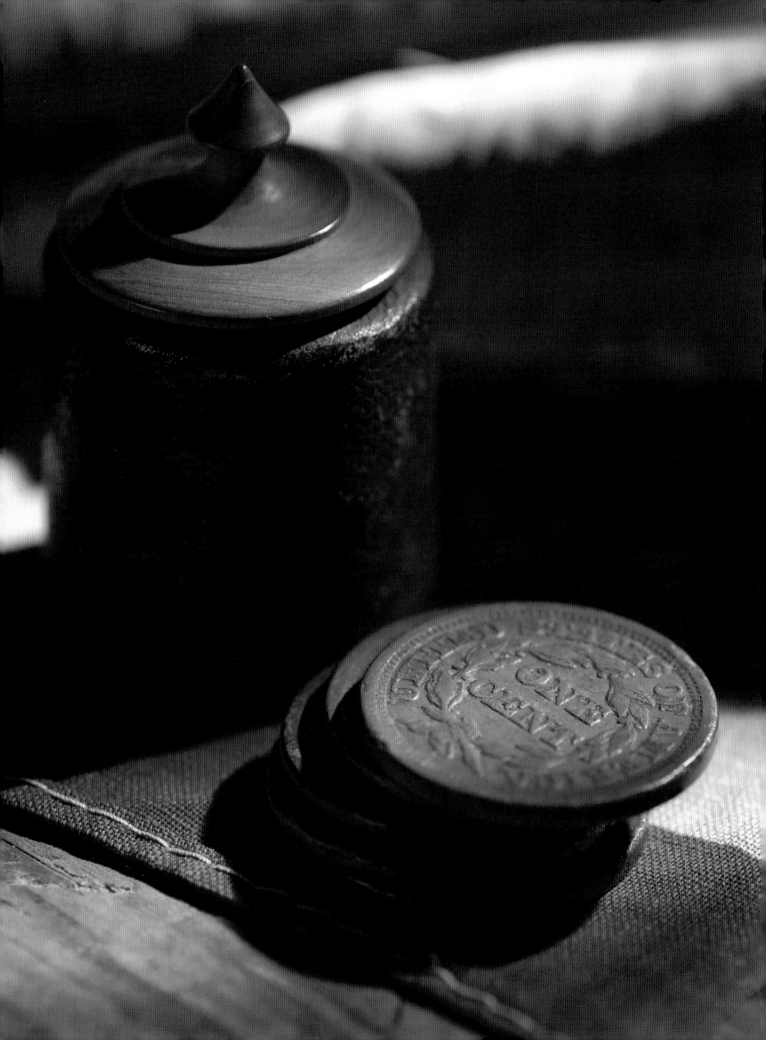

Prestidigitation and the Presidency

➤ WYMAN THE WIZARD'S CAP AND PENCE ⬅

These vintage pennies and small leather cap belonged to a now-forgotten mid-nineteenth-century mystery maker, and help uncover the curious association between conjuring and the White House.

John Wyman Jr. was born in Albany, New York, around 1816 and spent his early years learning ventriloquism and magic. Adopting the moniker "Wyman the Wizard," he eventually created a series of remarkable shows that involved him catching a bullet in his mouth, pouring a multitude of different drinks from a single bottle, staging a pie-eating contest between children from the audience, and exhibiting a dog that could allegedly perform 113 tricks.

In addition, Wyman's evening of wonders frequently included a "gift show," in which randomly chosen audience members were handed valuable prizes. This format was popular with American magicians at the time and their playbills contained impressive lists of the treasures on offer, including sewing machines, tons of coal, barrels of flour, opera capes, and even live pigs ("Free pigs for good people"). Unfortunately, the idea attracted hucksters who charged people for tickets and then absconded before the show, with one writer memorably describing these unscrupulous operators as "so crooked that they could have hidden behind a corkscrew." Unlike many of his dodgy counterparts, Wyman was an honest deceiver and genuinely bestowed a series of expensive gifts on lucky audience members, including gold watches, leather-bound Bibles, canes, and silverware.

Wyman toured the same small cities year after year, and these regular appearances, combined with his warm personality, resulted in a loyal and loving following. Reports suggest that Wyman's popularity also extended to the White House, and that early on in his career he was invited to entertain Presidents Martin Van Buren and Millard Fillmore. He was also apparently a particular favorite of Lincoln, and was asked to perform before the president a remarkable four times. During one performance Wyman is said to have asked the president to hold out his hand. Wyman carefully placed a stack of pennies on Lincoln's hand and covered them with a small leather cap. A few moments later the cap was lifted and shown to be empty, and the coins appeared to penetrate through the president's hand. These pennies and that small leather cap now reside in my museum. Somewhat appropriately, Lincoln's profile appeared on the American penny in 1909 to commemorate the hundredth anniversary of his birth, and has remained there ever since.

Lincoln's encounters with Wyman were not the only time that he apparently crossed paths with a magician. In fact, another magical protagonist claimed to have met the president twice and each time under the strangest of circumstances.

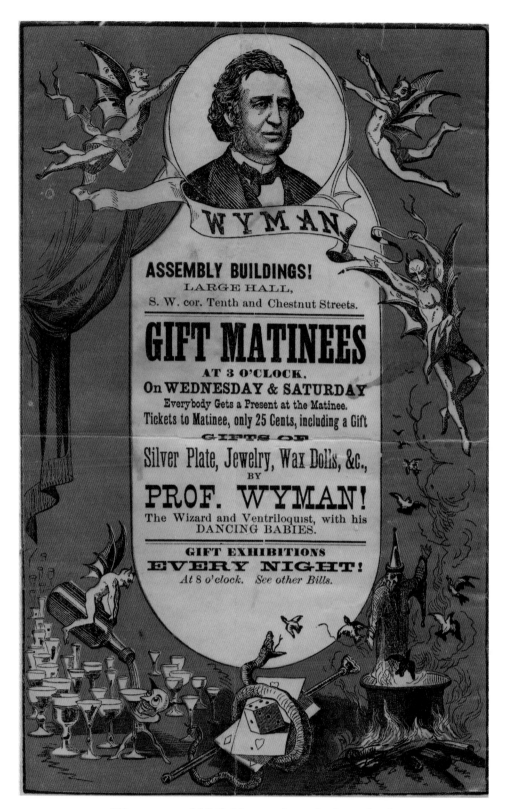

Wyman staged "Gift Matinees" in which randomly chosen audience members were given valuable prizes.

Born in 1844 in Norwich, Connecticut, Horatio Cooke developed an early fascination with magic and escapology. When the Civil War broke out in 1861, Cooke enlisted in the Union army, reportedly proved to be an excellent marksman, and was invited to join an elite band of scouts trained to carry out daring missions behind Confederate lines.

Much later on in his life, Cooke was interviewed by a journalist and described how he first met Lincoln. According to his story, Cooke had developed a reputation for being able

Horatio Cooke claimed to have performed for Abraham Lincoln and been at Ford's Theatre when the president was assassinated.

to escape from a variety of restraints. In 1864, word of Cooke's remarkable escapology skills reached the capital, and the twenty-year-old magician was invited to demonstrate them in front of some of the country's top leaders, including General Winfield Scott Hancock and the president himself. Cooke was tied up by the group with a clothesline. Duly restrained, the young magician requested that Lincoln walk ten feet away, and then turn and make his way back. Cooke managed to escape within seconds and shook hands with the president upon his return. Jubilant and amazed, Lincoln handed Cooke a two-dollar bill and remarked: "Here, my boy, keep this to remember Uncle Abe by."

Following Cooke's death another, and far more dramatic, encounter with the president was reported in the press. In late 1864, Cooke and his men were apparently ambushed and captured by a group of Confederate sympathizers. Worse still, when Cooke's attackers rifled through his pockets they found a letter from Lincoln confirming his appointment as a scout. He was relieved of the letter, tied to a tree, and sentenced to hang the following morning. Once again, his escapology saved the day, with Cooke managing to free himself and return to the Union lines under the cover of darkness.

A few days after the end of the Civil War, Cooke made his way to the White House in the hope of obtaining a copy of his stolen letter. Upon his arrival, he was told that the president and first lady had gone to see a play at Ford's Theatre. Cooke hurried to the theatre, hastily purchased a ticket, and stood at the back of the auditorium. About twenty minutes later, Cooke heard a pistol shot and saw John Wilkes Booth jump down from the president's box and run backstage. The president died the following morning and Cooke eventually persuaded the then secretary of war, Edwin Stanton, to allow him into the room where the dead president lay.

Over time, Cooke became a professional magician, befriended many famous conjurors including Harry Houdini, and was still treading the boards in his seventies. Although some historians have cast doubt on the veracity of Cooke's Civil War adventures, he was clearly a talented magician with an exceptional ability to entertain and fool in equal measure.

The curious link between magic and the White House has continued throughout the years. Sleight of hand expert Max Malini entertained Theodore Roosevelt, illusionist Howard Thurston performed for Calvin Coolidge (and nearly destroying Coolidge's watch in the

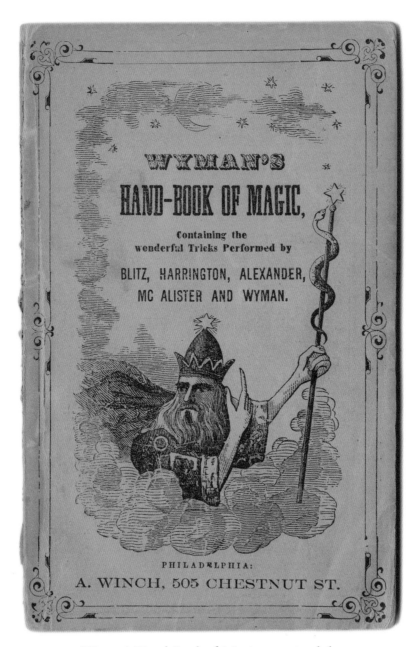

Wyman's Hand-Book of Magic *contained the*
secrets to many popular illusions.

process), card manipulator Cardini amused Franklin Roosevelt, and Doug Henning appeared before Ronald Reagan. Similarly, I have been invited to perform for Ronald Reagan, Bill Clinton, and George Bush—all at Ford's Theatre!

Perhaps presidents like the intellectual challenge of trying to figure out how we make the impossible seem possible. Or perhaps they are attracted to the idea of creating equally magical solutions to the difficult issues that they frequently face: Reagan once quipped that if I ever wanted to get into politics, I would be welcome in the Oval Office, as he had a long list of problems that he would like to make disappear. Or perhaps they simply enjoy the company of those who have dedicated their lives to trying to fool all of the people all of the time. Whatever the reason, these vintage coins and little cap represent the surprising long-standing link between magic and the American presidency.

MASKELYNE AND COOKE'S

MANAGING PARTNER MR. DAVID DEVANT

MYSTERIES

"WILL, THE WITCH AND THE WATCHMAN."

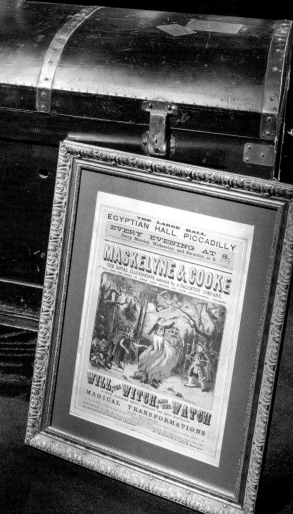

THE LARGE HALL.
EGYPTIAN HALL PICCADILLY
EVERY EVENING AT 8,
Every Monday, Wednesday, and Saturday, at 3

MASKELYNE & COOKE
THE ROYAL ILLUSIONISTS, assisted by a TALENTED COMPANY.

WILL, THE WITCH, AND THE WATCH
MAGICAL TRANSFORMATIONS

Will, the Witch, and the Watchman

In the Victorian era, the public flocked to London's Egyptian Hall to witness remarkable performances by some of the world's finest magicians. At the heart of the entire enterprise sat a man with an unfeasibly large mustache, an equally impressive imagination, and a pioneering new way of presenting illusions.

Born in 1839 in England, John Nevil Maskelyne was fascinated by magic from an early age. When he was in his twenties, Maskelyne attended a show presented by two American performers known as the Davenport Brothers. William Henry and Ira Erastus Davenport were both magicians, but had created an act that was designed to exploit the then fashionable notion of attempting to communicate with the dead. During their performance, the two brothers placed several musical instruments inside a large cabinet, climbed inside the cabinet, and invited audience members to tie them up. The cabinet doors were closed and the spirits allegedly made their presence known by ringing bells, rattling tambourines, tooting horns, and even throwing the instruments out of the cabinet. Maskelyne apparently got lucky when he went to see William and Ira perform because during the show a curtain covering a window fell down, revealing a glimpse of the musical instruments being manipulated by one of the brothers. Maskelyne stood up, boldly announced that the entire affair was a sham, and declared that he could produce the same phenomena without spirit intervention.

The budding magician made good on his word. Maskelyne teamed up with his friend George Cooke, and within a few months the two of them were performing shows in which they both duplicated the Davenports' act and presented a new illusion of their own making. During Maskelyne and Cooke's new illusion, a performer was sealed inside a large wooden box in the cabinet. The cabinet doors were closed and, moments later, opened to reveal the performer sitting on top of the box. It appeared as if the performer had magically dematerialized inside the box and rematerialized on top of it. Encouraged by the success of their early shows, Maskelyne and Cooke embarked on a tour across Britain.

As time went on, their illusion evolved and eventually involved a performer vanishing from the box and reappearing at the back of the auditorium. In 1873, Maskelyne and Cooke arrived in London and started to perform at the Egyptian Hall. Opened in 1812, the hall was decorated with mysterious hieroglyphics and exotic images of the Sphinx, the Nile, and the Pyramids. By the late nineteenth century it was predominantly associated with strange exhibitions, popular entertainment, magic, and educational lectures. Maskelyne and Cooke moved in and proudly declared the hall to be "England's Home of Mystery."

Maskelyne remained at the Egyptian Hall for more than thirty years and has several claims to fame. He helped invent an astonishing levitation illusion that was the envy of his

English stage magician John Nevil Maskelyne frequently incorporated plays and dramas into his illusions.

peers, was stolen by his competitors, and is still performed today. He penned a classic text about gambling cheats, was involved in exposing several fake mediums, designed a highly intricate typewriter, and helped to develop a door lock for public toilets that required a penny coin to operate (thus giving rise to the British euphemism "to spend a penny"). However, Maskelyne's most lasting contribution to both magic and popular culture came from his pioneering work into the way in which illusions were presented.

Rather than talk his way through illusions, Maskelyne often incorporated them into short plays. By far the most successful of these dramatic productions was a farce centered

on his beloved box. Titled *Will, the Witch, and the Watchman*, the performance began by a small number of spectators coming onto the stage and inspecting several pieces of apparatus, including the box and a cabinet decorated to resemble a jail. The spectators then remained onstage for the duration of the play. The script to *Will, the Witch, and the Watchman* changed over time, but always featured a bewildering array of magical appearances, disappearances, and transformations. At the start of the play a sailor was thrown into the jail and vanished. Then a gorilla (usually George Cooke dressed in an ape suit that, unlike actual gorillas, sported a tail) suddenly appeared and had a fight with a butcher. In some versions of the play, the butcher appeared to cut off part of the gorilla's tail and the severed section danced around the stage on its own. Next, the gorilla dragged the butcher inside the jail, and both of them disappeared. The gorilla then reappeared and was locked inside the box, which was

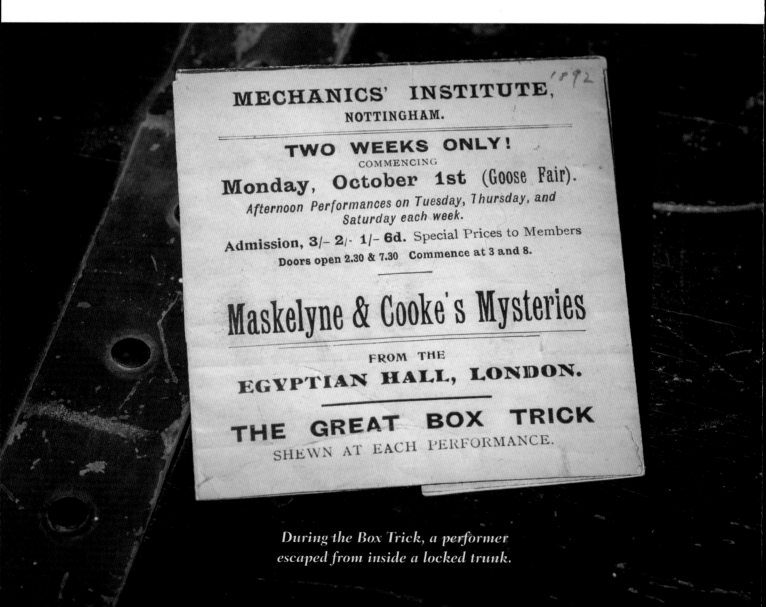

During the Box Trick, a performer escaped from inside a locked trunk.

then placed into the jail. However, when the box was taken out of the jail and opened, the gorilla had disappeared. And so it went on. The dramatic extravaganza contained several comic songs and proved a sensational hit, with Maskelyne claiming that it was performed an estimated eleven thousand times. I am delighted that the box from Maskelyne's wonderful play now resides in my museum.

Maskelyne publicly offered £500 to anyone who could discover the secret of the box used in *Will, the Witch, and the Watchman*. The reward remained unclaimed until 1898, when two young clerks from London declared they had built their own version of the illusion. Maskelyne argued that the clerks had come up with a completely different method and refused to hand over the reward. Frustrated, the two clerks took the master magician to court, with the case making headline news and eventually ending up being discussed in the House of Lords. With Maskelyne refusing to explain how his illusion worked, the courts found against him; he was forced to hand over the reward, but he kept his secret. But it was money well spent, with the publicity ensuring that crowds flocked to see his magical play.

Maskelyne died of pneumonia in 1917 but his magical dynasty lived on. His son, Nevil Maskelyne, was also a magician and inventor, and famously hacked Marconi's wireless telegraph to prove that it wasn't secure (sending the signal "Rats, Rats, Rats" followed by "There was a young fellow of Italy, Who diddled the public quite prettily"). Nevil's son Jasper also worked as a successful stage magician and claimed to have used his understanding of illusion during World War II. According to Jasper, he was involved in a number of schemes, including using canvas and wood to construct fake tanks, and concealing the Egyptian city of Alexandria from German bombers by creating fake buildings several miles away from the actual city. Some historians have argued that many of Jasper's wartime claims were probably wild exaggerations.

John Nevil Maskelyne's pioneering work combining illusion and narrative had a significant influence on popular culture. In 1895, the Lumière brothers arrived in Paris and exhibited the first moving films. Showing short films depicting people going about their daily business, the screenings were a huge hit. French magician Georges Méliès saw the potential to extend this new medium into storytelling and, inspired by the likes of Maskelyne's magical plays, created hundreds of short films that incorporated special effects and illusions into

£1,000 REWARD.

THE MASKELYNE BOX TRICK.

I will pay the above reward to the first person who can do both of the two following things :—(1) Prove that he has discovered the secrets of my Box trick ; and (2) Produce a Box, and in public competition, before a Committee to be mutually selected, show that it will stand the same tests of examination and securing to which I shall submit my own box at the competition. The expenses of the competition shall be guaranteed by both parties but paid by the loser.

I also give notice that I withdraw all rewards hitherto offered by me in connection with my Box trick. Imitators have compelled me for many years past to offer a reward, in order to establish the correctness of my statements, viz. :—that my Box is a unique mechanical problem, to which I have devoted two years of labour and experiment ; and that its secrets have never been discovered.

The reward of **£1,000** is now offered because it has been found that the terms of my previous offer can be misconstrued. Some appear to believe that "a correct imitation" means any performance which to inexperienced persons may seem to resemble mine, however different it may be in reality. Thus, escaping from a simple trap box, such as may be purchased at any conjuring apparatus depôt for a small sum, the secrets of which can be readily discovered, and which may easily be tied so that the performer cannot escape, is regarded as correctly imitating my box trick.

J. N. MASKELYNE,

Egyptian Hall.

J. Burgiss Brown, Printer, 11, Buckingham St , Strand, W.C.

Maskelyne originally offered £500 to anyone who could discover the secret of the Box Trick—and later increased the reward to £1,000.

simple plots. One of the first directors to use storyboards and fictional narratives, Méliès is now widely considered to be the father of modern-day cinema.

Early on in my career I studied the work of great film directors like Frank Capra and Orson Welles, and I am passionate about building a sense of story into my magic. My first television special featured Welles as a special guest and involved several narrative-based illusions. For instance, one illusion was performed to Sinatra's rendition of "When Somebody

Loves You," and reflected the pain of breaking up and the joy of reunion. In it, I played a brokenhearted diner who has just split up with his girlfriend at a restaurant. Befriended by a magical napkin that floats and dances around the stage, I eventually win over the love of my life. Another illusion in the show was a spoof piece based around the shower scene in Alfred Hitchcock's film *Psycho* and involved the magical disappearance of actress Valerie Bertinelli. Over the years, my magic has continued to incorporate key elements of storytelling, such as suspense, romance, and courage. That entire approach has its roots in Maskelyne and his wonderful box.

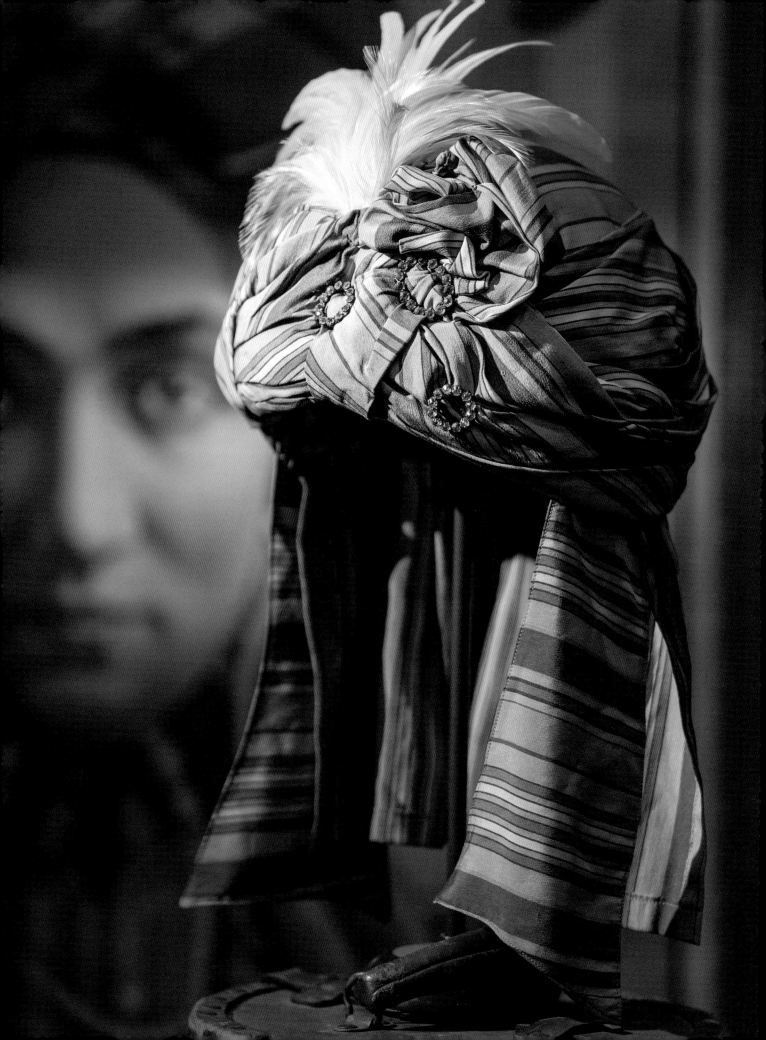

The Man Who Knows

≥ ALEXANDER'S TURBAN ≤

Onstage he appeared to be an astonishing mind reader, a mystical guru, and a wise counselor. Offstage he was a serial adulterer, a heartless con man, a prolific smuggler, and arguably the world's most duplicitous and devious magician.

Claude Alexander Conlin was born in 1880 in South Dakota. In his teenage years he was expelled from school, hit the road, and ended up in a spiritualist enclave populated by fake mediums and phony psychics. He quickly learned the tricks of their trade, including how to conjure up spirits, produce ectoplasm, and talk to the dead.

Over time, Conlin became fascinated with magic, and eventually donned a tux and top hat, and started to perform his own conjuring act. In November 1906, he was due to perform in Texas, but his apparatus failed to arrive on time. Ever resourceful, Conlin grabbed some pencils and paper, and staged an improvised demonstration of his seemingly psychic abilities. The surprising success of the show caused him to reimagine his entire act. Inspired by Eastern mysticism, he eventually swapped his tux for flowing robes, replaced his top hat with a jeweled turban, and created "Alexander: The Man Who Knows."

Part of Alexander's act often took the form of a straightforward magic show. A walking cane mysteriously vanished, an alarm clock disappeared, several handkerchiefs changed color, and Alexander commanded the spirits to paint a portrait on a blank canvas and then pointed out that the picture couldn't have been produced by human hands because it didn't contain any brushstrokes (in reality, the "spirit" portraits were created using the then-little-known technique of airbrushing).

The second part of Alexander's show was quite different, and revolved around the audience's everyday worries and concerns. Spectators were invited to jot down a question that they wanted Alexander to answer on a slip of paper and then to seal the slip in an envelope. A table was then brought onstage and all of the sealed envelopes were scattered on it. Alexander stood onstage, stared deep into his crystal ball, divined information about the lives of audience members, and offered solutions to their problems. Whether people were desperate to find love, discover what the future held for their children, embark on a long trip, start a new business, take out a mortgage, or change careers, Alexander had something to say.

Alexander's stage act used cutting-edge technology. Before the performance, assistants secretly obtained information about audience members. This information was relayed to Alexander via an electrical induction system hidden under the stage and an earpiece hidden in his turban. Alexander's assistants used the system to transmit a constant flow of information to him about the people in the audience.

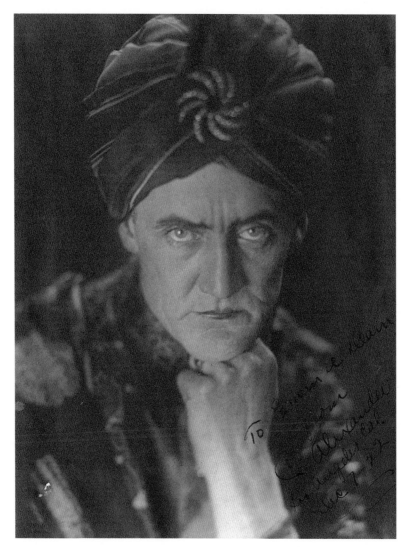

Alexander earned millions of dollars during his career and was one of the richest magicians in the world.

Promoted by huge eye-catching posters featuring striking imagery and his now-famous turban, the show played to packed houses across the country. Alexander supplemented his considerable ticket revenue with several moneymaking schemes. When his show arrived in town, he would approach local dignitaries and explain that for a small fee their portrait could be featured in one of his airbrushed "spirit" paintings. In addition, Alexander set up a thriving mail-order business selling wide-ranging texts promising a better life, including a five-volume course on psychology and health ("Volume 4: Constipation") and a small booklet on how best to use a crystal ball to improve various aspects of everyday life ("Lesson 10: Sex"). One of

to the
Grave

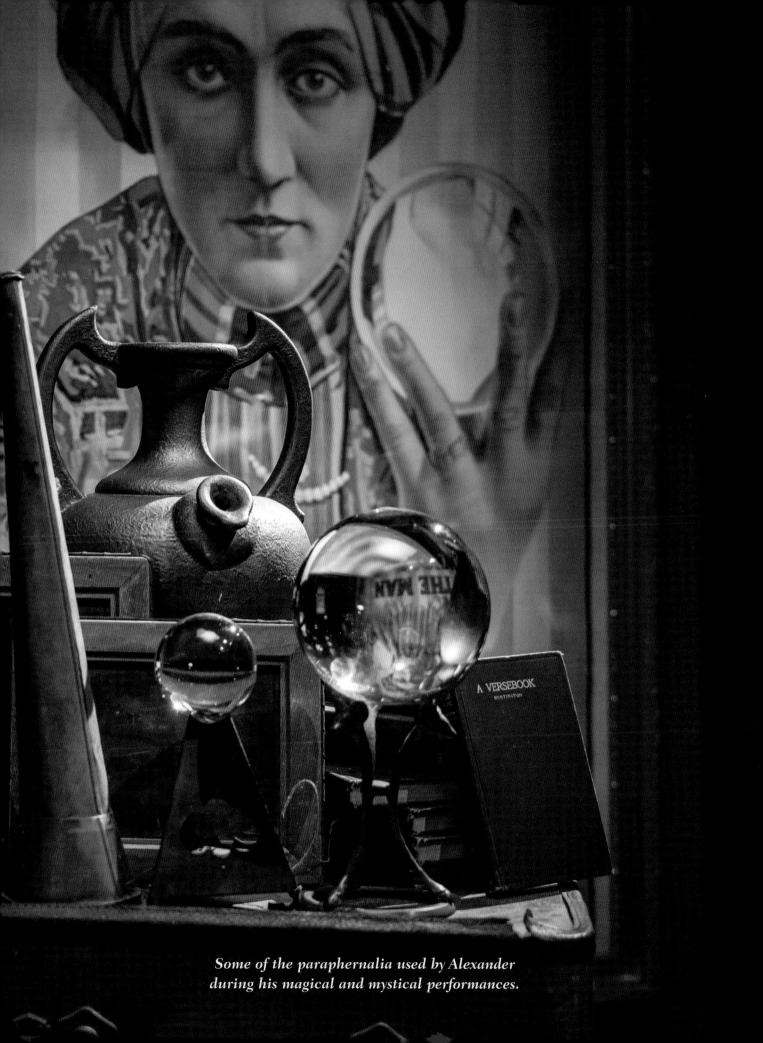

Some of the paraphernalia used by Alexander during his magical and mystical performances.

*Alexander stared into this crystal ball, and advised audience
members on their travel plans, finances, and love lives.*

Alexander's biographers, David Charvet, noted that to provide material for these publications, "The Man Who Knows" sent his assistants to public libraries and had them cut out pages from popular psychology books.

The ticket sales and schemes proved astonishingly successful, such that by the end of his career Alexander had earned millions of dollars. When he retired, aged just forty-seven, Alexander was one of the richest magicians in the world.

Alexander's private life was complicated, as he was a serial adulterer and a bigamist, and was married at least seven times. He also had a reputation for violence and extortion.

In one episode, Charvet described how a magician once visited Alexander in his dressing room and later recalled how the magician had a sack of gold coins, a bottle of whiskey, and a revolver on his table. When asked about why the objects were there, Alexander casually explained that he never knew which one he was going to need. In fact, he used all three throughout his life.

In 1926, a California millionaire received an anonymous blackmail note demanding fifty thousand dollars, and was informed that if he didn't pay up he would be killed. The FBI traced the note to Alexander, whereupon the great magician appeared to have bribed the attorney general to ensure that the case was dropped. On another occasion, Alexander was indicted for tax evasion and fined in excess of one million dollars in today's money (he reportedly paid in cash). Then, much later on in Alexander's life, the authorities caught him using a specially designed speedboat to transport bootleg liquor into America. He ended up behind bars, but once again apparently put his hand in his pocket and bribed prison staff to release him on medical grounds.

Toward the end of his life Alexander had started a new business taking photographs of nude women and selling the pictures in calendars. The enterprise reportedly netted him another small fortune. He died at the age of seventy-four following an operation to treat a stomach ulcer.

Most magicians are honest deceivers, and audiences are aware they are watching carefully crafted illusions. However, some conjurors conceal their magical skills and instead present themselves as a psychic, medium, or self-help guru. Unfortunately, some spectators believe that these tricksters possess genuine magical powers and so follow their advice. Alexander was one of magic's most amoral and exploitative characters, and yet, night after night, he stood onstage telling others how they should live their lives. His high-tech turban is now in my museum and symbolizes the dark side of magic. On the surface it appears to be a harmless piece of cloth. However, dig a little deeper, and a far more devious picture soon emerges.

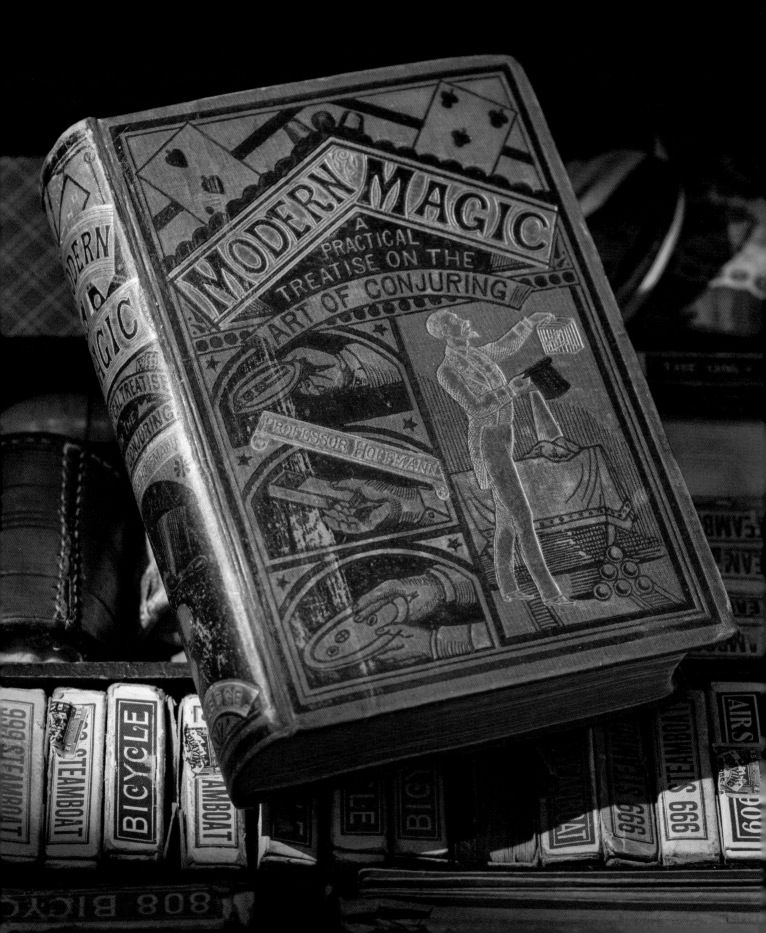

"P" Is for Private

❧ PROFESSOR HOFFMANN'S NOTEBOOK ❧

One quiet corner of my museum houses a collection of books and letters that once belonged to a Victorian magician named Angelo Lewis. Lewis rarely set foot onstage, yet his writings were hugely influential and illustrate how one person can change the course of magic history.

Angelo Lewis was born in 1839, studied law at Oxford University, and then became a London barrister. He had fallen in love with conjuring at a young age, and when he wasn't practicing law, he was practicing magic. In his early thirties, Lewis decided to share his passion for prestidigitation with the public by writing several popular magazine articles. Under the adopted pen name Professor Hoffmann, the articles proved a huge success and in 1876 were collected together into a single volume titled *Modern Magic*.

From Reginald Scot's *Discoverie of Witchcraft* onward, previous conjuring books had tended to present relatively short descriptions of magical secrets. Not so with Hoffmann. In line with Victorian notions of edification and betterment, he set out to educate rather than expose. In *Modern Magic,* budding wizards discovered the importance of practice and preparation, learned sleight of hand step by step, and received advice on how to dress, stand, and speak. Hoffmann's pioneering book didn't just tell readers how illusions were accomplished, but rather taught them how to become magicians. Beautifully illustrated with hundreds of intricate engravings, *Modern Magic* described secret sleights ("To Make the Pass"), hidden gimmicks ("Mode of Preparing Specially Adhesive Wax for Conjuring Purposes"), and countless tantalizing miracles ("To Guess, by the Aid of a Passage of Poetry or Prose, Such One of Sixteen Cards as, in Your Absence, Has Been Touched or Selected by the Company").

The first edition of Hoffmann's book sold out within weeks and subsequent printings continued to fly off the shelves. Unfortunately, many of Hoffmann's fellow magicians didn't share his sense of joy. With their most cherished secrets now in the public domain, conjurers put pen to paper, declaring that "Hoffmann deserves to be hanged" and that "the world will be as full of magicians as the Jersey coast is of mosquitoes." The dean of the Society of American Magicians went further than most, urging his fellow conjurors to burn copies of *Modern Magic* and condemning Hoffmann himself ("it would have been well had he died in his Mother's womb").

In reality, Hoffmann had the best of intentions. Unlike those involved in unethical and mean-spirited exposés, he didn't write *Modern Magic* to grow rich, to garner attention, or to spoil the fun of seeing a magic show. Instead, Hoffmann wanted to provide readers with a formal schooling in his beloved art of illusion. He also went to great lengths not to

*Professor Hoffmann sought to provide readers with a
comprehensive education in the art of illusion.*

expose any secrets without the permission of their creators. My museum provides a loving
home to Hoffmann's personal copy of *Modern Magic,* along with his letters and notebook.
A few years ago British magic historian Will Houstoun examined the museum's Hoffmann
collection. Many famous magicians told Hoffmann how their illusions worked and his pri-
vate notebooks are full of their secrets. Houstoun noticed that many later entries have the
letter *P* scribbled next to them and eventually discovered that this mysterious annotation
indicated that the idea was "private," which is why these illusions never found their way into

Hoffmann's published works. Hoffmann's pedagogical approach, combined with his ethical stance on ownership, ensured that *Modern Magic* wasn't a heartless exposure. Instead, it offered readers a measured peek behind the curtain, and was designed to promote curiosity and exploration.

Within a few short years, *Modern Magic* started to have Hoffmann's desired effect, and the book helped mold the magical minds of a new generation of conjurors. At the start of

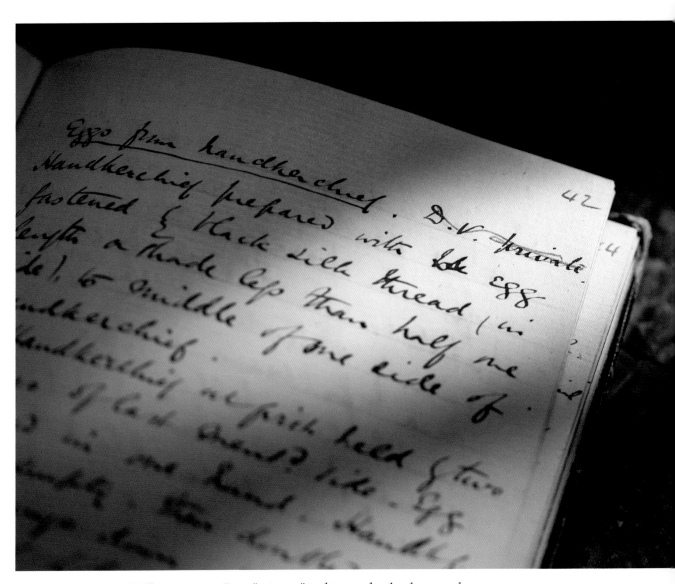

*Hoffmann wrote P, or "private," in his notebook whenever he
didn't have permission to expose the secret to an illusion.*

the 1900s, Howard Thurston was one of America's best-known magicians and constantly crisscrossed the country with his large-scale illusion show. When asked how he became interested in conjuring, Thurston pointed to *Modern Magic*. Magician William Robinson worked under the stage name Chung Ling Soo and played to packed auditoriums across America, Britain, and Europe. Like Thurston, Robinson was raised on Hoffmann's revolutionary book. Similarly, the most famous mind reader of the time—"Alexander: The Man Who Knows"—became interested in conjuring when he chanced across *Modern Magic*. Perhaps most important of all, the legendary Houdini was inspired by Hoffmann's writings as a young man and later described him as "the brightest star in the firmament of magical literature." Little wonder then that many magicians treat Hoffmann's book like a bible, and some have even suggested that the history of conjuring be split into two eras: "Before *Modern Magic*" and "After *Modern Magic*."

The success of *Modern Magic* allowed Hoffmann to become a full-time writer, and for the next forty years or so he produced books and articles relating to magic and other pastimes. His work included a magic-centered children's novel (*Conjurer Dick*), several more major compendiums of illusions (including *More Magic, Later Magic,* and *Latest Magic*), and a manual for "prospective tricyclists." Hoffmann's love of his topics, goodwill, and lighthearted approach always shone through. For instance, when imparting advice to tricyclists, Hoffmann noted: "Never run over an only child; parents don't like it. Where the family is large they are less particular." And when sending a friend one of his books on card games, he wrote: "I never play Patience Games, but everyone to their own taste, as the old woman said when she kissed her cow."

In 1919, Houdini wrote an article about the then elderly Hoffmann and described how his passion for magic hadn't deserted him: "The grand old author lies stricken. . . . [M]agic has been the one great love of his heart, and even now, when overtaken by almost total blindness and suffering from a mortal ailment, the letters which he dictates to his faithful sister show that his mind is keenly alive to the progress of the art through which his name has become world-famous." A month after Houdini's article was published, Hoffmann passed away at the age of ninety.

Hoffmann's magical children, grandchildren, and great-grandchildren have shown their

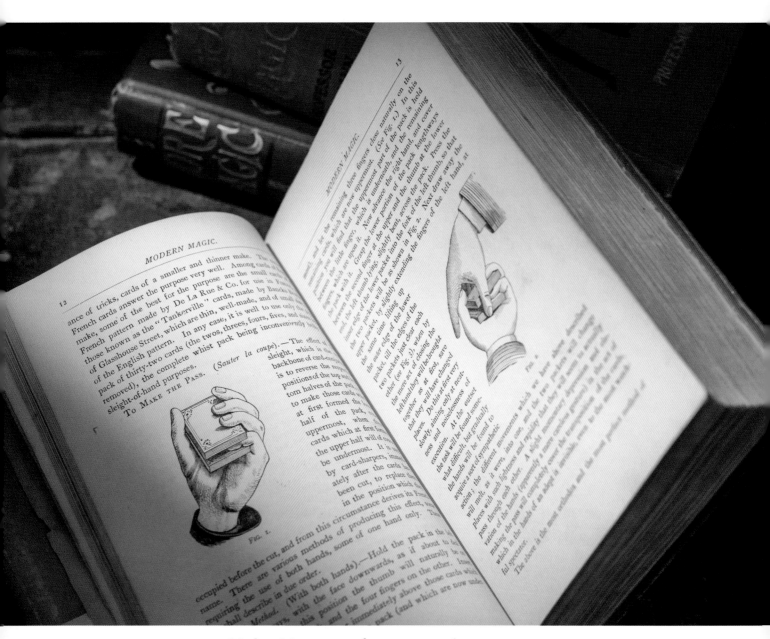

Modern Magic inspired a generation of great magicians,
including the illusionists Harry Houdini and Howard Thurston.

appreciation for their creator. The famous British illusionist P. T. Selbit described Hoffmann as "the greatest writer that has ever devoted his gifts to magic." In the 1920s, a past president of the Magic Circle declared that *Modern Magic* was "the most important book on conjuring that has ever been published or is ever likely to be published. . . . If you cannot then see what Professor Hoffmann did for conjuring . . . you cannot be mentally sound." Many years later the

legendary sleight-of-hand master Dai Vernon was clear about the initial volumes that should grace every magician's bookshelf: Hoffmann's *Modern Magic, More Magic,* and *Later Magic.*

 Modern Magic was Hoffmann's love letter to magic. Initially misunderstood by many of his peers, the book eventually played an essential role in elevating the art of conjuring and may have acted as a catalyst for the entire golden age of magic. His works are an inspirational reminder of how one person's passion and perseverance can change the world.

This Is My Wife

⋙ BUATIER DE KOLTA'S EXPANDING DIE ⋘

The remarkable illusion contained in this small box will never be performed again. It sprang from the mind of an innovative illusionist whose creations still bamboozle modern-day audiences, and his enduring work perfectly illustrates how magicians transform nuts and bolts into wonder and awe.

"This is my wife," said Buatier de Kolta as he walked onstage at New York's Eden Musée in September 1903. Strangely, he was only carrying a small case. In broken English, the French magician assured the audience that his wife resided inside the tiny case and explained that this rather unusual method of transportation saved on expensive cab fares. De Kolta then opened the case, took out a die some eight inches across, and placed it on a low table. The illusionist clapped his hands and in the blink of an eye the cube expanded until it was three and a half feet square. Finally, de Kolta made good on his promise by lifting the giant-sized die and revealing his regular-sized wife. Hugely impressed with the surreal events that had just rapidly unfolded in front of them, the audience clapped and cheered. Although de Kolta wasn't aware of it at the time, he had just given one of his final performances. A few weeks later he traveled to New Orleans and passed away suddenly from kidney disease. With his death, magic lost one of its greatest inventors and a man who perfectly illustrates the intimate relationship between illusion and technology.

Born in France in 1847, Joseph Buatier became fascinated by magic at an early age and eventually decided to become a professional illusionist. It was an unusual career choice for a man who was once described as having "no personality whatsoever." However, unperturbed by his shortage of showmanship, the French magician adopted the theatrical-sounding stage name Buatier de Kolta and bravely stepped into the limelight. Fortunately, what de Kolta lacked in charisma he more than made up for in creativity.

De Kolta lived through a time of unprecedented technological change. Engineers were laying long railway lines, building enormous bridges, digging ever-deeper tunnels, and launching huge ships capable of circumnavigating the globe. Similarly, inventors were busy creating a vast range of new mechanisms, machines, and materials. From telephones to tarmac, sewing machines to streetlights, and toilets to typewriters, rapid progress was the order of the day.

De Kolta had an astonishing gift for creating new illusions using these engineering marvels, and despite having had no formal training, he constructed clever contraptions that enabled rapid transformations, productions, and vanishes. Like many maverick inventors, de Kolta was something of an eccentric. He worked with the simplest of tools and every room in his house was littered with half-finished pieces of apparatus. De Kolta worked on several illusions at the same time and mid-conversation he often had a bright idea, and ran out of the

room to file some metal or saw some wood. Yet, out of this chaos came some of the greatest magic of all time.

De Kolta's illusions were novel, visual, quick, surprising, and, perhaps most important of all, highly deceptive. He debuted in England in 1875 and the press universally lauded his feats, with one reporter proclaiming that they were "far in advance of anything of the kind lately seen in London." Many of de Kolta's astounding inventions have stood the test of time and form the basis for illusions still performed by modern-day magicians. When an illusionist makes a bird cage instantly disappear, that's de Kolta. When billiard balls multiply in a

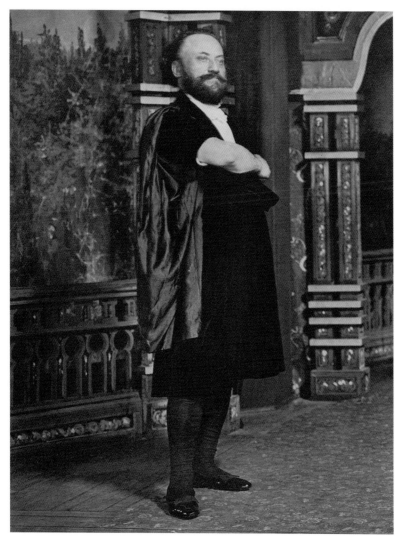

Buatier de Kolta was an eccentric genius who invented many illusions that are still performed by modern-day magicians.

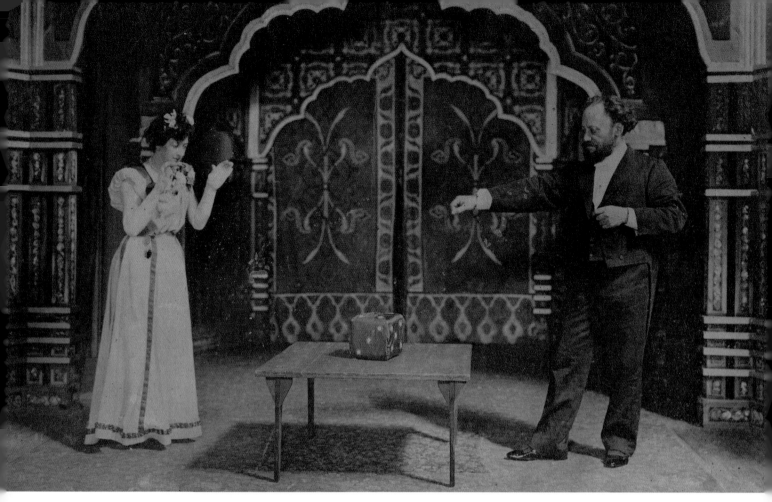

During the Expanding Die, an eight-inch die suddenly grew to over three feet square, and was then lifted up to reveal de Kolta's wife inside.

magician's hand, that's de Kolta. And when someone sits in a chair, is covered by a cloth, and then vanishes as the cloth is pulled away, that's de Kolta, too (although in de Kolta's show, the cloth also vanished). There is, however, one de Kolta illusion that stands out from the crowd because it will probably never see the spotlight again.

De Kolta's legendary Expanding Die illusion is a fiendishly difficult feat to perform. The die really does grow from eight inches to three and a half feet in size in the blink of an eye. Those who have been brave enough to examine the apparatus have described it as a bomb waiting to explode. When de Kolta performed the illusion, it took several people to close the apparatus back up for the next show, and the force of the sudden expansion often broke the illusion's components. It was a trick only its creator, the man who invented it, built it, and repeatedly repaired it, could love.

When de Kolta died, the press announced that he had arranged for the Expanding Die apparatus to be destroyed so that its secret went to the grave with him. In reality, it proved

impossible to conceal its innermost workings. Throughout his career, de Kolta was plagued by copyists and several duplicate Expanding Dies had sprung up around the world. In 1913, escapologist and magician Harry Houdini obtained the rights to the trick, and presented De Kolta's Marvellous Cube during his tour of Britain. Unfortunately the illusion proved too troublesome for even Houdini and he never performed it again.

I have performed several de Kolta illusions over the years, and owe a debt of gratitude to his clever and inventive mind. Houdini's Expanding Die now resides in my museum and is housed in a strong wooden box commissioned by the great escapologist himself. It's likely to remain in the box because removing it would run the risk of destroying a vital part of magical history. Astonishing and terrifying in equal measure, the Expanding Die celebrates de Kolta's eccentric genius, and provides a fascinating insight into how the latest engineering marvels are used to drive magic forward.

Removing the Expanding Die from its storage box would risk destroying an important part of magical history.

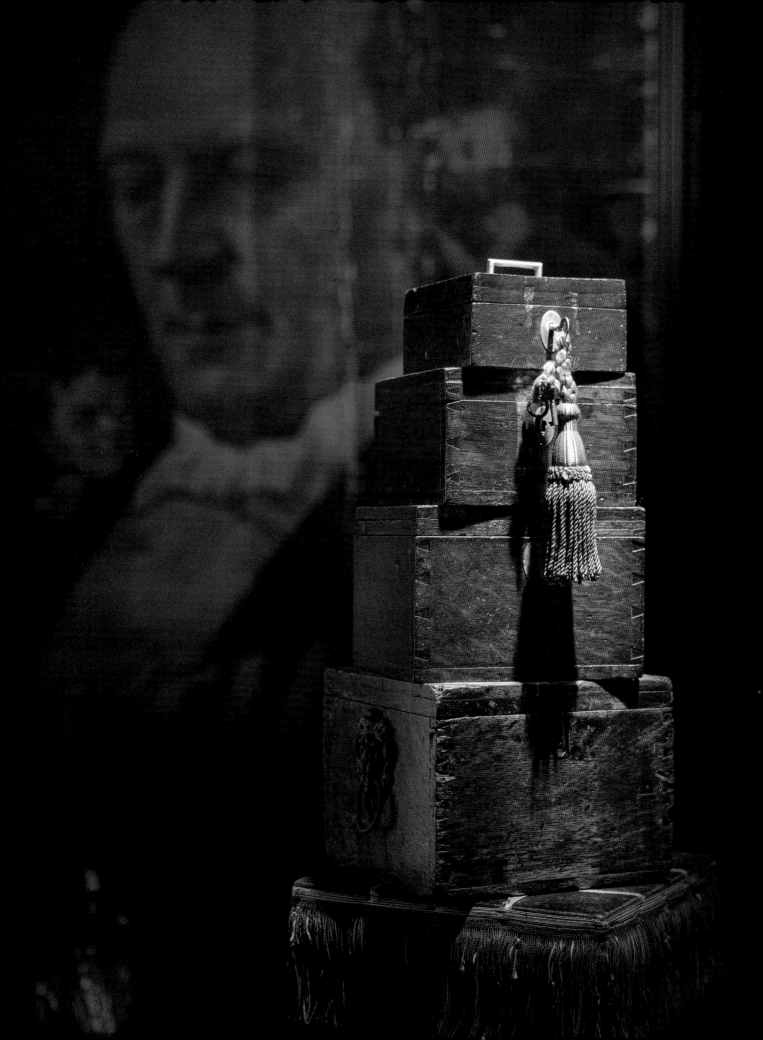

We're Off to See the Wizard

❧ HARRY KELLAR'S NEST OF BOXES ☙

This set of wooden boxes belonged to one of America's most famous illusionists. He astounded audiences across the world and attracted huge crowds wherever he went. However, his biggest claim to fame comes from the most unexpected and unusual of places.

In January 1904, President Theodore Roosevelt and his family arrived at Washington's Lafayette Theater to see the most famous magician of the day, the legendary Harry Kellar. At one point during his presidential performance, Kellar borrowed six finger rings from members of the audience, including from Roosevelt's daughter Ethel. The master magician then attempted to place the rings into the barrel of a pistol, but discovered that they were too large to fit into the gun. Appearing somewhat frustrated, Kellar took out a hammer, seemed to smash up the rings, load the pieces into the pistol ("They will drop in quite easily now"), and fired the pistol at a wooden chest hanging at the side of the stage. The chest was then opened to reveal a slightly smaller box inside. This second box contained an even smaller third box, and so it went on, until Kellar was surrounded by a series of increasingly diminutive boxes. Finally, he opened the innermost box and removed five of the six borrowed finger rings! Unfortunately, Ethel's ring was missing, apparently causing the president's daughter to remark, "Papa, I didn't get my ring back. Tell that man I want my ring."

Unperturbed, Kellar continued with his performance. He brought out an opaque bottle, invited everyone to call out their favorite drink, and then proceeded to pour the desired refreshments from his seemingly bottomless bottle. After several audience members had enjoyed a glass of wine, vodka, or gin, Kellar broke open the bottle to reveal a live guinea pig with a blue ribbon tied around its neck. Even more remarkably, Ethel's ring was attached to the ribbon. Finally, Kellar wrapped up the guinea pig in paper and offered it to the president's daughter as a pet. However, when Ethel unwrapped the parcel, the guinea pig had been transformed into a bouquet of pink roses. The president and first lady laughed, Ethel smiled, and Roosevelt's son Kermit openly expressed his disappointment at losing a potential pet ("Shucks").

Kellar was born in Pennsylvania in 1849, and became fascinated by magic as a young boy when he saw a performance by the exotically named "Fakir of Ava" (actual name: Isaiah Harris Hughes). At the time, two magicians called the Davenport Brothers were performing an innovative act in which they were tied up in a cabinet along with bells, tambourines, horns, and the like, and then appeared to summon the spirits and have them play the instruments. Kellar spent four years working as a stage manager for the brothers before stepping into the limelight himself. After touring around the world learning the trade of the tricks, he

*Harry Kellar staged elaborate magic performances during the late 1800s
and early 1900s and was known as the Dean of American Magicians.*

returned home and capitalized on the massive expansion of the American railroad system to
tour increasingly elaborate magic shows across the country. By the time Kellar was perform-
ing for Roosevelt, the illusionist was at the peak of his career. Traveling from one major city
to another, the wily wizard would make women levitate high into the air, have objects vanish
in the blink of an eye, and even appear to cut off his own head and have it float around the
stage. Kellar's impressive reputation, combined with his gigantic imp-based posters, ensured
impressive ticket sales and packed auditoriums wherever he went.

However, perhaps Kellar's biggest claim to fame comes from the most unexpected of places. In 1900, author L. Frank Baum and illustrator William Denslow published their children's novel *The Wonderful Wizard of Oz*. The book describes the adventures of a young midwestern farm girl called Dorothy in the magical Land of Oz. During Dorothy's journey she joins forces with a scarecrow, a tin man, and a cowardly lion, and together the unlikely quartet make their way to the Emerald City to meet the Wizard of Oz. Some magic historians have suggested that Kellar may have been the inspiration for the wizard in Baum and Denslow's classic story. When the *Wizard of Oz* was written, he was by far the best-known magician in America, and Denslow's illustrations depict a bald-headed, clean-shaven, middle-aged wizard who bears a striking resemblance to Kellar.

The claim is contentious, with others arguing that the Wizard of Oz was actually a mix of P. T. Barnum and Thomas Edison. However, regardless of whether Kellar really was the inspiration for the all-powerful wizard, there are several interesting similarities between the two men. According to Baum, the wizard was originally a traveling magician, and had arrived in Oz after a strange and scary journey in a hot-air balloon. Similarly, Kellar spent much of his life performing around the world and his travels were frequently far from smooth. For instance, in 1875 Kellar completed a tour of South America and set sail for England. Unfortunately, his ship ran into dense fog and collided with rocks off the coast of Brittany. Although Kellar and his fellow passengers were able to escape to a nearby island, all of the magician's props and possessions reportedly ended up at the bottom of the sea.

The similarity between Kellar and the Wizard of Oz doesn't end there. Although mainly benevolent and well meaning, the Wizard of Oz is not above the occasional misdemeanor, and even sent the innocent Dorothy on a potentially deadly mission to kill his nemesis, the Wicked Witch of the West. Similarly, when Kellar found himself in a tight spot, he may not have been above engaging in a spot of skullduggery. In 1901 he discovered that British magician John Nevil Maskelyne had added a new and dramatic levitation illusion to his show. When Maskelyne refused to tell his American competitor how the illusion was achieved, Kellar traveled to London and went to several of Maskelyne's shows. He sat in different parts of the auditorium and reportedly even used opera glasses to get a better look at the stage, but still struggled to discover the secret. At the time, a German sleight-of-hand artist named Paul

Valadon was performing with Maskelyne. Kellar eventually poached Valadon from Maskelyne by offering him the opportunity to perform across America. Many magic historians believe that Valadon told Kellar the innermost secrets of Maskelyne's levitation. Whatever the truth of the situation, Kellar was soon presenting his own version of the levitation, without Maskelyne's permission, on a nightly basis.

Kellar retired in 1908. Around a decade later, the great Harry Houdini persuaded the legendary performer to return to the stage for one final performance. At the end of a sparkling

Kellar's Wonder Book *explained how to produce eggs from a top hat and how to stick a dinner knife into your hand.*

HOUDINI

Dean Harry Kellar
460 S. Ardmore Ave.
Los Angeles, Cal.

My dear Dean Kellar:

Just received your letter in whi
have instructed Mr. Hering to sell you
I think it is magnif
that girl will

KELLAR

460
SOUTH ARDMORE AVE.
LOS ANGELES, CALIFORNIA.

Nov. 6, 1920

Dear Harry Houdini :—
I am sending you
a letter from our friend
Zealand. He

Kellar and Houdini exchanged letters over many years. Much of this
correspondence has now been brought together at the museum.

show, Houdini asked Kellar to sit in a sedan chair. With a 125-piece orchestra playing "Auld Lang Syne," a group of magicians lifted Kellar onto their shoulders and slowly carried him around the stage.

Kellar went to the great Emerald City in the sky in 1922. Houdini was hugely impressed by the great magician and was eager to write his biography. Alas, Houdini only penned a hundred pages before passing away four years after his hero. Houdini's manuscript, along with hundreds of letters between Houdini and Kellar, now reside in my museum. These documents, along with the historic boxes that once entertained the Roosevelts, remind us that Harry Kellar was a wonderful wizard, because . . . because because because . . . because of the wonderful things he did.

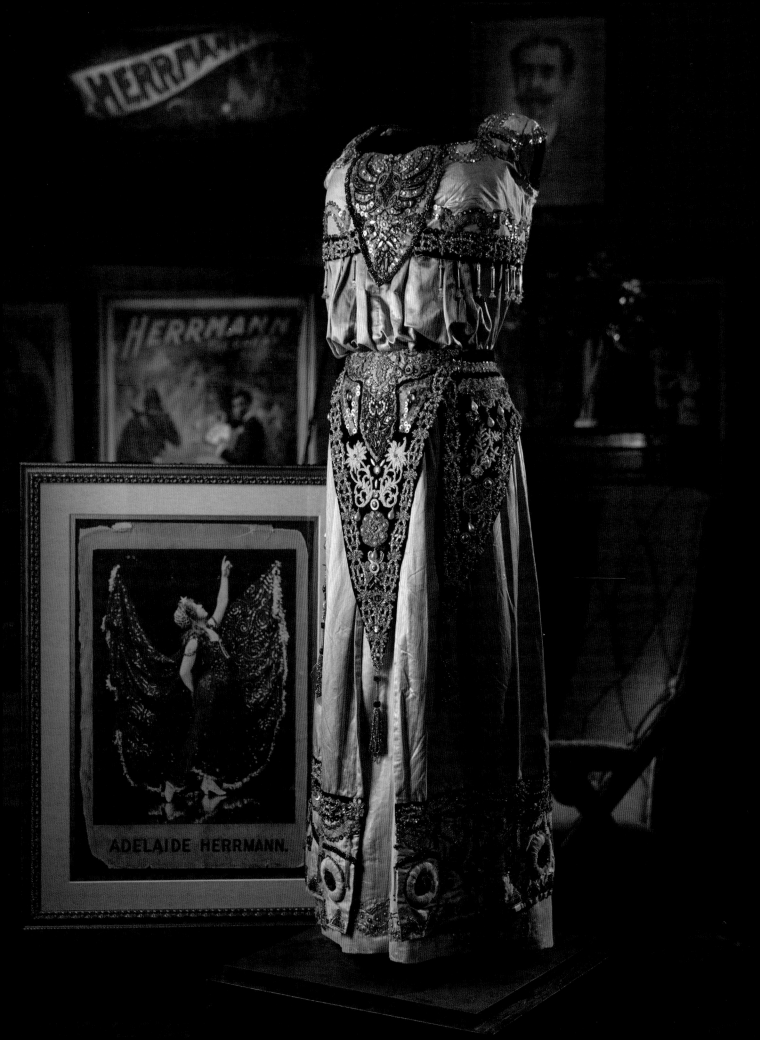

The Queen of Magic

⇝ ADELAIDE HERRMANN'S DRESS ⇜

She shared the limelight with one of the world's most famous magicians, became a headliner in her own right, and kept going in the face of great hardship and tragedy. Welcome to the remarkable life of illusionist Adelaide Herrmann.

In January 1897, New York's Metropolitan Opera House played host to an evening of astonishing magic. At the finale of the show, six soldiers marched onstage and formed a firing squad. Six bullets were marked and loaded into the soldiers' rifles. A few yards away, a china plate was held in front of the magician's chest. On cue, the soldiers aimed at the magician and fired. Gunshots and gasps of horror filled the auditorium. Moments later, the magician staggered forward and revealed all six bullets on the plate. With the death-defying bullet catch safely completed, the audience clapped, cheered, and jumped to their feet. The trick had been staged many times before but this was a performance like no other. At the time, almost every headline magician was male. However, that night it was a woman facing the firing squad. And it was far from the first time that this remarkable performer had defied convention. Nor would it be the last.

Born in London in 1853, Adele Scarsez pushed boundaries from an early age. As a teenager she developed a passion for dance, became an expert trick rider on the "velocipede" (a forerunner of the modern-day bicycle), and joined Professor Brown's Lady Velocipede Troupe. In 1874, the troupe rode around Europe and then set sail for America. As Scarsez climbed on board the ship, she was just days away from encountering a mysterious Frenchman who would turn her world upside down.

In the 1870s, magician Alexander Herrmann was at the peak of his career. Performing in a black velvet suit and sporting a goatee, the devilish-looking illusionist had toured his highly successful magic show across America and Europe. Herrmann was heading back to New York after enjoying a run of record-breaking shows in London and was traveling on the same ship as Scarsez. During the two-week voyage the master magician met the trick cyclist, fell in love, and asked for her hand in marriage. Scarsez accepted the proposal and the loving couple decided to tie the knot in New York. In a ceremony presided over by the city mayor, Alexander declared that he couldn't pay for the event, but then solved the problem by reaching under the mayor's long beard and magically producing a bundle of banknotes.

Scarsez adopted the stage name Adelaide Herrmann and began to work alongside her husband. At a time when most magicians' assistants were seen as little more than attractive and subordinate helpers, Adelaide received co-billing and took a leading role in many of the illusions. In addition, the first lady of magic frequently performed solo spots, exhibiting her trick cycling skills and staging unusual dance routines in which she would don a voluminous

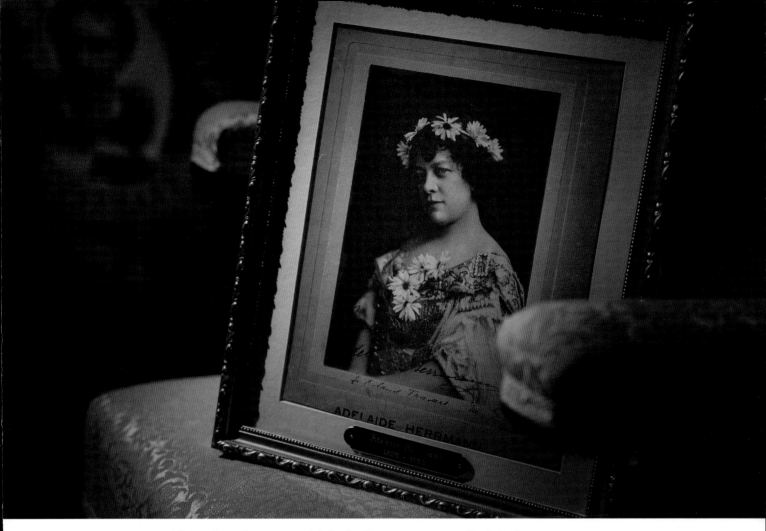

Throughout her career, Adelaide Herrmann repeatedly defied convention
and encouraged women to embrace the art of magic.

silk dress and manipulate the vast swathes of cloth while illuminated by colored lights and prismatic projections. The productive partnership continued offstage, with the two of them devising new illusions that combined Adelaide's passion for dance with Alexander's love of magic.

Throughout the 1870s and 1880s the dynamic duo toured the world, with Adelaide being levitated, vanished, dismembered, and cremated on a nightly basis. Often, pragmatism ruled the day. When their trapeze artist suddenly left the show during a tour of South America, Adelaide stepped up and took on the acrobat's terrifying role as a human cannonball. The act involved being shot fifty feet through the air and, on a good night, landing in a net stretched across the auditorium. The feat was as dangerous as it looked, and Adelaide was once accidentally set on fire by the cannon's gunpowder; another time she dislocated her shoulders during an especially bad landing.

Adelaide and Alexander's successful teamwork allowed the couple to live the high life. Fine wine and fancy food were supplemented with more extravagant purchases, including a mansion on New York's Long Island, a private yacht, and their own train carriage. Unfortunately, the spending spree came to an abrupt halt. In December 1896, the Herrmann train pulled into Rochester, New York, and the couple completed a weeklong engagement of successful shows. As they set off on the next stage of their tour, Alexander suffered a heart attack and died aged fifty-two. Adelaide's life was instantly thrown into chaos. The Herrmanns had made money vanish as quickly as it appeared, and the grieving widow was suddenly forced to deal with considerable debts while trying to keep a large traveling troupe on the road.

Once again Adelaide reinvented herself: her solo show made her magic's first female headliner. But her metamorphosis into the self-proclaimed "Queen of Magic" was far from easy. In the late 1890s, opportunities for touring a full evening show were slowly vanishing due to the rising popularity of vaudeville. Instead of coming to see a single star performer, audiences were attracted by multi-act bills made up of musicians, comedians, jugglers, dancers, athletes, and magicians. The Queen of Magic changed with the times and transformed her full evening show into a much shorter and faster-paced act, and topped vaudeville bills the world over for the next twenty-five years, including appearances at the London Hippodrome, the Folies Bergère in Paris, and the Berlin Wintergarten.

Throughout her career, Adelaide encouraged other women to study the art of magic. She published articles that showed women how to perform miracles, and when a female fan wrote to her asking for advice, Adelaide replied: "I see no reason why you should not become a good artiste of legerdemain. While there are few women who have made the art a study, still we must remember that this is the new era for woman. . . ."

Around the turn of the twentieth century, the majority of female performers were young women. In contrast, Adelaide continued to challenge convention and carried on touring into her seventies. Many of her illusions involved large pieces of apparatus and several animals. In one of her most popular pieces a box resembling Noah's Ark was shown empty and a large amount of water—symbolizing the great biblical flood—was then poured into it. The box was opened and a seemingly endless parade of animals emerged two by two, including doves, ducks, lions, zebras, and elephants. The birds were genuine while the other animals were actually dogs in various costumes.

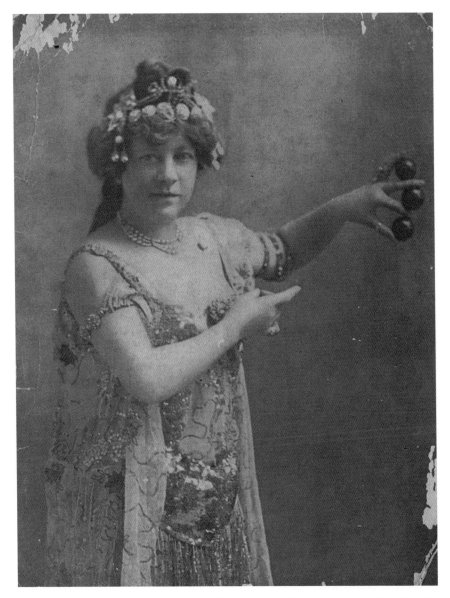

*As well as performing large-scale illusions and the infamous Bullet Catch,
Adelaide Herrmann was a skilled sleight-of-hand artist.*

In 1926, Adelaide moved her apparatus and animals to a theatrical warehouse in Manhattan. Unfortunately, one September morning the warehouse caught fire and more than two hundred crates of her equipment were quickly reduced to ashes. In her autobiography, Adelaide describes with deep sadness how it was fire not flood that eventually destroyed Noah's Ark and her other illusions. Adelaide also lost all of Alexander Herrmann's memorabilia, papers, and awards in the fire. Worse still, almost all her treasured animals perished in the

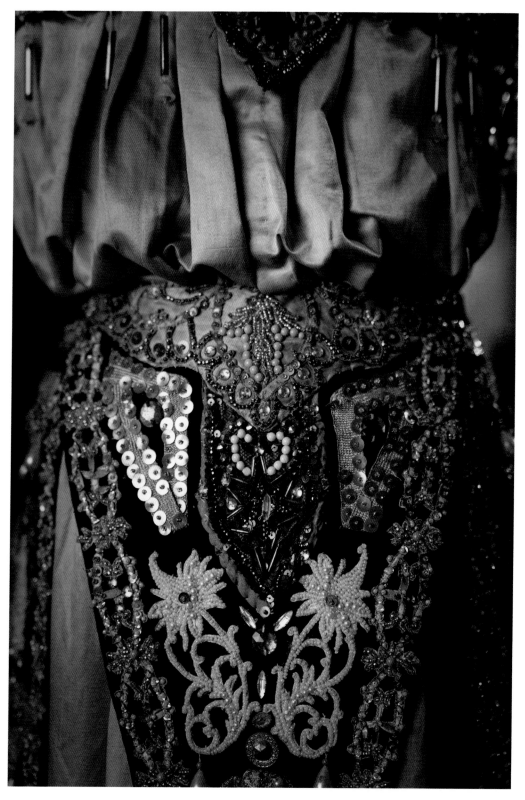

*This orange and green silk dress is beautifully made
and looked stunning onstage.*

blaze, along with an animal trainer named Thomas Collins, who had been on the ground floor of the building when the fire broke out and had rushed upstairs to try to save his creatures. When the fire brigade came across the trainer's body they discovered that he had spent his dying moments embracing a beloved kangaroo.

The seventy-three-year-old trouper defied convention one last time and, still agile, dignified, and regal, continued to perform. She delivered a smaller-scale show until her retirement in 1928. Four years later, Adelaide passed away from pneumonia.

Adelaide always paid great attention to the way that she dressed, with one review noting that the first lady of magic "gowns superbly." The exhibit devoted to her in my museum consists of a beautiful orange-and-green silk dress that was said to be worn by Adelaide. Almost all of her other apparatus and costumes were lost in the tragic 1926 blaze, and so the exhibit stands as an almost unique tribute to this groundbreaking, norm-busting, and resilient illusionist. Adelaide was a woman of immense talent, remarkable determination, and stunning vision. She was a fearless pioneer throughout her entire life, and her work has continued to inspire female magicians through the ages. Little wonder then that all of these years later, Adelaide Herrmann is still widely revered as a true Queen of Magic.

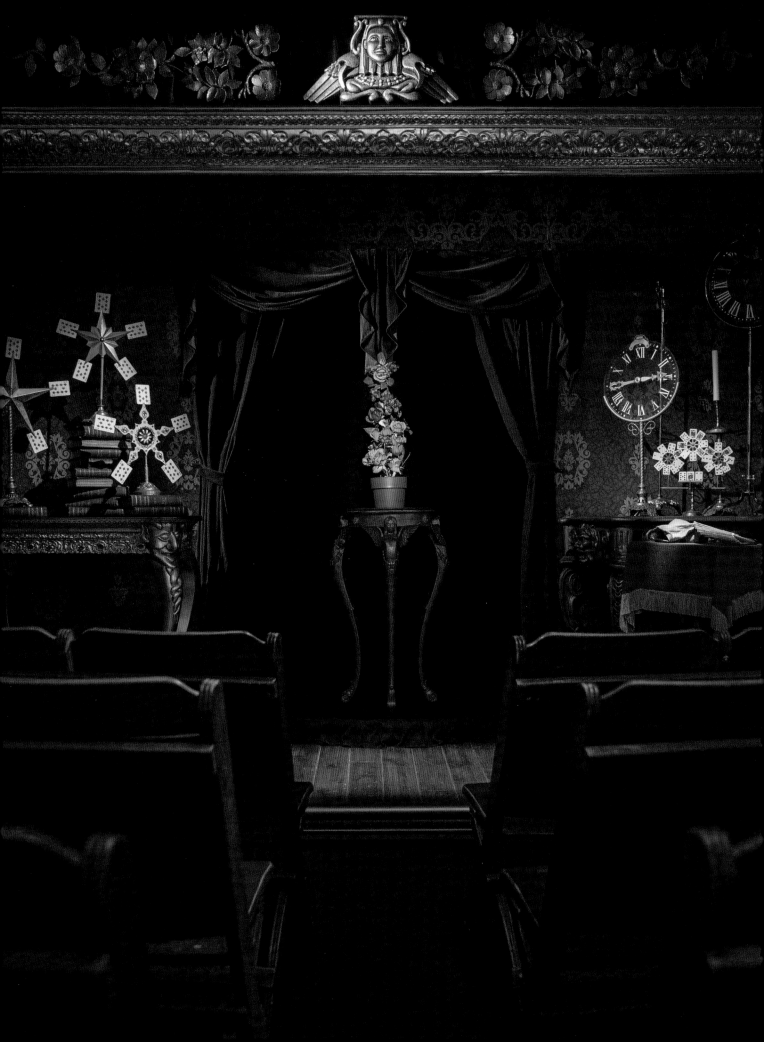

The Palace of Magic

❧ MARTINKA'S THEATRE ❧

Around the turn of the last century, 493 Sixth Avenue in New York City was home to a unique magic store. From the outside the store appeared small and unimportant. But in reality it was at the epicenter of American conjuring and contained a legendary secret theatre.

In 1872 the Martinka brothers arrived in New York City. Both men had been born in Prague and both had a background in conjuring. Francis Martinka was around thirty years old and had managed a Viennese magic theatre, while his mechanically minded brother, Antonio, was ten years older and had built illusions for several famous magicians. The brothers quickly developed a reputation as the purveyors of fine magical apparatus and after occupying various premises across the city, eventually established a magic store at 493 Sixth Avenue. Although the Martinkas didn't know it at the time, their address was to become seared into the minds of magicians the world over.

Martinka's store was set on the ground floor of a dingy old building and its dusty windows contained a modest display of conjuring apparatus. A sign above the door advertised the "Palace of Magic" in tarnished gold letters. Inside, a counter ran along one side of a small showroom and the shelves behind the counter contained boxes of magical paraphernalia. The run-down building and modest interior gave the impression of a small-scale operation. But this was an illusion.

Martinka's narrow-fronted store stretched back hundreds of feet, and contained several rooms packed with magical apparatus, secret gimmicks, books, pamphlets, posters, and paraphernalia. The store also housed a well-equipped workshop, and over the years, Antonio Martinka and his team conjured up a huge range of ingenious illusions as well as supplied bespoke items to the era's greatest magicians, including Harry Kellar, Adelaide Herrmann, Harry Houdini, and Horace Goldin.

But magicians didn't visit Martinka's just for the apparatus or workshop. Francis Martinka and his wife, Pauline, quickly assessed each and every visitor as they entered the store. Those with a casual interest in conjuring weren't invited to progress beyond the front showroom. However, professional illusionists and knowledgeable amateurs were allowed to make their way into a secret inner sanctum known affectionately as the "little back shop." To be invited into this private room was a rite of passage, and it was here that the real magic happened.

Here, the walls were adorned with huge colorful posters from the golden age of magic, and glass cabinets displayed priceless magical artifacts, including a replica of Robert-Houdin's Marvellous Orange Tree, Herrmann's magic wand, and an amazingly lifelike papier-mâché bust that Kellar had used to apparently decapitate himself. As visitors continued their journey through the store they would encounter other wondrous rooms, including one containing a

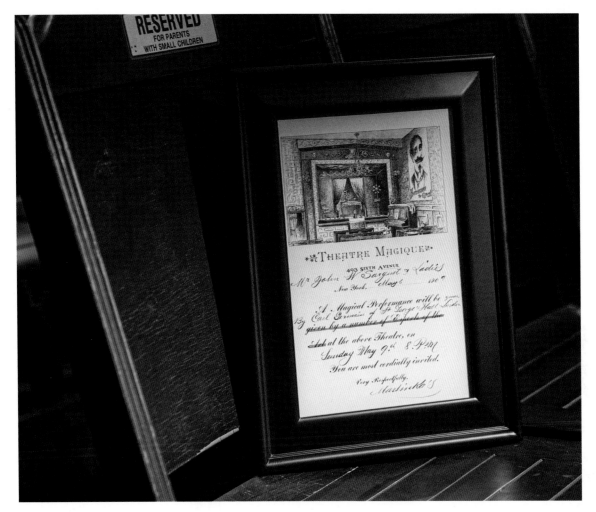

A personal invitation to a magic show held at Martinka's in 1909.

beautiful bijou theatre with an ornate gold-and-black proscenium, a stage set with classical French furniture and candelabras, and seating for a hundred guests.

It was in these rooms that highly skilled illusionists performed for one another and discussed the latest developments in the world of magic. Over time, the store attracted magical royalty, including Herrmann, de Kolta, and Kellar. In the late 1880s, Francis began inviting a handful of the most knowledgeable and experienced magicians to his Palace every Saturday night. New York City was a rough and tough place, and the street lighting on Sixth Avenue was poor. When Francis heard a knock on the store door, he pushed his face close to the glass to see if he recognized his visitor. Only then did he unlock the door, invite his guest inside, and ask them to make their way to the rooms behind the shop. For fifteen years, these

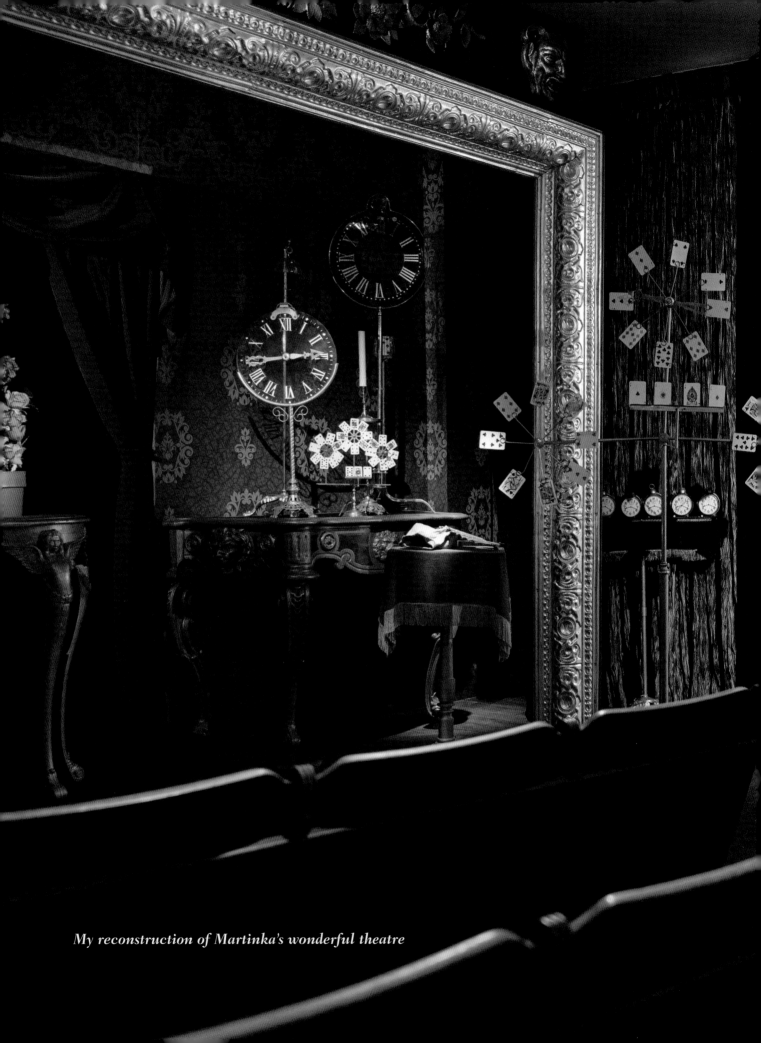

My reconstruction of Martinka's wonderful theatre

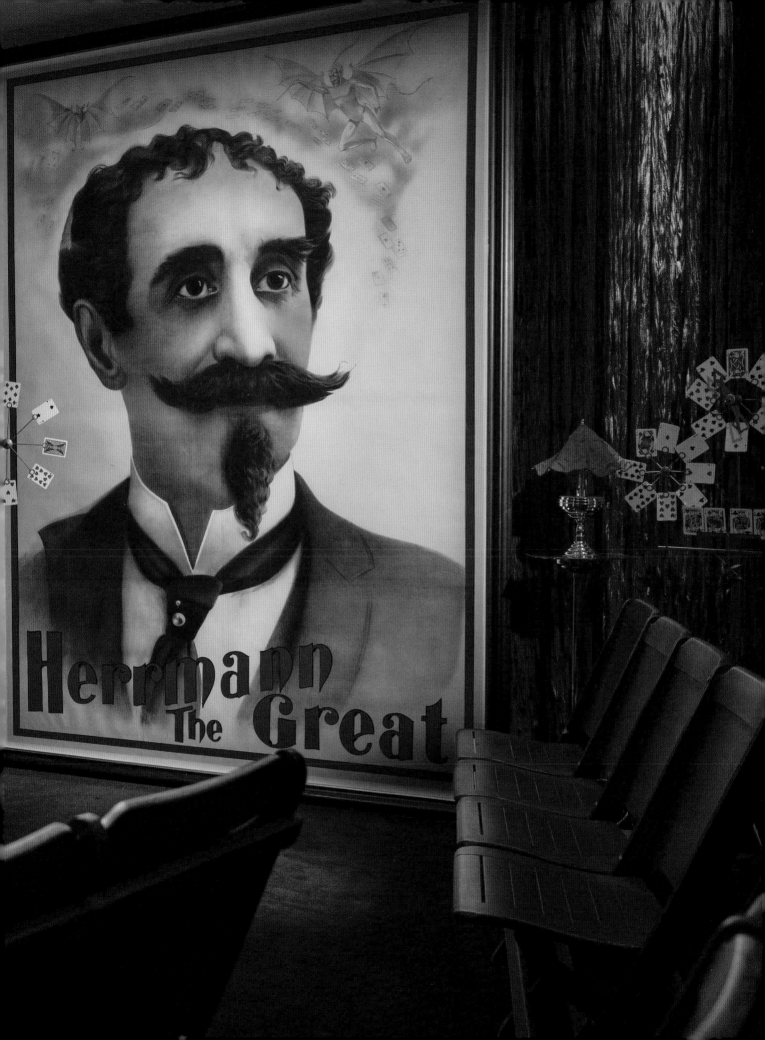

meetings were a constant source of inspiration and merriment. Then, around the start of the 1900s, these casual get-togethers were placed on a far more formal footing. In 1902, one of Martinka's most regular visitors, a physician and amateur magician named Dr. Saram Ellison, gathered together twenty-four conjurors in the store and founded the Society of American Magicians. For the next fifteen years, the Society held their meetings in this legendary building. The Society is now widely considered to be the oldest magic organization in the world, and over the years more than 47,000 magicians have joined its ranks. A few years ago, I was kindly awarded the Society's highest honors and named both "Magician of the Century" and "King of Magic."

In 1917, Francis retired and the globe-trotting illusionist Charles Carter ("Carter the Great") took over the reins. Carter performed with a lion, and one (possibly apocryphal) story suggests that he kept the lion in the back of the store. Carter struggled to make money from Martinka's and he sold the business a few years later. The new owner brought Harry Houdini on board, but even the great Houdini couldn't turn a profit and escaped after only a few months. Several other magicians ran the shop over the forthcoming years as it moved from one location to another.

In 1939, magician Al Flosso bought the business. Known as "The Coney Island Fakir," Flosso was a colorful character who had spent his life on the road performing magic. When he was a young boy, Flosso had visited the Palace and paid twenty-five cents for a small sealed envelope of magic. The purchase had left him without enough money to get home, and so he was forced to walk several miles back to his tenement apartment. When Flosso took over Martinka's he always ensured that his younger customers had enough money to return home, and even handed out cash or subway tokens to those in need. Under Flosso's stewardship the store became a chaotic mess of antique apparatus, papers, posters, and props. Nevertheless, Flosso claimed to know where everything was and put up a sign proudly proclaiming: "The Store of 3 Wonders: You Wonder if I Have It, I Wonder Where It Is, Everybody Wonders How I Found It." Flosso's son, Jackie, took over the business until 2000 and most recently it has moved online.

Martinka's original store and inner sanctum are now long gone. However, my museum contains a replica of the legendary ornate theatre. The room features original display cases and apparatus from Martinka's store. Also, the original room had a large poster of magician

Alexander Herrmann hanging on the wall. That actual poster now has pride of place in my homage to Martinka's Palace of Magic. The room allows visitors to follow in the footsteps of the past masters of magic and feel what it must have been like to walk into the inner sanctum. Once there, they discover how a seemingly unassuming magic store played a pivotal role in the history of magic.

In 1902, the then president of the Society of American Magicians, John William Sargent ("The Merry Wizard"), dedicated a long poem to Martinka's little back shop. Although perhaps not the greatest of literary works, the poem illustrates the love that magicians had for the room, and the first and last verses provide the perfect way to end our visit to this most magical of secret spaces.

MARTINKA'S LITTLE BACK SHOP

You've all of you been in that snug little place,
Where you wizards all love to resort,
Where the shelves all about bear the tools of your art,
And where all your best tricks have been bought,
You all of you know it and love it, I'm sure,
And in passing you always will stop,
For there's no other place on the whole Earth's face,
Like Martinka's little back shop.

Then there is Martinka, the chief of them all,
Who's genius we gladly confess,
I am sure that with me you will join in the wish
That his shadow may never grow less.
And as onward o'er life's thorny pathway we trudge,
Till the last fluttering heart-beat shall stop,
For each of us here will have memories dear
Of Martinka's little back shop.

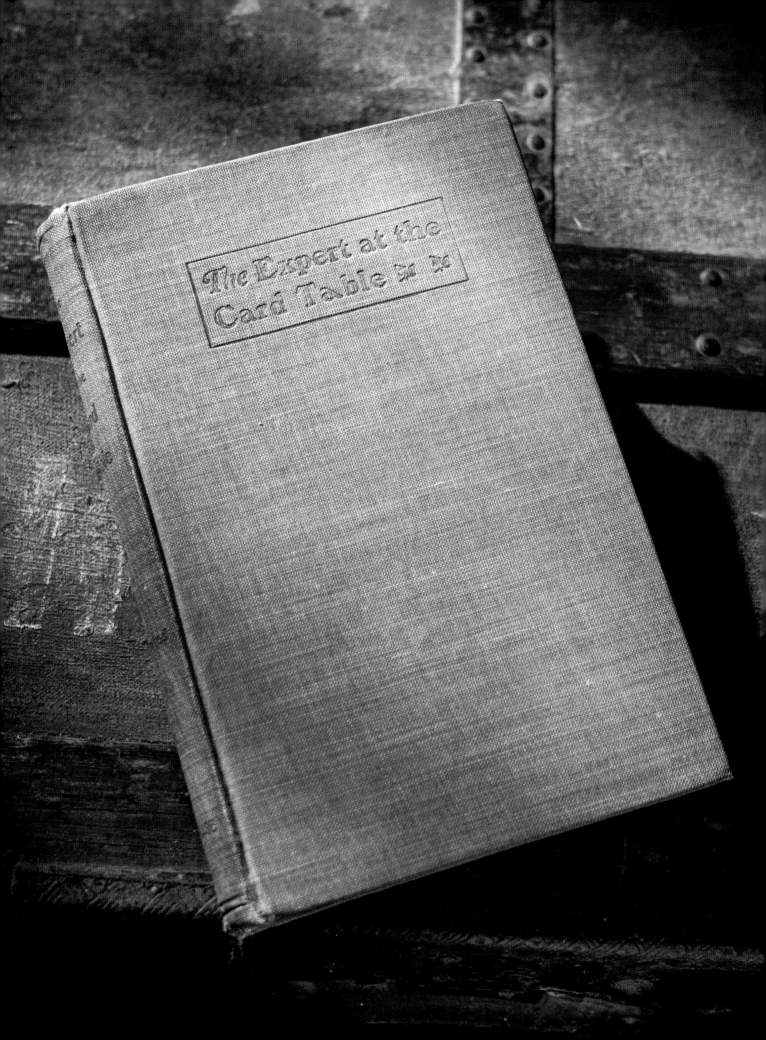

Author Unknown

❧ *THE EXPERT AT THE CARD TABLE* ☙

The Expert at the Card Table *is a slim book measuring about eight inches high by five inches wide. Covered in green cloth and with a gold embossed title, this modest volume is legendary within the conjuring fraternity and has been driving magicians crazy for well over a century.*

In 1902, *The Expert at the Card Table* was published in Chicago to little fanfare. Written by S. W. Erdnase, it contained 101 illustrations and presented a detailed description of the sleight of hand used by crooked gamblers and card magicians. With discussion of everything from false shuffles to fake cuts, dodgy dealing to secret palming, it was the ultimate instructional manual on how to cheat.

At the start of the book, Erdnase outlined the reason for putting pen to paper, openly declaring that "if this books sells it will accomplish the primary motive of the author, as he needs the money." Unfortunately for Erdnase, *The Expert* apparently didn't sell. Originally advertised for two dollars a copy, it was being sold within twelve months for half that, and the book's printers had declared themselves bankrupt. Indeed, the book might have faded into obscurity were it not for the perseverance of a precocious eight-year-old boy.

Born in 1894 in Canada, Dai Vernon developed a childhood fascination with magic, went in search of books and articles on the topic, and eventually chanced across *The Expert* in a local store. He doggedly worked his way through the difficult language and dense text (". . . the resourceful professional failing to improve the method changes the moment; and by this expedient overcomes the principal obstacle in the way of accomplishing the action unobserved"). By the time he was twelve years old, Vernon said he had mastered every move in the book and could recite the text from memory. As a young man, he rubbed shoulders with some of the world's best card magicians and gamblers, but as most of them had struggled to make heads or tails of *The Expert,* they failed to understand his devotion to Erdnase.

Unperturbed, Vernon continued to extol the virtues of his beloved book and magicians came to realize the error of their ways. The sleights described in *The Expert* were difficult but brilliant, and the book contained profound insights into how best to deceive at the card table. By 1910, *The Expert* had started to find its way onto magicians' bookshelves, with Professor Hoffmann declaring Erdnase's knowledge of card manipulation as extensive, peculiar, and profound. Since then, countless editions of the book have been published, along with additional annotations, videos, and DVDs. Most recently, the Conjuring Arts Research Center in New York created a version of the book that resembled a Bible. The edition was printed on very thin paper and with a gilt edge, and each line of the text was numbered to

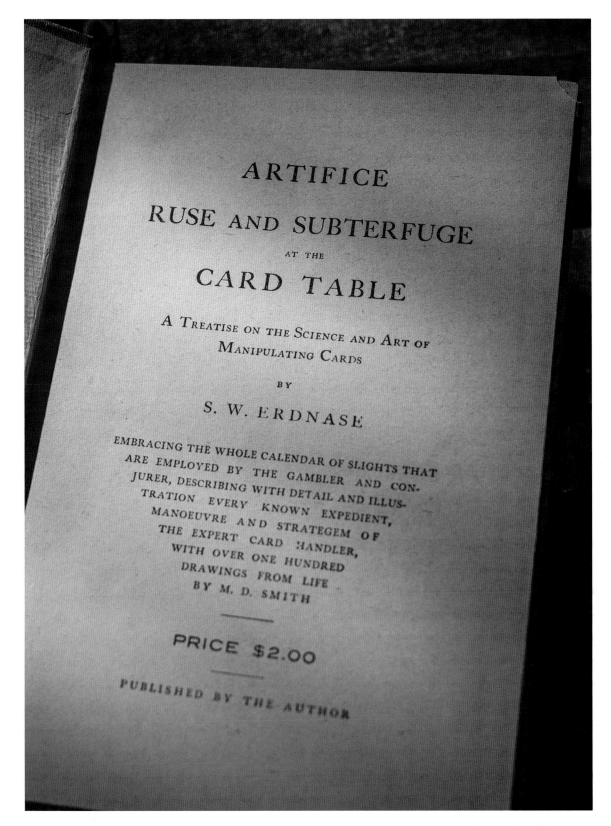

My museum contains a highly collectable first edition of The Expert at the Card Table.

allow magicians to reference accurately the descriptions of sleights, in the same way that the Bible allows readers to locate religious verse. First editions of *The Expert,* like the one here in my museum, are now highly sought after by collectors.

There remained, however, one small issue: no one knew who Erdnase actually was. In the early nineteen hundreds, it was illegal in America to circulate literature on crooked gambling and other "immoral" topics, and the authors of such works could face arrest and

The book has been reprinted many times, but no legal documentation has ever been found that identifies the author.

imprisonment. As such, it seemed likely that Erdnase was an assumed name, but who was this remarkable author? Magicians were curious and the game was afoot.

The first major breakthrough came in the 1940s and was the work of two amateur magicians, Martin Gardner and Bill Woodfield. Gardner would later become famous for his work on recreational mathematics and Woodfield would become a screenwriter for several television shows, including *Mission: Impossible* and *Columbo.* Magicians had long noted that a reversal of "S. W. Erdnase" yielded the more likely sounding moniker of "E. S. Andrews." Digging around in the New York Public Library, Gardner discovered references to a hardened gambling cheat called Milton Franklin Andrews, who was involved in several cons around the turn of the last century, eventually went on the run from the police, and in 1905 killed his girlfriend and then himself in San Francisco. Woodfield uncovered additional details and the two of them became convinced that *The Expert* was the work of Milton Franklin Andrews. The prime suspect's lack of connection with magic explained why most conjurors didn't know him, and the timing of his death provided a plausible explanation of why he never came forward to claim authorship. Case closed. Mystery solved.

Except that it wasn't. Gardner tracked down the artist responsible for the illustrations in *The Expert,* and he recalled meeting Erdnase at a dingy hotel room in Chicago around 1901, but his description of the author didn't match the rough-and-tough Milton Franklin Andrews. According to the artist, Erdnase was quietly spoken, appeared well educated, and had the softest hands he had ever seen. The illustrator's estimation of Erdnase's age also didn't match Milton Franklin. Oh, and just one more thing: he said Erdnase was short whereas as Milton Franklin was very tall.

Most magicians concluded that Milton Franklin Andrews wasn't their man and resumed their search. Over the years, magic enthusiasts have turned the spotlight on a succession of colorful characters, including New York clairvoyant James Andrews, Chicago casino owner James M. Andrews, lawyer James DeWitt Andrews, traveling railroad agent Edwin Summer Andrews, swindler E. S. Andrews, American electrical engineer William Symes Andrews, and wealthy mining engineer Wilbur Edgerton Sanders ("S. W. Erdnase" is an anagram of "W. E. Sanders"). Non-Andrews candidates include typesetter Edward Gallaway and Peruvian magician L'Homme Masque. Some even believe that the book is not the work of one author but two. Although the prima facie evidence for several of these candidates looked

In the 1940s, magicians tracked down the illustrator but even he couldn't lead them to the elusive author.

promising, in each case further investigation failed to deliver definitive evidence and the search moved on.

The pursuit of Erdnase has dominated the lives of many magicians and has led them to spend thousands of hours searching public records, newspaper articles, genealogical archives, bankruptcy files, image banks, magic books, yearbooks, census documents, and local libraries. The ongoing mystery has spawned a small industry of books and articles, performances and films (including a play directed by actor Neil Patrick Harris), and websites running to

hundreds of pages. Who was Erdnase? Despite this enormous amount of work, the search for his identity continues.

I am delighted to have a highly collectable first edition of *The Expert at the Card Table* in my museum. The book has inspired generations of conjurors to take card magic to a new level but the author's identity still remains an enigma and perhaps the mystery will never be solved. If that is the case, Erdnase will have pulled off arguably the most impressive illusion of all time, completely disappearing right before the eyes of the world's greatest magicians.

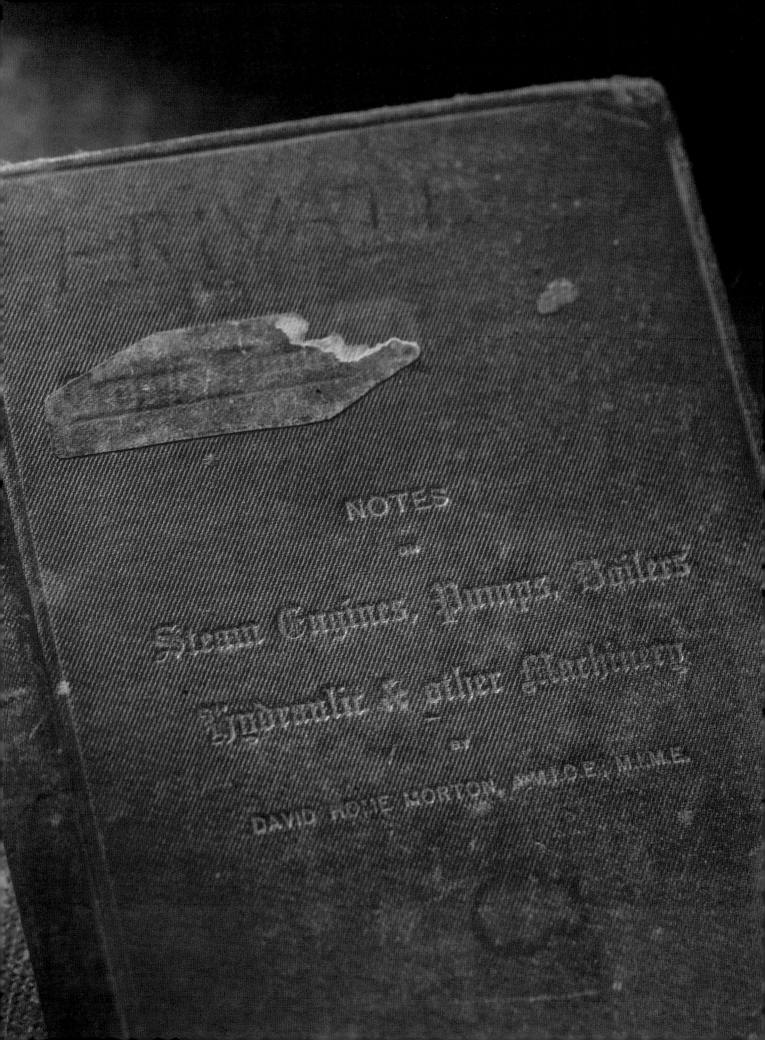

Notes on Steam Engines, Pumps, Boilers Hydraulic, and Other Machinery

⇒ MAX MALINI'S PECULIAR PARAPHERNALIA ⇐

In my museum there are a pair of opera gloves, a small black bag, and a little red book. These curious items once belonged to one of the world's greatest magicians and together they embody the secret of his phenomenal success.

Max Katz Breit was born in Austria in 1873 and emigrated to New York City at a young age. As a teenager he worked in a saloon own by retired magician "Professor" Frank Seiden. Seiden taught Breit the tricks of his trade and regular performances for the tough saloon crowds proved the perfect way to sharpen the young magician's skills. Graduating from this school of hard knocks with honors, Breit eventually became a professional magician and adopted the stage name Max Malini. Short and squat, with hands too small even to palm a playing card, Malini didn't look like a typical magician. Nevertheless, he would eventually stand head and shoulders above his peers.

Malini believed the route to fame and fortune lay in associating with the wealthy and powerful. ("You've got to mix with people with money if you want to make money.") In 1902 he went to Washington, D.C., and hung around the Capitol Building. When Senator Mark Hanna walked by, Malini approached him and, without warning, appeared to rip a button from the senator's suit. The senator was understandably shocked, but Malini then held the button against the suit and revealed that it was now safely sewn back in place. Impressed, the senator invited the eccentric little wizard to perform for his influential friends and associates. Malini's well-heeled audience warmed to him, and the magician quickly became the talk of the town, ultimately performing in the White House.

Billing himself as the "Napoleon of Magic," Malini set out to conquer the world. He caused a sensation everywhere he went, and slowly climbed the social ladder by taking letters of introduction and handbills from one prestigious client to another ("You'll Wonder When I Am Coming—You'll Wonder More When I Am Gone"). He made chosen playing cards emerge from his mouth, produced solid bricks from people's hats, and "hypnotized" walking canes. On one occasion Malini cut a long piece of hair from the head of a spectator, and then made the piece vanish and reappear back on the spectator's head. Later on in life, he enjoyed recounting how he once brought a cooked chicken to life just as the guests were about to carve it at the table. According to Malini's version of events, the chicken ran around the room while the guests all screamed. Master magician and entertaining raconteur, he became a highly sought-after society entertainer and rubbed shoulders with the rich and famous, including President Roosevelt, John D. Rockefeller, Al Capone, and the kings and queens of Europe.

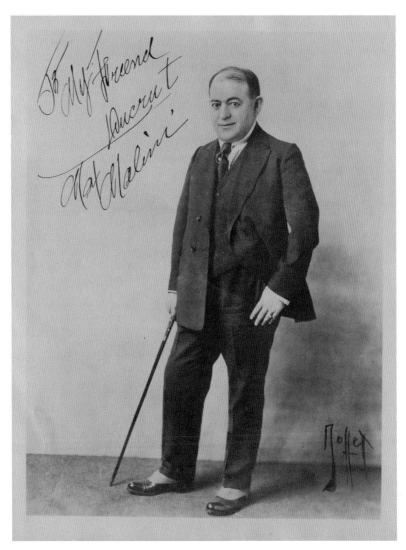

Max Malini billed himself as the Napoleon of Magic, and was known for his offbeat and often irreverent performing style.

Malini usually wore a fur-lined coat and carried a gold-topped cane. Although he was lacking in any formal education, his charisma often won the day, even in the most elite company. At one point he entertained Britain's Prince of Wales and finished his performance by remarking: "Good night your Majesty and say good night to Mrs. Wales." The inappropriately informal remark caused hilarity in court and was reported in the British press. During another performance, Malini had several playing cards selected and shuffled back into a deck, then spread the deck facedown on a table, was blindfolded, and located

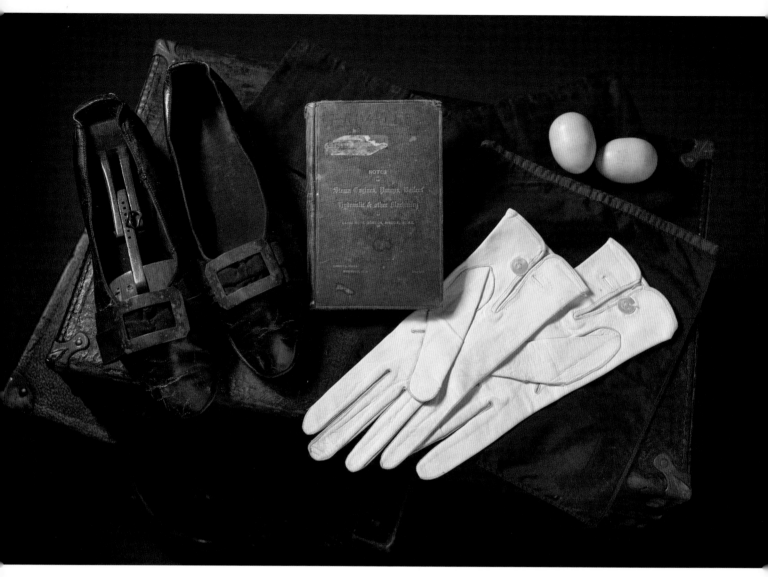

The Malini exhibit contains many important objects from this impactful performer, including his opera gloves, shoes, and legendary egg bag.

each of the chosen cards by stabbing them with a penknife. The table was an expensive antique, and the host was horrified at the knife marks left on its polished top. When the host asked Malini how he should explain the damage to people, the magician replied, "Tell them Malini did it."

The success of Malini's illusions rested on several psychological principles. He was a talented sleight-of-hand artist who knew exactly when to carry out a hidden action without attracting attention. When asked how long he was prepared to wait for the perfect moment,

Malini famously replied: "I'll vait a veek." He also knew his spectators were suspicious of unusual-looking apparatus, and so worked his magic with whatever came to hand, including coins, cigars, table knives, canes, chickens, oranges, glasses, and sugar cubes. Malini's impromptu approach to magic was a huge novelty, with one journalist reporting: "He had no benefit of footlights, no concealed wires, no cabinets. He is willing to do any of his tricks anywhere and at any time."

Perhaps Malini's greatest psychological weapon was his ability to create the illusion of spontaneity. His performances often looked unplanned and impromptu, but like any great general, the Napoleon of Magic carried out extensive preparations before going to war. While having a drink with someone at the bar, Malini might secretly place a potato under their hat or slip a card into their pocket. Later, when the person asked Malini to perform, the wily wizard magician was set to produce a "spontaneous" miracle. He was often as patient as he was prepared. When, for instance, Malini attended a party at Bess Houdini's house, he quietly slipped into the kitchen, secretly picked up an alarm clock, and hid it under his coat. Malini kept the clock hidden for three hours as he chatted with guests. When the time felt right, he gathered some guests around and magically produced the clock. Similarly, when he visited the house or office of someone he suspected might become a future client, he might secrete playing cards behind their picture frames or inside their books, in the hope of magically revealing the cards during a later performance. According to some magicians, Malini even tracked down his clients' tailors months before a performance, and had them secretly sew a playing card into the lining of the client's jacket.

Malini's skill, impromptu approach, and preparedness fooled some of the best minds in magic. The legendary sleight-of-hand artist Dai Vernon idolized him. On one occasion, Vernon and Malini were dining with a group of people at a New York restaurant. Malini borrowed a coin and a hat from one of the women present, spun the coin on the table, placed the hat over the spinning coin, and asked the woman whether it would land "Lady or Eagle." She made her guess, and Malini lifted the hat to reveal that she was right. He repeated the game and the woman was right again, but the third time he lifted the hat, the coin was gone and in its place was a huge block of ice. Vernon said the waiter standing behind Malini fell over in astonishment. The trick created a profound impression on all who saw it, and one that they remembered and retold for the rest of their lives.

*A drawing of Malini created by the
world-famous tenor Enrico Caruso.*

Malini died in Hawaii in 1942, having made and lost several fortunes. At a time of limited social mobility, this self-taught immigrant rose through the ranks and became friends with the rich and famous. Malini's legacy doesn't involve colossal cabinets and colorful costumes. His opera gloves are an elegant symbol of the hands that once transformed ordinary objects into extraordinary experiences, and the small black bag was used to perform one of his signature illusions, in which an egg repeatedly appeared and disappeared within it.

Finally, there is his little red book. Like many master magicians, Malini was a devotee of a now-classic text on sleight of hand, *The Expert at the Card Table*. Curiously, his copy has been disguised to look like a volume about hydraulic engineering and carries the fake title: "Notes on steam engines, pumps, boilers hydraulic and other machinery." In many ways, the curious book perfectly symbolizes Malini's approach to magic. If he had been seen looking at the book in public, the fake cover would fool people into believing that he was reading about steam engines and pumps. In reality, Malini was doing what he always did best—planning, preparing, and practicing for his next spontaneous miracle.

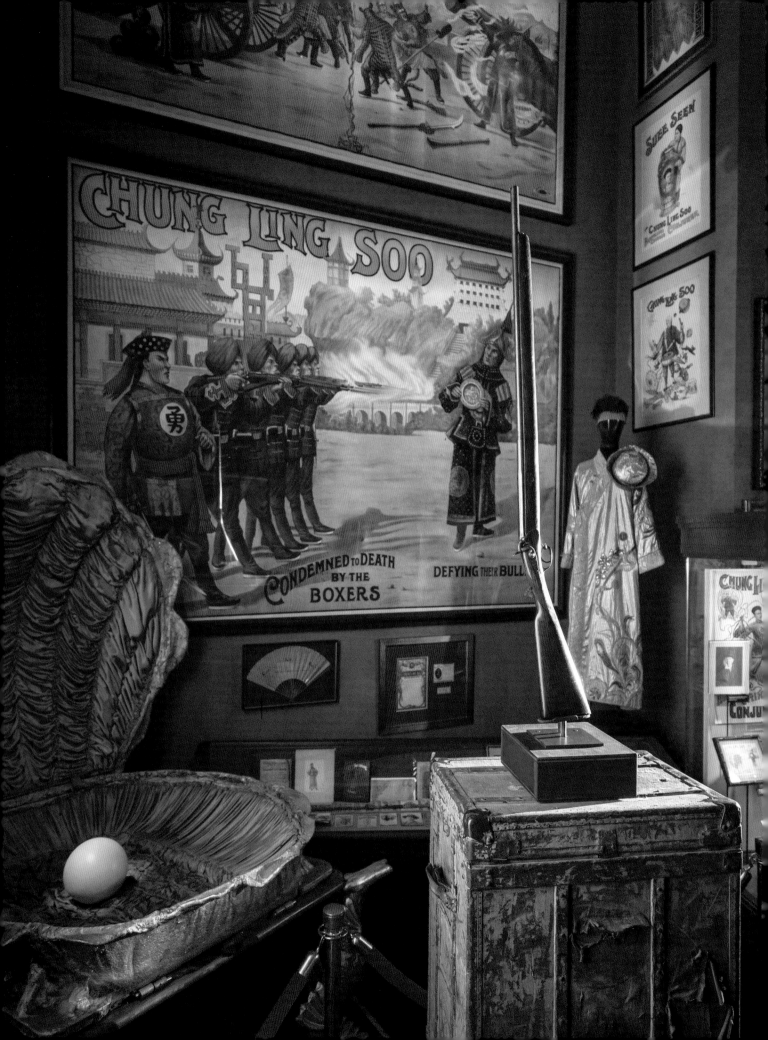

Condemned to Death by the Boxers

❧ CHUNG LING SOO'S GUN ❧

This antique gun belonged to one of magic's most deceptive characters. It has a strange story to tell and symbolizes the deadly risks that some magicians are prepared to take each time they step onto the stage.

Chung Ling Soo's shows were a kaleidoscopic display of dazzling illusions. Dressed in brightly colored Chinese costumes, the master magician linked solid metal rings, conjured up colorful silk handkerchiefs, and produced live chickens from a giant cauldron. The public believed that they were witnessing a genuine display of magic from the "mysterious Far East." In reality, Chung Ling Soo was American and had never set foot in China.

Born in New York in 1861, William Robinson developed a childhood fascination with conjuring, read Professor Hoffmann's seminal book, *Modern Magic,* and spent his early career assisting two famous American illusionists—Harry Kellar and Alexander Herrmann. Robinson eventually tried to develop his own show, but was naturally shy and struggled to speak to audiences in a charismatic and commanding way. At the time, a Chinese magician known as Ching Ling Foo was enjoying great success in America and Robinson decided to capitalize on audiences' fascination with Chinese magic by creating an entirely fictitious identity. A product of the time, Robinson reinvented himself as Chung Ling Soo, shaved his head, wore a fake pigtail, and used makeup to darken his skin. Dressing in a traditional Chinese costume, he declared himself the son of a Cantonese woman and claimed that he had been taught ancient Chinese magic tricks during his childhood.

Soo said almost nothing onstage and when quizzed by reporters he spoke through his interpreter. The interviews were a complete sham. When the reporters asked a question, Soo's interpreter appeared to speak in Chinese, Soo replied in a made-up nonsense language, and Soo's interpreter then pretended to translate Soo's response back into English. Remarkably, the deception went unnoticed.

The genuine Chinese conjuror Ching Ling Foo was appalled at Soo's success. Journalists in England were delighted when Ching Ling Foo challenged Chung Ling Soo to a contest of magic and a meeting was arranged at the offices of the *Weekly Dispatch* (headlines included "Did Foo Fool Soo?" and "Can Soo Sue Foo?"). Foo failed to show up for the contest and Soo won the day by performing some of Foo's best-known tricks, including producing enough fruit pies to keep the "Dispatch staff from entering a restaurant for a week." Following the challenge, Chung Ling Soo quickly became one of the most popular magicians of the period and played to packed houses wherever he went.

Around the time of Soo's performances, several well-known magicians were eager to

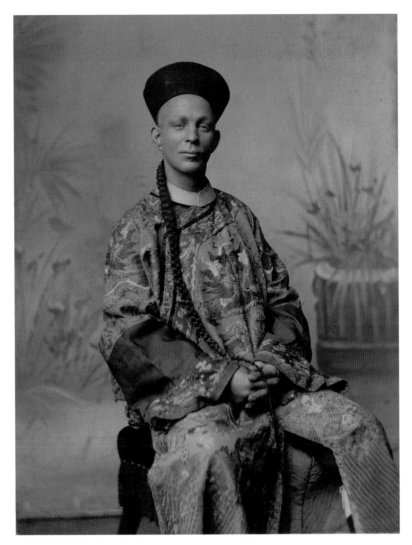

William Robinson capitalized on the public's fascination with
Chinese magic and created a fictitious identity—Chung Ling Soo.

conjure up associations with the "mysterious East." These performances have been viewed as harmless acts of escapism and spectacle. However, as professor of philosophy Chris Goto-Jones has noted, Soo's appropriation of Chinese magic and culture, and his negative impact on the career of an actual Chinese magician, casts Soo in a more questionable light.

Curiously, Soo's most enduring contribution to magic history is not associated with his life, but rather his death. Around 1900, China had experienced an anticolonial uprising known as the Boxer Rebellion. Over the years Soo had capitalized on these events by staging one of his most dramatic illusions: Condemned to Death by the Boxers. According to the story line,

Soo had fought against the Boxer Rebellion, but had been caught and sentenced to death by firing squad. However, Soo managed to survive the deadly encounter by magically catching the bullets before they reached him. Condemned to Death by the Boxers was presented as a reenactment of these dramatic events. Two bullets were marked by audience members and placed into the barrels of two muzzle-loading guns. Soo then stood on one side of the stage holding a willow-pattern plate, and two of his assistants stood a few feet away from him holding the guns. When the great magician was ready, the assistants took aim and fired at Soo. After a dramatic pause, Soo staggered forward and revealed the marked bullets on the plate.

On March 23, 1918, Soo performed the Bullet Catch to almost two thousand spectators at the Wood Green Empire in North London. The bullets were marked and loaded into the guns. The two assistants and Soo assumed their positions. They had been performing the trick successfully for many years and there was no reason to believe that tonight would be any different. On cue, the assistants took aim and fired. There was a loud report and flash of flame from the barrels of both guns. Suddenly, Soo fell to the ground. He had been shot through the chest. Several members of his troupe attempted to stem the blood that was now starting to cover the stage and the curtains were closed. Soo was taken to the hospital, where he died the following morning.

Some speculated that the magician had been murdered. Others wondered whether Soo had taken his own life. Soo used several guns during his show. During the inquest, the two guns that had been aimed at Soo during his final performance were dismantled and examined, and the truth revealed. The way it was supposed to work was that, while some gunpowder and a genuine bullet were placed into the barrel of each gun, the bullets weren't actually fired because Soo had gimmicked the guns. Under his scheme, when the guns were fired, the resulting spark didn't set off the gunpowder in the main barrel, but rather traveled down a secret channel and ignited a blank charge in a second barrel. Soo had sometimes taken the guns apart to clean them, and over time one of the guns had developed a tiny passageway between the area in which the spark occurred and the main barrel. In addition, World War I had made it difficult for Soo to obtain coarse-grained gunpowder and so by 1918 he was using a much finer-grained substitute. Unbeknownst to the great illusionist, over time this fine-grained powder had made its way into the tiny passageway, and on the fateful night the

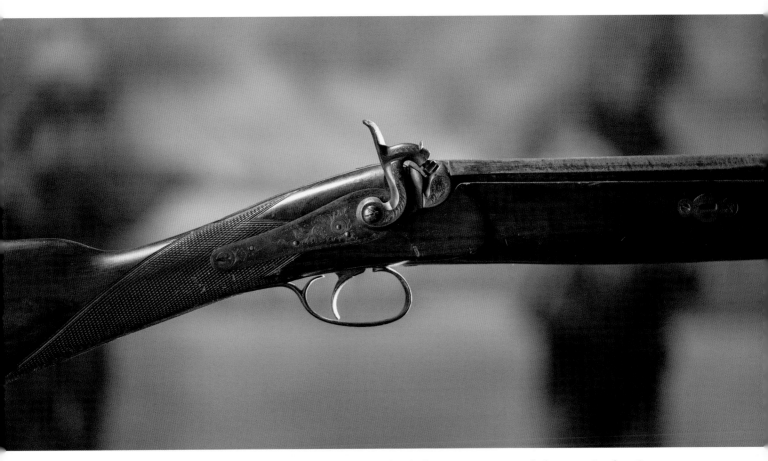

During the Bullet Catch, two marked bullets were loaded into two guns, and the guns fired at Soo.

spark ignited the gunpowder in the main barrel and fired the bullet. The coroner recorded death by misadventure.

Condemned to Death by the Boxers was Soo's version of a well-known illusion called the Bullet Catch. Several performers have staged the illusion over the years and some have lost their lives in the process. In 1829, Polish magician Louis de Linsky was performing for German royalty, and concluded his act by having his wife attempt the Bullet Catch in front of six soldiers. At the time, soldiers loaded their rifles by biting open a paper cartridge, and then pouring the enclosed gunpowder and bullet down the rifle's barrel. De Linsky secretly asked the soldiers to only pour in the gunpowder and retain the bullet. Unfortunately, one of the soldiers failed to follow the magician's instructions. De Linsky's wife was shot in the stomach and died the next day. In 1869, magician Adam Epstein staged his version of the

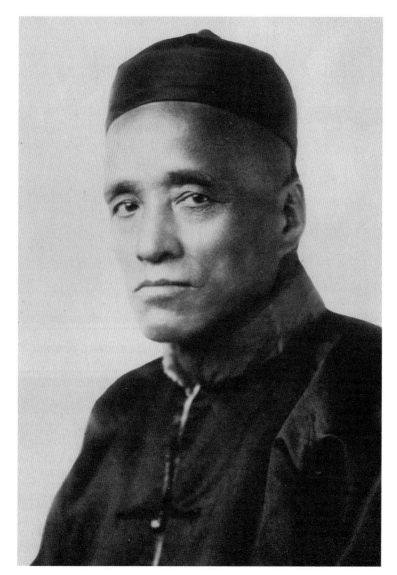

*Ching Ling Foo was not only one of the highest-paid acts
in American vaudeville but also one of the most imitated.*

Bullet Catch. Reports of his performance are somewhat ambiguous, but Epstein appeared to have either inadvertently left the ramrod in the barrel of the rifle or broken the end off the ramrod when he loaded the gun. Either way, when the rifle was fired, Epstein was hit by a projectile from the gun and killed. Perhaps not surprisingly, many magicians consider the Bullet Catch too dangerous to perform. Indeed, the great escapologist Harry Houdini thought about staging the illusion, but was persuaded otherwise by another legendary American magician, Harry Kellar.

Dangerous illusions like the Bullet Catch attract audiences, but there is always the risk of them going terribly wrong. No matter how careful the preparations, apparatus can malfunction, spectators can misunderstand instructions, and performers can make mistakes. I have performed many potentially dangerous illusions during my career, including being strapped into a straitjacket and suspended high above a flaming bed of spikes, being locked into a box and thrown over Niagara Falls, and withstanding the intense heat created by a tornado of fire. Luckily, I have emerged unharmed. However, other performers have not been so fortunate, and Soo's gun commemorates the conjurors who put their lives on the line to thrill audiences but end up paying the ultimate price.

Escaping Mortality

֍ THE HOUDINI COLLECTION ֎

Houdini was strapped into straitjackets, locked in jails, nailed into crates, shut in safes, bound in chains, and secured with manacles. Yet the escapologist always managed to set himself free. Even today he remains the most famous escapologist of all time and his enduring fame provides a tantalizing insight into one of humanity's most fundamental concerns.

Ehrich Weiss was born in Hungary in 1874, and was the son of Rabbi Mayer Samuel Weiss and his wife, Cecelia. The Weiss family traveled to America in 1878 but struggled to live the American Dream. Life was tough and money hard to come by. Ehrich took all manner of jobs to help supplement the family income, including selling newspapers and shining shoes. But he also had a knack for performing. During his childhood he proved an able athlete and worked in a local circus as a trapeze artist (Ehrich, the Prince of the Air). Eager to put his son on a more secure footing, Ehrich's father allegedly apprenticed him to a locksmith and inadvertently sowed the seeds for a lifetime of escape.

Conjuring began to dominate Ehrich's thoughts, and he eventually adopted the stage name of Houdini as a tribute to the great French magician Robert-Houdin. Houdini then left home again, and started working dime museums and sideshows. Initially treading the boards in a double act before working solo as the self-proclaimed "King of Cards," Houdini struggled to secure bookings. In 1894 he met and married a dancer named Wilhelmina Beatrice "Bess" Rahner and, troubled by his continuing lack of success, decided to change tack. Combining his natural athleticism, love of lock picking, and passion for magic, he crowned himself the "King of Handcuffs" and set out to conquer vaudeville.

Vaudeville proved to be the road to fortune for many immigrants, and was a melting pot of ethnicities, cultures, and entertainment. It employed thousands of artists across America, giving multiple shows a day, week after week. However, unlike many of his fellow performers, Houdini had a remarkable gift for showmanship. Each time he arrived in a new town or city he challenged the local police to strip him naked and lock him in their most secure prison cell. Houdini's extensive knowledge of locks and handcuffs, combined with a talent for sleight of hand and deception, made him impossible to jail.

As vaudeville grew from a rough-and-rowdy form of entertainment to middle-class family theatre, Houdini moved with the times. His publicity stunts also became ever more daring. He was chained and thrown into rivers, locked in boxes, and buried alive. Newspapers lapped it up. By the early nineteen hundreds, he had established his celebrity status and eventually became one of the highest-earning entertainers in America. Houdini frequently declared that his escapes were due to human ingenuity and intense preparation. ("My brain is the key that sets me free.") However, later on in his career, the great escapologist enjoyed describing how

*Houdini's escapes were a mixture of ingenuity and preparation,
and he would declare, "My brain is the key that sets me free."*

his brain once failed him and kept him secure for far longer than was necessary. According to the story, Houdini issued his usual challenge to the local police during a tour of Britain. He was searched and led into a jail cell and the door closed. Once alone, Houdini employed various concealed lock picks to try to open the cell door but to no avail. Two hours later, and bathed in sweat, an exhausted Houdini leaned against the door. The door unexpectedly swung open. It had never been locked.

In addition to lock picking and leaning his way out of jails, Houdini declared that no restraint could hold him. On one occasion he allowed himself to be sewn into the large carcass

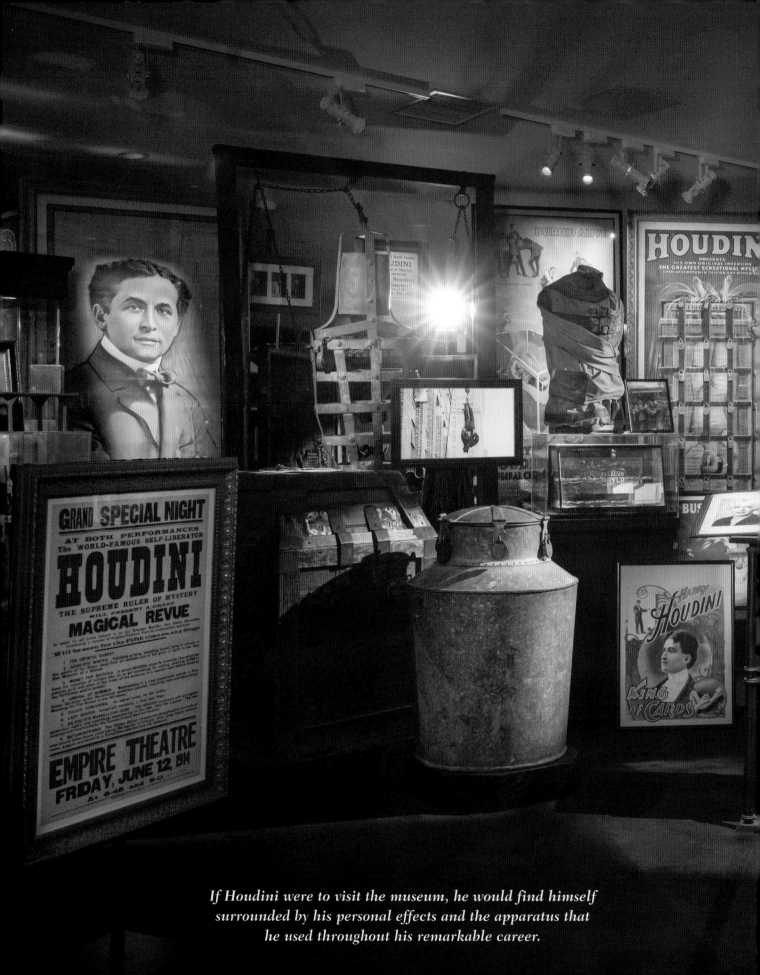

If Houdini were to visit the museum, he would find himself surrounded by his personal effects and the apparatus that he used throughout his remarkable career.

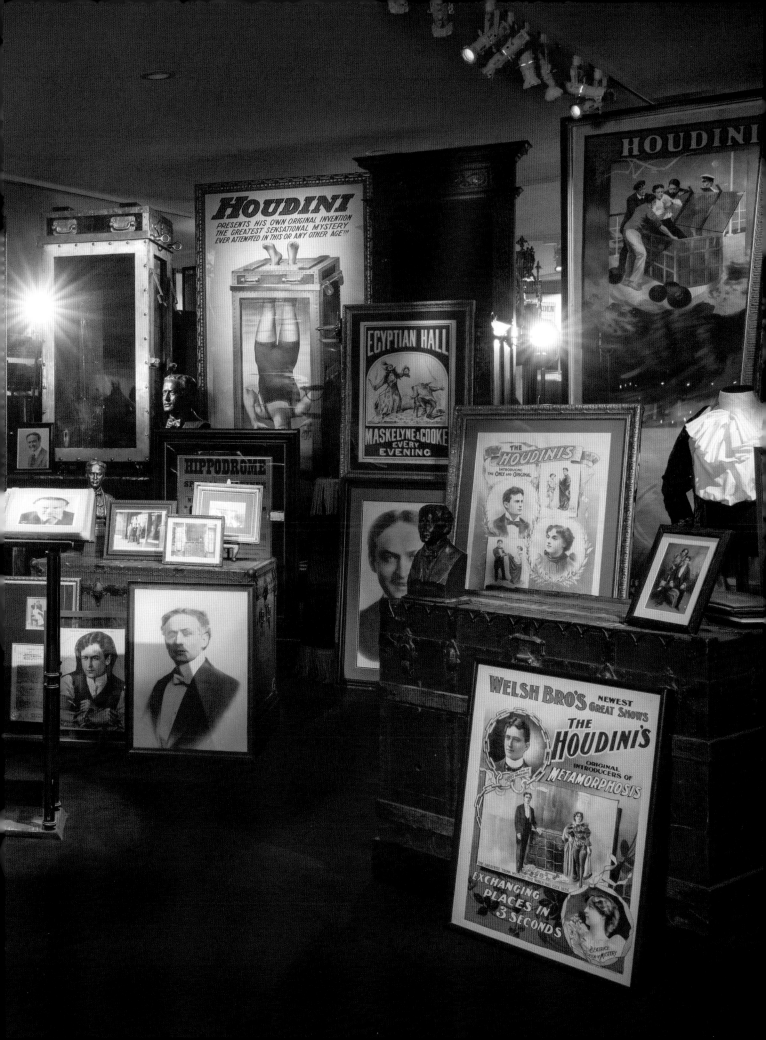

of a mysterious sea creature that had washed up onto a beach in New England (probably either a giant sea tortoise or an elephant seal). He escaped but was nearly overcome by the fumes from the arsenic that had been used to embalm the creature. The *Daily Illustrated Mirror* newspaper challenged Houdini to escape from a pair of handcuffs that had taken a locksmith five years to make. More than 4,000 spectators and 100 journalists watched as Houdini worked away for over two hours. He eventually emerged triumphant, but bloodied and bruised. The great showman later declared it to be the most challenging escape of his entire career.

When he wasn't staging dramatic escapes, Houdini devised other eye-catching ways of ensuring that he remained in the public gaze. He performed daredevil stunts in his own movies and even made an elephant disappear at New York's Hippodrome Theatre.

In 1908, Houdini premiered a terrifying feat that quickly became a feature of his theatre shows. An oversized galvanized milk can was filled with water. Houdini was locked inside and the lid fastened in place with six padlocks. People from the audience supplied the locks and a committee examined the apparatus. "Failure Means a Drowning Death," warned the posters. But Houdini did escape, leaving all the locks secured in place and the milk can still filled with water. This utterly impossible locked room mystery became a huge success.

A few years later, Houdini debuted what he considered to be one of his greatest inventions: the Water Torture Cell. The apparatus consisted of a large steel and mahogany glass-fronted tank. Once it was filled with water, Houdini was lowered headfirst into it, his ankles trapped in wooden stocks that formed the lid of the cell. The lid was locked and a large cloth was raised up to hide the tank and Houdini from view. A thousand-dollar reward was offered to anyone who could prove Houdini could get air in this upside-down position. As Houdini attempted his escape, the orchestra played "The Diver"—a mournful tribute to those drowned at sea. Seconds slowly passed during which the audience literally held their breath in an effort to match Houdini. After a minute most had given up. Houdini remained inside the tank. Two minutes and people began to get agitated and wondered whether the stunt had gone wrong. Houdini's assistants seemed nervous. Three minutes and suddenly Houdini emerged from behind the cover, exhausted and wet. Somehow he had managed to escape from the cell and the crowd roared their approval. It was, as he predicted, a supreme mystery.

During his career Houdini frequently said that he could withstand any blow to the

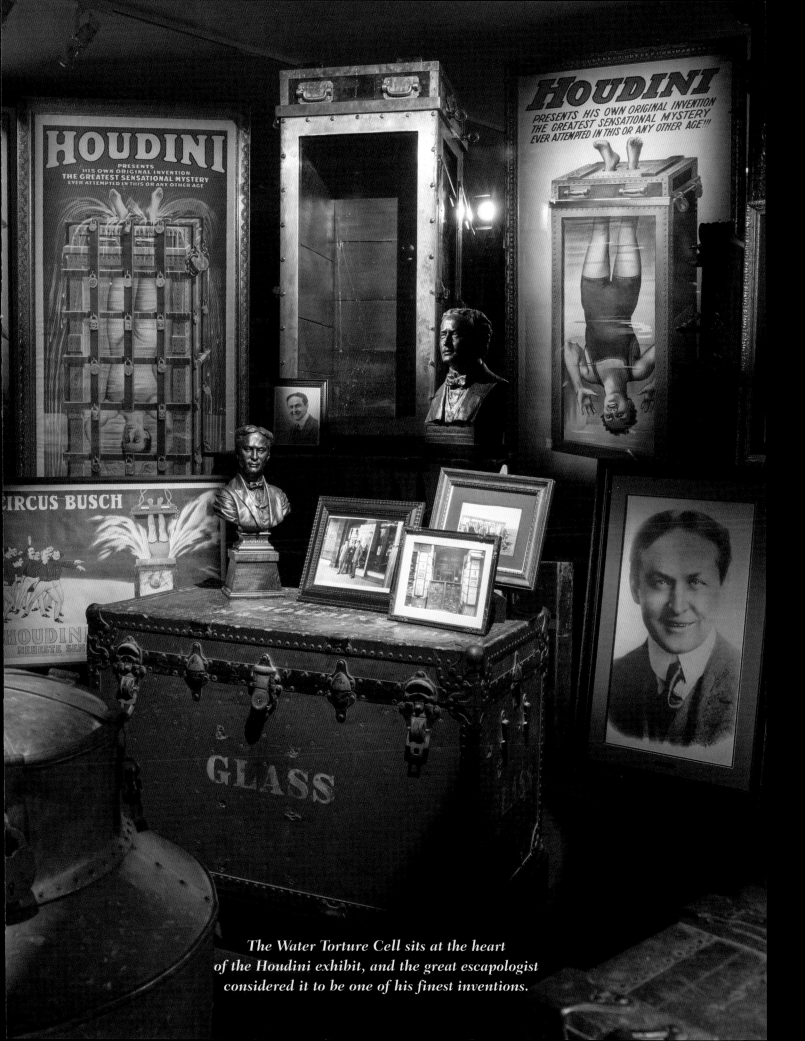

The Water Torture Cell sits at the heart
of the Houdini exhibit, and the great escapologist
considered it to be one of his finest inventions.

abdomen. In October 1926, a student visited his dressing room after a show and delivered four blows to Houdini's stomach. Houdini experienced severe stomach pains after the incident, but refused to cancel shows or seek medical attention. Carrying on his demanding physical performances despite having a dangerously high temperature, he eventually collapsed onstage. On October 31, 1926—Halloween—the great Houdini died from peritonitis, brought about through a ruptured appendix.

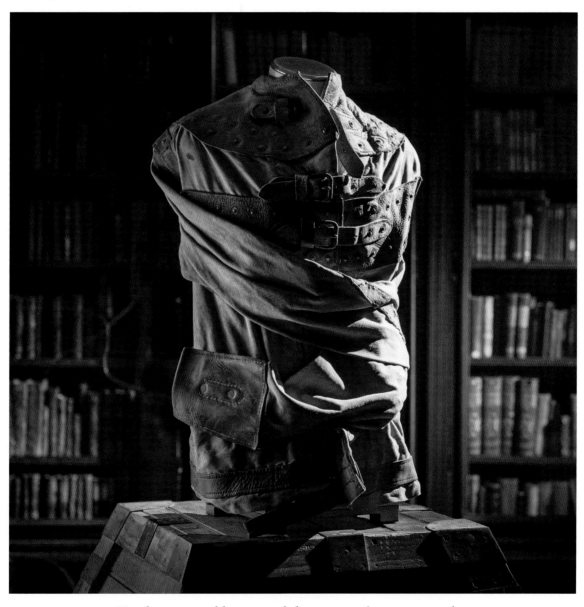

Houdini attracted huge crowds by escaping from a straitjacket
while suspended high above a crowded street.

My museum contains a large collection of Houdini apparatus and memorabilia, including his famous Mirror Cuffs, several straitjackets, and the terrifying Milk Can Escape. The museum also houses the bathtub that Houdini used to practice holding his breath for underwater escapes ("If I grow panicky, I am lost") and rare Edison wax cylinders containing recordings of him introducing the Water Torture Cell (his ghostly voice proclaims "There is nothing supernatural about it"). And sitting at the very heart of the collection is his famous Water Torture Cell. Houdini is one of my magical heroes. His ability to think big and develop innovative pieces of theatre has influenced my own work, and helped inspire me to stage a series of dramatic illusions, including walking through the Great Wall of China and making the Statue of Liberty disappear. In 2020, I was honored that the National Museum of American Jewish History inducted both Houdini and myself into its Hall of Fame, joining the likes of Ruth Bader Ginsburg, Steven Spielberg, and Stephen Sondheim.

It's almost a century since Houdini died, yet his name is still in common parlance and even appears as a noun in modern-day editions of the *Oxford English Dictionary* ("Houdini: a person or an animal that is very good at escaping"). Houdini's biographers have long speculated about why he has stood the test of time. Many have noted that his escapes were a metaphor for freedom. Here was a poor immigrant who had been born into poverty and yet achieved fame and fortune. He showed that it's possible to shake off the shackles of the past and succeed against the odds. Other times writers have noted that while many magicians shut their *assistants* in boxes, Houdini was always the one at the center of the action, suffering and succeeding in equal measure. In doing so, he became an archetypal hero, with magic historian and Houdini biographer William Kalush labeling him "America's first superhero." Finally, there was Houdini's ability to face death on a nightly basis and emerge victorious. Some anthropologists have argued that throughout history people have tended to venerate those who appear to provide evidence of immortality. According to this approach, Houdini's name has lived on because he tapped into a powerful narrative traditionally associated with shamans, spiritualists, mystics, and mediums.

Freedom fighter, courageous hero, and modern-day shaman. Little wonder then that Houdini has come to represent the ultimate symbol of liberation, courage, and death-defying hope.

To Joe Dunninger
From his friend
Howard Thurston
Sept 23/23

BAKER
ART
GALLERY.

The Magician Who Made Himself Disappear

⇒ HOWARD THURSTON'S DISEMBODIED PRINCESS ⇐

Howard Thurston was one of America's greatest illusionists and regularly played to packed auditoriums across the country. However, like many magicians, there was much more to this master of illusion than met the eye.

Howard Thurston's magic shows were hugely extravagant affairs involving tons of equipment and requiring several train cars to be transported from city to city. Performing in the early part of the twentieth century, Thurston sold millions of tickets, and entertained presidents, celebrities, and royalty alike. In 1932, he was filmed at Cleveland's Palace Theatre performing one of his favorite illusions, and one that now resides in my museum: The Disembodied Princess. The footage shows Thurston's assistant entering a sarcophagus-shaped box and several doors being closed around her head, body, and legs. Next, Thurston thrusts two giant metal blades through the sides of the box and appears to slice through the assistant's neck and waist. The doors on the box are then opened to reveal that the assistant's head and legs are still in place, but that her middle has completely vanished. Throughout it all, Thurston is wearing full evening dress, replete with a neat white bow tie, crisp wing collars, and tails. To the world, it appears that he is the product of a respectable and well-heeled upbringing. In reality, this onstage persona was perhaps Thurston's greatest illusion.

Thurston was born in 1869 in Ohio. His mother came from a farming background, and his father was a failed wheelwright and carriage maker. Frequently beaten as a child, Thurston ran away from home at a young age and traveled around America by illegally riding freight trains. Often risking his life by desperately clinging to the bottom of a carriage, or secreting himself on the "cowcatcher" at the front of the train, he slept rough, stole food, picked pockets, and became involved in small-time scams.

When Thurston was in his teens, the New York police caught him dipping his hand into one pocket too many. After receiving a suspended sentence, he was hauled before the secretary of the New York Prison Association, who would later describe him as a bold and brazen young thief. A leading advocate for prison reform, the secretary put him to work in a local rehabilitation center. One day, Thurston declared that he had found religion and expressed a desire to devote his life to God. Impressed by his passion, the local church authorities asked Thurston to save lost souls by standing on street corners and reading lengthy biblical passages to the down-and-out. Thurston's own salvation came when a local philanthropist took pity on him and agreed to cover the costs of sending the novice street preacher to school.

Thurston had been interested in magic throughout his childhood, and had carried a copy of Professor Hoffmann's *Modern Magic* with him through thick and thin. When he left

*The Disembodied Princess, in which an assistant's body
appears to vanish, forms the centerpiece of my Thurston exhibit.*

school, Thurston returned to the good book and wondered whether he might be able to make his living as a professional magician. After spending hours developing his sleight-of-hand skills, he eventually created a highly innovative act in which playing cards would magically rise out of the deck, disappear and appear at his fingertips, and finally be skimmed out into the auditorium. Having enjoyed some success in vaudeville, he then used his savings to create a much more elaborate show. The gamble paid off and Thurston's star began to rapidly rise. His *Wonder Show of the Universe* toured the world, and in 1907, Harry Kellar, America's most famous magician at the time, crowned Thurston his worthy successor. Over the next twenty years, Thurston's warm personality charmed audiences of all ages, and when Dale Carnegie

Thurston's spectacular shows involved large amounts of apparatus that was transported in several train cars.

was writing his classic book, *How to Win Friends and Influence People,* the legendary self-help guru sought him out to inquire about the secret of his success. Thurston attributed his achievements to him repeating the phrase "I love my audience" to himself before every show.

Thurston performed The Disembodied Princess many hundreds of times during his career, and without giving too much away, the secret of the illusion involves the assistant in the box having to lean a certain way. When he performed the trick, Thurston always referred to his assistant as "Eileen" (as in "I lean") and many magicians wondered whether he was secretly letting the audience in on the secret. I had the pleasure of knowing Thurston's daughter, Jane, who during her younger years had performed with her father, and had lots of wonderful stories about him. I asked her about the "I lean–Eileen" theory and she assured me that it wasn't true. According to Jane, Thurston had a terrible memory for names and so used to call all of his assistants Eileen!

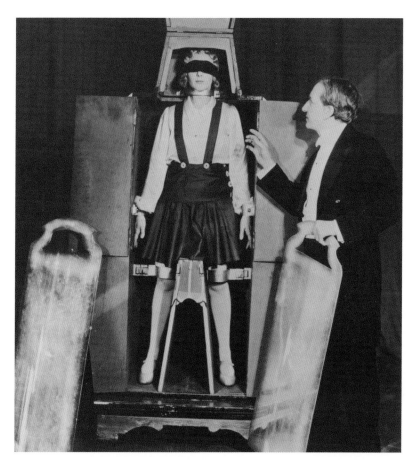

Thurston performing The Disembodied Princess.

Thurston became a national institution and audiences were enchanted by his respectable demeanor. However, from time to time, even the great illusionist struggled to keep the mask in place. Thurston regularly performed an amazing levitation that was the brainchild of the British illusionist John Nevil Maskelyne and brought to America by Harry Kellar. During the illusion, an assistant came onstage, lay down, and then floated high into the air. Thurston made one curious change to the way in which this remarkable spectacle was presented. When his assistant was floating high in the air, Thurston invited a young boy from the audience to come onstage. He then took the boy behind his levitating assistant and lifted him up so that he could take a close look at the remarkable illusion. Night after night, the audience enjoyed the look of astonishment that slowly spread across the lucky young boy's face. Magicians were dumbfounded because they knew that the boy must have been able to see the complex machinery responsible for the levitation. The mystery was solved many years after Thurston's death. In the 1980s, a magician found himself chatting to a man who, as a young boy, had been invited onstage by Thurston. The man explained that as Thurston had lifted him up to see the floating assistant, the master magician had whispered a series of four-letter expletives into his ear, threatening him not to touch the mechanism or ever mention it to anyone. The look of astonishment on the boys' faces was not the result of their witnessing a seemingly impossible miracle, but rather an understandable response to unexpectedly encountering a threatening foul-mouthed magician.

Such indiscretions aside, Thurston's journey from petty thief to world-famous illusionist was astonishing. Within the world of magic, such dramatic transformations are not unique and while few other master magicians experience similar childhood encounters with crime, many are from modest backgrounds and have also been equally touched by the genuinely transformative power of magic. Harry Kellar, for instance, was the son of an unskilled laborer, Harry Houdini was from a poor immigrant family, and my father ran a clothing store in New Jersey.

On the face of it, Thurston's Disembodied Princess illusion involves the apparent disappearance of part of a person. In reality, it symbolizes far more. Thurston's greatest achievement was to make his old self disappear, and to create a new persona that was far more positive and successful. It was a truly remarkable feat that he performed on a nightly basis, and one that has been equaled only by a handful of other illusionists.

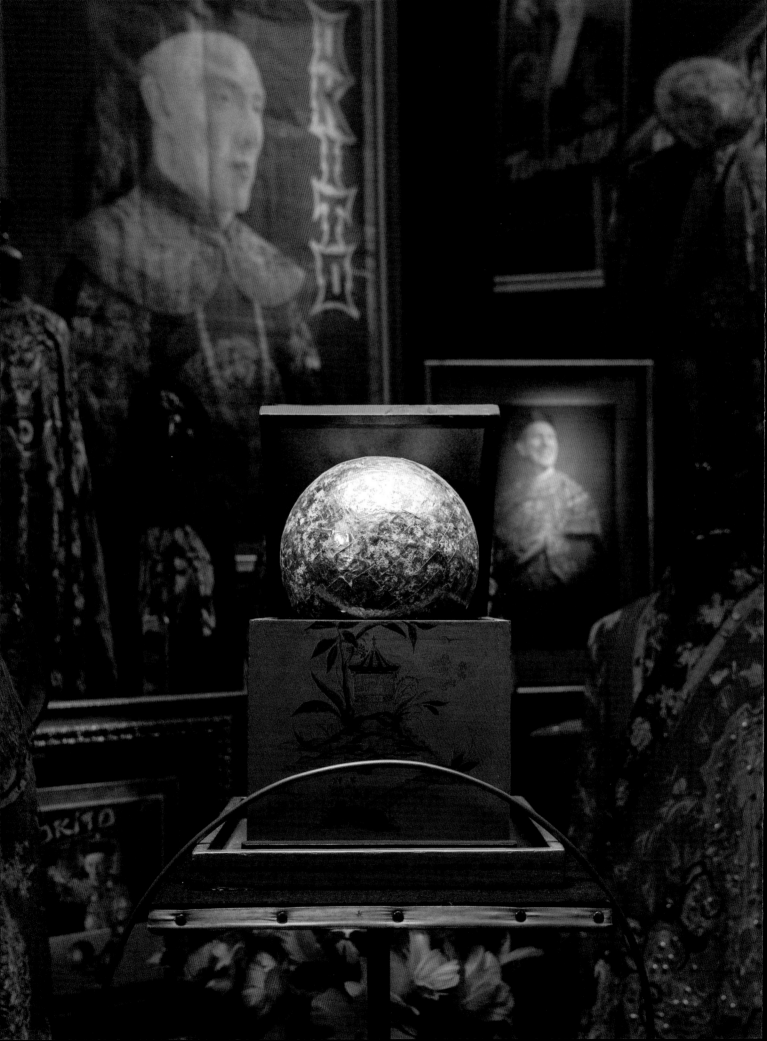

Lighter Than Air

≈ OKITO'S FLOATING BALL ≈

This beautiful golden ball and elaborately decorated box belonged to one of magic's most talented and artistic performers. He was part of a famous conjuring dynasty, and his work still provides modern-day audiences with one of the most wondrous experiences that magic has to offer.

The Bamberg family hailed from Holland and were associated with magic for more than two hundred and fifty years. Eliaser Bamberg was born in Leiden in 1760, worked as a professional magician, and specialized in performing sleight of hand with cups, coins, and cards. In 1807, Eliaser was on board a ship when a powder keg exploded and badly injured his leg. Doctors were forced to amputate and Eliaser spent the rest of his life with a wooden leg. Earning the nickname "Le Diable boiteux" (French for "the lame devil"), Eliaser continued to perform magic using a special hollow leg that creatively doubled as a hiding place for small objects during his shows.

Following in his father's footsteps, Eliaser's son, David Bamberg, also became a magician and frequently performed for the Dutch aristocracy, including King William II. David's son Tobias continued the Bamberg dynasty and then passed the mantle onto his son David, who in turn handed the crown to his own son Tobias.

Born in Amsterdam in 1875, Tobias started performing in his father's shows when he was just nine years old. When Tobias was eighteen, he lost his hearing after an accident. Unable to speak clearly onstage, Tobias became worried that his performing days were over and that the legendary Bamberg dynasty was at an end. However, the family's resilience and creativity saved the day. At the time, most magicians spoke during their performances, but Tobias decided to break with tradition and create a Japanese-themed act that could be performed to music.

Like Chung Ling Soo, and in an act that was of its time, Tobias drew on Europe's fascination with the "Far East." He mixed together elements drawn from different countries to produce performances that appeared both mysterious and exotic. Tobias rearranged the letters in the traditional spelling of the Japanese capital, Tokio, to create the stage name Okito. Then he appeared in colorful authentic Chinese robes and surrounded himself with ornate apparatus to perform one beautiful miracle after another. He plucked an endless array of flowers from thin air, produced six ducks from an empty shawl, and conjured up large bowls of water from nowhere. Between illusions Okito often changed from one vibrant robe to another, and writers frequently praised his artistic sensibilities and sense of theatre. ("What a performer. What poise, personality, showmanship, timing, and magic! Just to see him take his well-deserved bows was an education in stagecraft.")

Okito toured with the famous American illusionist Howard Thurston, and at one point the two of them paid a visit to a well-known amateur magician called David P. Abbott. Abbott

was a wealthy businessman with a deep understanding of conjuring and an uncanny ability to fool even the best minds in magic. Based in Omaha, Nebraska, he had spent a small fortune on transforming his home into the "House of Mystery." Abbott's handsome Arts and Crafts–style house had a large front parlor where he staged performances for small groups of invited guests. Although the room appeared perfectly ordinary, in reality it concealed a wealth of secret paraphernalia, including microphones, loudspeakers, threads, and a giant electromagnet. America's greatest illusionists beat a path to his door and sat agog as Abbott made teakettles talk, had oil paintings slowly appear on blank canvases, and exhibited a skull that magically answered questions by clicking its teeth together.

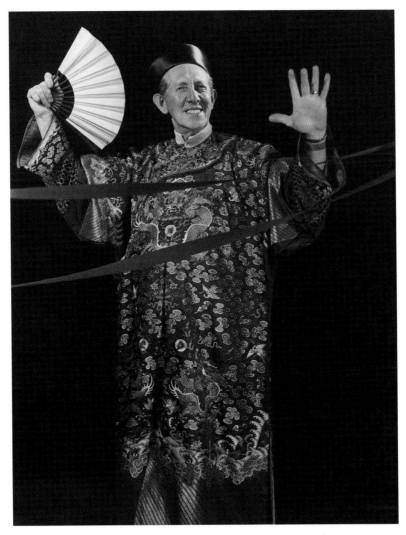

Okito came from one of the most famous dynasties within magic.

During Okito's visit, Abbott demonstrated a jaw-dropping illusion. He walked into his parlor holding a seemingly solid metal ball about seven inches in diameter. Moments later the ball slowly floated away from Abbott's hands and made its way across the room in a most mysterious manner. While it was suspended in space, Abbott passed a hoop around the levitating ball to apparently demonstrate that it wasn't attached to any secret threads or wires. Finally, the ball made its way back into Abbott's waiting hands and the magician took his bow. Abbott's Floating Ball was a sensation.

Levitations like this one provide an interesting insight into the nature of magic. In most illusions, the moment of magic happens in the blink of an eye. For instance, a person might suddenly appear or instantly disappear. However, during an apparent levitation, an object or a person floats around the stage, and so the moment of magic is extended. Properly performed, such illusions possess the potential to weave a haunting, and powerful, spell over audiences.

Abbott spent the next three days teaching Okito how to perform the Floating Ball, moment by moment. Okito later likened Abbott's generous gift to that of being given a violin, explaining that he had been handed a precious instrument and it was now up to him to make his own music. Okito worked away and eventually produced an illusion that surpassed Abbott's original creation. Okito's version involved a much larger ball and could even be performed on a well-lit stage. At the start of the performance, Okito's assistant brought on an elaborately decorated box. At Okito's command, the lid of the box mysteriously opened, and a large golden ball floated out and made its way around the stage. At the conclusion of the illusion, the ball drifted back into the box and the lid mysteriously closed.

The illusion was extremely difficult to perform, and depended on Okito's gestures, stance, grace, and timing. It also required the very careful use of stage lighting. When rehearsing in a new venue, Okito wore a special white costume and had his assistant watch the performance from the orchestra pit. Okito knew that if the illusion worked in front of a solid white costume then it would be completely deceptive when he was wearing a colorful Chinese robe. In addition, the apparatus was extremely delicate, and so Okito banned people from walking around backstage during his performance because even the slightest of vibrations caused the ball to wobble and the illusion to fail.

After spending a lifetime traveling the world, Okito spent his final years living in Chicago and passed away in 1963. Okito's son David went on to become the sixth generation

A watercolor painting shows Okito performing his signature illusion, the Floating Ball.

of Bambergs to work in magic. Adopting the stage name "Fu Manchu," he toured a hugely successful large-scale illusion show around South America and frequently performed the Floating Ball. David died in 1974 and the Bamberg magical dynasty finally came to an end.

Okito's original Floating Ball and box are now at rest in my museum, and are a fitting tribute to a wonderfully artistic and creative magician. Okito dedicated himself to perfecting the Floating Ball and his work has inspired me to create my own version of his gravity-defying illusion. In one of my television specials I appeared to make a large mirror ball magically float around an elegant ballroom. At the start of the piece I magically make all of the dancers in the scene freeze, before causing the mirror ball to levitate down from the ceiling and float from hand to hand. I then pass a hoop around the Floating Ball, cover it with a cloth, and have it levitate high into the air. With a clap of my hands, the cloth falls to the ground and the ball has disappeared. Like Okito's original Floating Ball, the illusion was very hard to stage and required a vast amount of work. The Bamberg magical dynasty may no longer survive, but the thinking behind Okito's beautiful ball still continues to provide modern-day audiences with a sense of wonder.

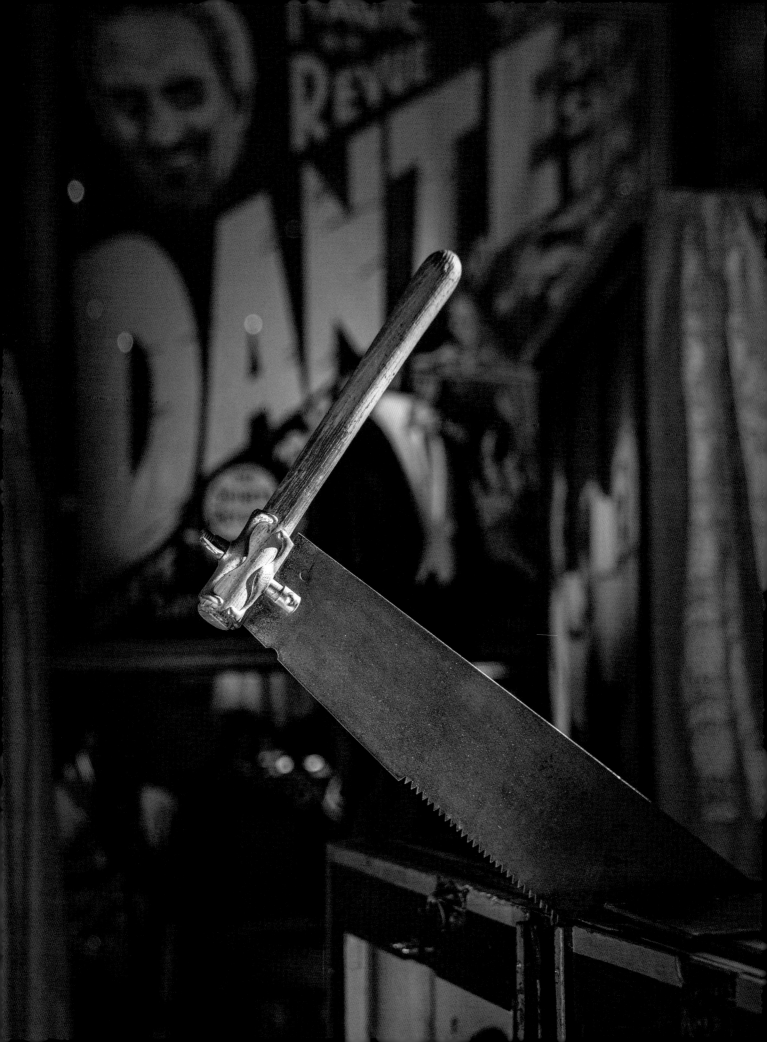

Divided

⤳ DANTE'S SAWING ILLUSION ⤶

To the uninitiated, this beautiful piece of apparatus consists of two nicely decorated boxes sitting on an elegant table. In reality, the boxes and table have witnessed a lifetime of drama, and are a wonderful illustration of the complexity underlying the creation of magic.

On January 17, 1921, magician P. T. Selbit walked confidently onstage at London's Finsbury Park Empire and invited his assistant, Betty Barker, to step into an upright, coffin-sized wooden crate. Selbit had tied ropes around Barker's wrists, ankles, and neck. The ends of the ropes were then fed through several tiny holes in the crate, and audience members were invited to come onstage and hold on to them. Even though spectators couldn't see Barker's face, hands, or feet, the ropes ensured that she was secured inside the crate. Next, Selbit's assistants placed a lid on the crate, positioned the entire affair across a horizontal wooden platform, and brought out several large sheets of glass and metal. The master magician plunged the sheets through slits in the crate and appeared to slice Barker into small pieces. Finally, a two-handed crosscut saw was brought onstage and the audience gasped in disbelief as Selbit instructed his assistants to saw widthways right across the middle of the crate.

After the sawing was complete, the lid was removed and the ropes were released. Amazingly, Barker emerged unharmed and the audience had witnessed what is widely regarded as the first public performance of a now-legendary illusion.

People flocked to see Selbit's performance and historians have long debated why the illusion was such a sensation. Some scholars have pointed out that British suffragettes had just won a hard-fought battle for women's voting rights and argue that the illusion reflected the increasing power of women in society. Others have suggested that World War I had created battle-hardened audiences that were receptive to gruesome illusions and shocking imagery. Whatever the reason for the illusion's success, Selbit was delighted with his creation and frequently staged publicity stunts to promote ticket sales. Some nights he ghoulishly had buckets of stage blood poured into the gutter outside the theatre to suggest that the trick hadn't gone according to plan, and on another occasion Selbit offered to pay a leading suffragette twenty pounds a week if she would take the place of his assistant in the illusion (the ironic request was ignored).

The sawing illusion proved equally popular among Selbit's fellow conjurors, and soon several of his competitors were contemplating how best to add the item to their own repertoires. In June 1921, American magician Horace Goldin performed his variation of the sawing illusion at a New York banquet attended by many leading magicians of the day. Unlike Selbit's original creation, Goldin's illusion involved the assistant's feet and head protruding from the ends of the crate, and the two halves of the crate being pushed wide apart before being

The charismatic Dante and beautiful Moi-Yo Miller.

reassembled and the assistant emerging unharmed. Unfortunately, Goldin's performance was far from deceptive, in part because it involved a large crate sitting on a suspiciously thick table. However, illusionist Howard Thurston recognized the potential of the piece and asked a Danish-born magician and inventor named Harry Jansen to see if he could improve it. Jansen figured out how to perform the trick using a smaller box and a thinner table. Throughout Goldin's sawing illusion the audience could see the assistant's face and so knew that they were not coming to any harm, but Jansen was worried that the illusion might still appear too gruesome and so replaced the crate with a far more theatrical-looking box.

Jansen's association with the sawing illusion didn't end with his iconic creation. In fact, it was just the very beginning of a long and lasting relationship. In the 1920s, Thurston toured America with his large-scale show of spectacular illusions, and unable to personally satisfy the public's appetite for live magic, he coproduced additional shows that were presented by other performers. Jansen was chosen to be his first protégé and, after adopting the stage name

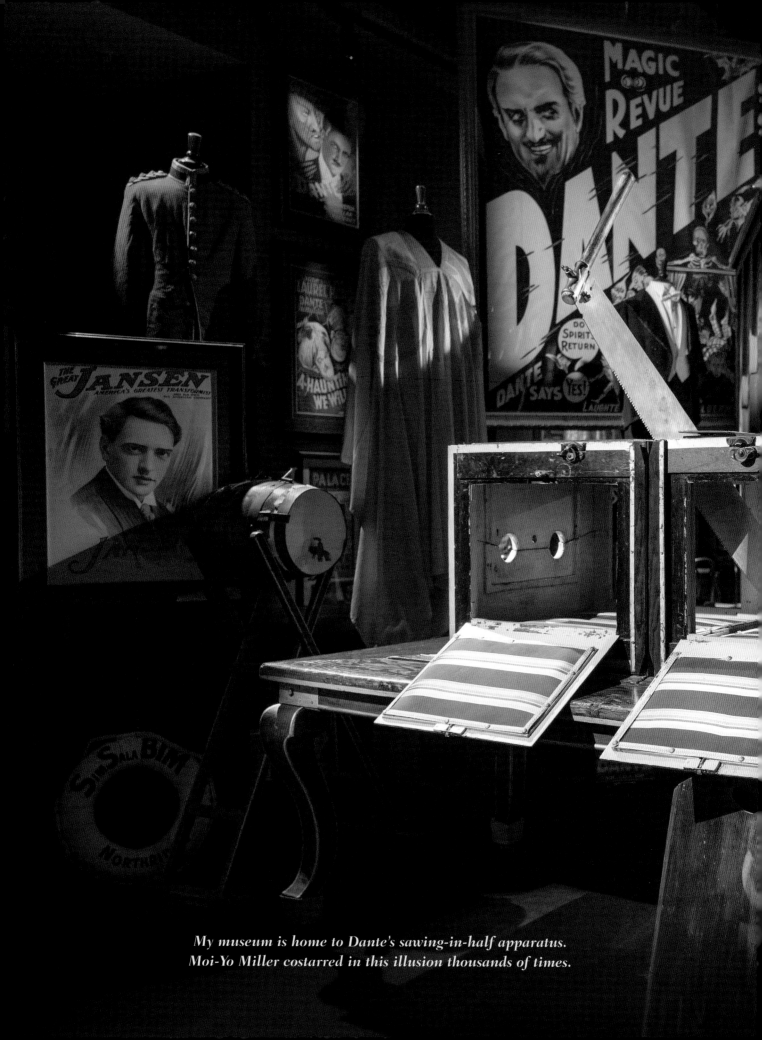

My museum is home to Dante's sawing-in-half apparatus.
Moi-Yo Miller costarred in this illusion thousands of times.

Dante, became the perfect personification of the public's perception of a prestigious presti-digitator. Indeed, the *New York Times* once described the silver-haired, goateed magician as a cross between Mephistopheles and Buffalo Bill, with just a hint of Santa Claus.

Dante was a performer who would work with a twinkle in his eye and a spring in his step. After performing his illusions, he frequently stepped up to the footlights and acknowledged the audience's applause by uttering his trademark magical words "Sim Sala Bim" (actually a series of nonsense words taken from a Danish children's song).

During the late 1920s and early 1930s, Dante embarked on several international tours. In 1933 the Dante spectacular rolled into Melbourne and the illusionist drummed up some publicity by attempting to find the most beautiful woman in Australia. A petite nineteen-year-old dancer named Moi-Yo Miller took the title and was invited to join the show and work as Dante's assistant. The strikingly beautiful and charismatic Miller also proved to be extremely supple, with one reviewer remarking that she seemed able to "fold up like a piece of Chinese

Dante's favorite chair and gold-handled cane.

silk." As a result, Miller soon became Dante's principal assistant and costar, and played a key role in every aspect of the show, including costume design, music selection, and the auditioning of assistants (Miller would reportedly ask potential assistants their hat size, noting that when it came to squeezing into tiny boxes, people could contort their bodies but not shrink their heads). For more than twenty years, Miller shared the spotlight with Dante and spent her entire career being levitated, vanished, crushed, set on fire, and, of course, sawed in half. Looking back on her remarkable time with the Dante show, Miller once estimated that she had performed the sawing illusion over eleven thousand times.

It was, however, often far from smooth sailing. Dante's show was in Berlin when World War II was declared and the illusionist needed to flee the country as quickly as possible. Members of the troupe were forced to abandon their apparatus and personal belongings, and had just a few hours to reach the German border and cross into the safety of Sweden. Fortunately, they managed to do so and, once there, Dante and Miller set sail for America, with their ship spending much of the journey zigzagging across the Atlantic to avoid German submarines. Ever the troupers, when they eventually arrived in America, the dynamic duo once again took to the road.

Dante became one of the best-known magicians in America, and in 1942 starred alongside Laurel and Hardy in their classic film *A-Haunting We Will Go*. After a lifetime of curtain calls, the illusionist entered semi-retirement in the late 1940s and passed away in 1955.

In 1993, the then-seventy-nine-year-old Miller was invited to attend a private meeting of magicians and perform the sawing illusion for some of the world's leading illusionists. Even though she hadn't used the apparatus for more than forty years, the still-supple Miller effortlessly secreted herself in the boxes. A few years later, she visited my museum and was reunited with the apparatus one final time. She lived until she was 104 years old and passed away in 2018.

At one level, Dante's sawing apparatus is a fitting tribute to a master magician and the equally extraordinary Moi-Yo Miller. But the apparatus also provides a wonderful insight into the evolution of magic. Modern-day spectators are still thrilled by the sawing illusion, but often don't realize that they are witnessing the culmination of a hundred years of magical thinking by the likes of Selbit, Goldin, Dante, and Miller. Magic doesn't remain static. Instead, illusions adapt and grow over time, and seen from this perspective, Dante's sawing illusion is the perfect celebration of the dynamic, organic, and evolutionary nature of magic.

ECLIPSES
THE
SUN

BLACKSTONE

GREATEST
MAGI

BLACKSTONE
THE WORLDS
MASTER MAGICIAN

IN P
BLACKST

Free Rabbits

⇒ THE HARRY BLACKSTONE COLLECTION ⇐

This colorful collection of apparatus belonged to a magician who charmed audiences with his warmth and affection. These magical qualities also extended far beyond the footlights, and transformed the lives of strangers and friends alike.

Harry Boughton was born in Chicago in 1885, came from a modest background, and developed an early interest in conjuring. When he was around fifteen years old, he took a job in a machine shop, and quickly discovered that he was a natural when it came to working with wood and metal. The owner of a local magic store commissioned several small-scale illusions. Each time Boughton was asked to create a piece of apparatus, he made a duplicate for himself and so slowly built up his repertoire of remarkable illusions. In 1909, Boughton left his secure job and teamed up with his brother, and eventually created a comedy conjuring act called *Straight and Crooked Magic*. Touring across the country and taking work wherever they could find it, the two brothers learned the trade of the tricks through trial and error.

Throughout his life, Boughton extended the hand of friendship to those less fortunate than himself. In 1911, for instance, a journalist reported how Boughton came across a man begging in the street, reached into the poor man's pocket, and magically produced a dime. Boughton father's had been a heavy drinker, and as the magician handed over the coin he told the beggar that it was cursed and that bad things would happen if the man spent the money on alcohol.

Just before World War I, an American illusionist named Fredrik produced a large number of lithographs and playbills to publicize his national tour, but was then forced to cancel it. Ever resourceful, Boughton adopted the stage name Fredrik the Great, bought the playbills at a bargain price, and used them to advertise his own act. Unfortunately, the outbreak of war made German-sounding acts unpopular with American audiences, and so by 1917 the playbills had been trashed and Fredrik the Great had magically transformed into Harry Blackstone.

Over the course of the next few decades, Blackstone became one of the most famous magicians in America. His performances were fast and fooling, and his wild shock of hair and neatly trimmed mustache made him instantly recognizable wherever he went. Reporters described how Blackstone, striding out onstage in full evening dress and performing mainly to upbeat music, grabbed audiences by the imagination and never let them go. He was affable, easygoing, and genial, and everyone loved to be fooled by Blackstone.

Blackstone's show involved several large-scale illusions, including making his assistant float in midair, cutting a person in half with a buzz saw, and staging the world-famous Indian

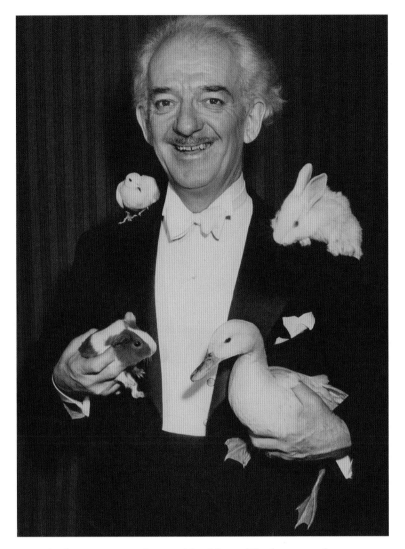

Audiences were charmed by Harry Blackstone, who was
affable, easygoing, and instantly recognizable.

Rope Trick. He was also one of the few magicians to attempt to make a live camel disappear, although the unruly animal was later relegated to the role of window dressing for an illusion set in Egypt. One of his most puzzling illusions began with a female assistant crawling into a row of ten automobile tires. Next, his other assistants rolled the tires across the stage one by one, revealing that the woman had vanished. The tires were then stacked into a column and a bar was lowered into the center of the stack. When the bar was pulled back up, the woman had reappeared and was suspended from it. Blackstone's tire illusion was extremely fooling and now sits in my museum.

Throughout the show, these impressive set pieces were interspersed with more intimate magic. Blackstone made a spectator's handkerchief magically dance all over the stage, with one journalist reporting that the movements possessed "the verve of a Cossack and the beauty of a Pavlova." I have always loved the idea and performed a version of this charming illusion in my first CBS television special.

Blackstone also made an illuminated lightbulb float through the air before suddenly swooping over the heads of the audience. In one of his most famous feats he first brought out a small bird cage and instantly made it disappear. He then invited several children to join him onstage, went to the wings, and fetched a second bird cage. Holding the bird cage at arm's length, he asked the children to place their hands on it, and once it was completely covered, Blackstone gave a quick "hup" and the bird cage suddenly vanished right under the children's hands. Blackstone's delicate and beautifully made vanishing bird cage also resides in my collection.

Blackstone's show went from strength to strength, and eventually involved more than twenty-five assistants and an enormous amount of equipment transported in a seventy-foot baggage car. During World War II he embarked on a grueling tour across America entertaining servicemen. Constantly traveling from city to city, Blackstone always found time to call in on local hospitals and to visit injured troops.

In 1942, Blackstone's quick thinking and thoughtful attitude saved lives. One afternoon he was performing just outside of Chicago and about to start his "Bunny Matinee." During these performances a rabbit was given away free to audience members, and so the place was packed with children. A fire broke out in the adjoining building, and about twenty minutes before Blackstone was due onstage, the fire chief decided to evacuate the auditorium. With smoke starting to seep into the theatre, the chief was concerned that the children might panic and possibly stampede. Blackstone came up with an idea. He walked onstage and calmly announced that the next illusion was so large that it would be performed outside the theatre, and that everyone should exit the auditorium. Blackstone remained onstage directing the proceedings until all of the children were safely outside, and then helped staff move equipment out of the building. He only then left the theatre himself once he had ensured that everyone was safe.

Blackstone achieved fame and fortune, but always remained unpretentious, generous,

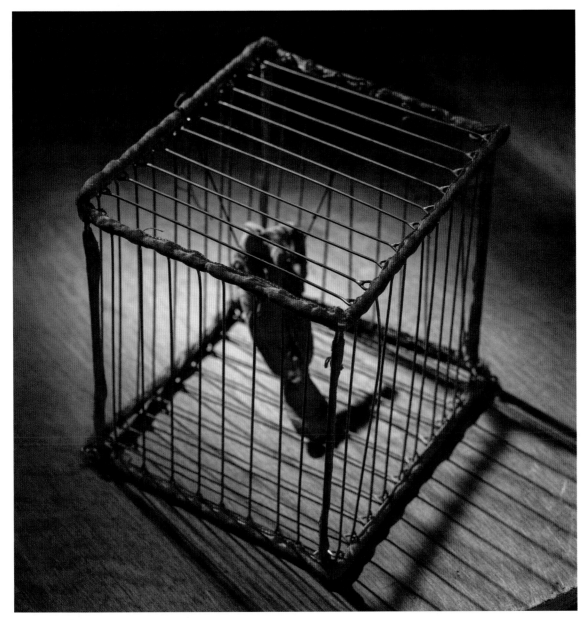

*In one of Blackstone's most famous illusions, he made this
bird cage disappear in the blink of an eye.*

and welcoming. Blackstone loved people, and people loved Blackstone. He was a conjuror
both on- and offstage and always had an illusion up his sleeve. Eager to entertain, he played
pranks, told tall stories, and always found time to chat. The American mind reader Joseph
Dunninger once recalled how he had invented a new illusion with him, and that whenever
Blackstone performed the piece he could have given the impression that the idea was his,

but instead he always made a point of acknowledging Dunninger's contribution. Dunninger described Blackstone as "the finest friend a fellow could have."

For much of Blackstone's career, theatres were not air-conditioned and so touring magicians tended to spend the summer developing new illusions and repairing their apparatus. In 1926, Blackstone and his wife went in search of a summer residence and settled on a large piece of land close to the small village of Colon in Michigan. Overlooking Sturgeon Lake, this relaxing and picturesque area proved the perfect summer retreat for fellow magicians and crew, and eventually became known as Blackstone's Island.

In 1955, poor health forced Blackstone to finally hang up his top hat, and he died in 1965 at the age of eighty. The following year, Colon renamed one of its main streets "Blackstone Avenue" in honor of their world-famous resident. It wasn't the only lasting tribute to the affable and friendly wizard.

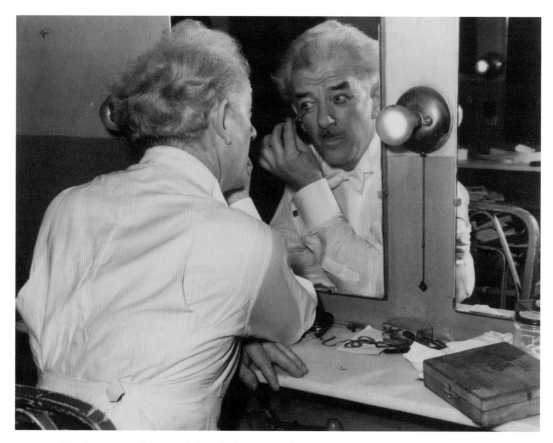

Blackstone and his wife lived close to Colon in Michigan. In 1966, the town renamed one of the main streets "Blackstone Avenue" in his honor.

Over the years many magicians came to Blackstone's Island, and in 1927 Blackstone invited an Australian conjuror named Percy Abbott to visit. Abbott liked the lifestyle, moved to the area, and eventually formed a magic manufacturing business called Abbott's Magic Co. The company is still going strong and for more than eighty years has hosted a large magic convention known affectionately as Abbott's Get Together. Each year over a thousand magicians descend on Colon to talk tricks and the once-sleepy village is now commonly referred to as the Magic Capital of the World. The village's Lakeside Cemetery is just across the water from Blackstone's Island and is the final resting place to more magicians than any other graveyard in the world. Residents include the comedy magician Karrell Fox (epitaph: "It Was Fun"), "Conjuring Humorist" Little Johnny Jones ("Now I have to fool St. Peter"), and magic historian Robert Lund ("Among friends"). Blackstone's ashes are interned at the cemetery, along with those of his late son, Harry Blackstone Jr., who followed in his father's footsteps and became a well-known magician in his own right.

Blackstone was a kindly and benevolent wizard who lent a helping hand to those in need and was quick to acknowledge the achievements of others. He was as affable as he was unpretentious, attracted people to him, and helped to sow the seeds that slowly grew into an astonishing magical community. I am delighted to have Blackstone's tire illusion, vanishing bird cage, and many other pieces of apparatus in my museum. They form a constant and inspirational reminder of the true magic of friendship and fraternity.

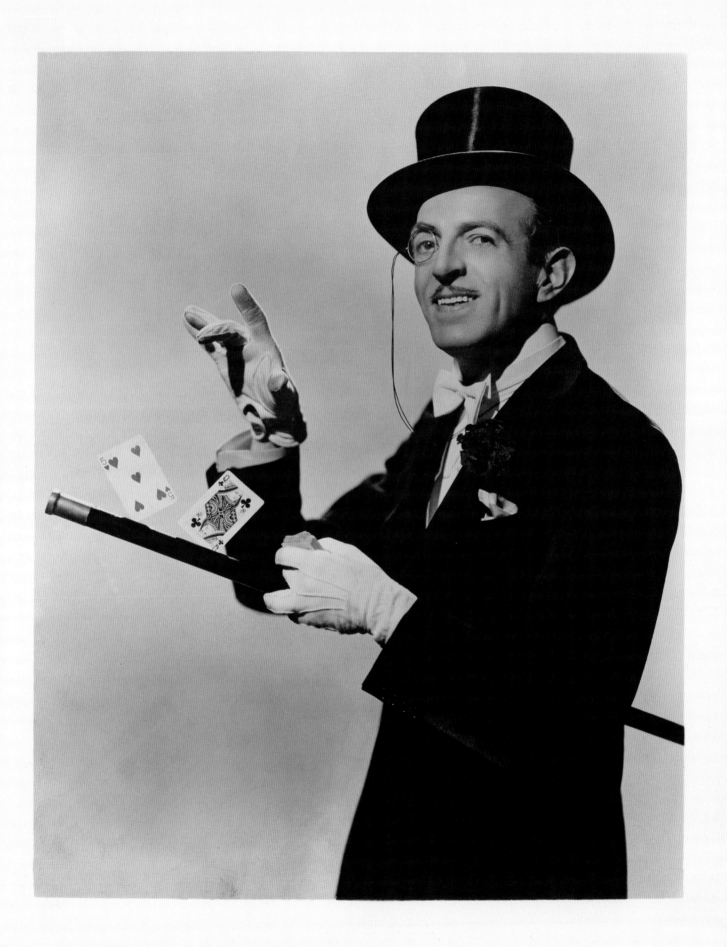

The Suave Deceiver

⇒ CARDINI'S TUXEDO, MONOCLE, AND PLAYING CARDS ⇐

These items belonged to one of the greatest sleight-of-hand artists the world has ever seen. Playing the role of a suavely inebriated aristocrat, he took the art of manipulation to a new level and became the most imitated magician of his generation.

Richard Pitchford was born in 1895 in a small Welsh fishing village. By the age of eight, he had developed an interest in the deceptive arts and would amaze his friends by diving into a local river and emerging with a lit cigarette between his lips. Pitchford had discovered how to safely hide a burning cigarette inside his mouth and this skill—which magicians refer to as "tonguing"—would eventually earn him standing ovations the world over.

During a somewhat checkered youth, Pitchford worked as a butcher's apprentice, a hotel bellboy, a pool hustler, a card cheat, and a general flimflammer. At the start of World War I he signed up to fight for king and country and was sent to France. The nineteen-year-old Pitchford had read that magician Harry Houdini could conceal a full pack of cards behind his hand and then produce the cards one at a time. Desperate to distract himself from the appalling conditions in the trenches, he found a battered deck of cards and spent hours practicing the trick. The weather was bitterly cold and the cards peeked through the joints of Pitchford's long, bony fingers. Undeterred, he solved both problems by donning woolen gloves and continuing his practice. When he discovered that the sticky cards and thick gloves meant that the cards often emerged in bunches, Pitchard made a virtue out of a necessity and became one of the first magicians to make fans of cards appear at his fingertips.

In 1916, Pitchford was sent over the top at the Somme, one of the bloodiest battles in history and where more than a million soldiers were wounded or slaughtered. During the battle, a shell exploded close to Pitchford and he fell unconscious. Around six weeks later he woke up in a military hospital on Britain's South Coast suffering from severe shell shock, with no memory of the attack, and both blind and deaf from a case of hysteria. He became convinced that practicing his sleights might aid his recovery, and insisted on resuming his manipulations. In doing so, Pitchford inadvertently became a pioneer of the then newly emerging field of occupational therapy. I have a strong link to this aspect of Pitchford's life, because several years ago I founded *Project Magic*, a rehabilitative program that helps patients to improve their motor skills by learning sleight of hand. The project was endorsed by the American Occupational Therapy Association and carried out in more than a thousand hospitals across the world.

Pitchford slowly regained his sight and hearing, and, recalling his time in the trenches, he asked nurses for a pair of gloves so that he could wear them during his practicing. The

staff became concerned about his psychological well-being and sent him to a mental hospital, where he continued to insist on the gloves. Fortunately, a kindly nurse eventually smuggled in some gloves and Pitchford devoted around twelve hours a day to manipulating playing cards.

Eventually discharged in 1919, the ever-persistent Pitchford insisted that he wanted to become a magician, and purchased several illusions, some doves, and a rabbit. Once again, fortune didn't smile on him and he played small Welsh theatres for little return. It was a

*Dressed in a top hat, tuxedo, and white gloves, Cardini played
the role of a sophisticated but tipsy aristocrat.*

tough life and once, when Pitchford failed to pay for lodgings, his landlady reportedly made his rabbit disappear by giving it a starring role in a hearty stew.

By the early 1920s Pitchford had grown tired of Britain and boarded a boat to Australia, where he managed to arrange to audition for a well-known agent. Unfortunately, his apparatus failed to arrive and he was forced to perform with whatever he could find in his pockets—a handful of cigarettes and a deck of cards. It proved the turning point in his career. The agent was astonished by Pitchford's remarkable sleight of hand and instantly booked him for a series of shows. Moreover, he suggested that Pitchford should add an air of sophistication to his act by wearing evening dress and adopting a stage name like Houdini. In the blink of an eye, Cardini was born.

His new act was an overnight sensation. Billed as "The Suave Deceiver," Cardini stumbled onstage in a top hat, opera cape, tuxedo, and white gloves. As he appeared to be a sophisticated but tipsy aristocrat, a seemingly endless array of playing cards, cigarettes, and billiard balls appeared at his fingertips. Throughout it all, Cardini appeared baffled by the uncanny events that were happening around him, often registering his surprise by having his monocle drop from his eye.

Cardini's astonishing ability to manipulate cards while wearing evening gloves, and to produce lit cigarettes at will, ensured packed houses across Australia. Flushed with success, he toured America and caused a sensation, and after teaming up with the woman who would become his wife and onstage assistant, Swan Walker, the act went from strength to strength. Over the years, Cardini worked with the Marx Brothers and Jack Benny, and performed for Al Capone, Franklin Roosevelt, and Harry Truman. At the time, London's leading department store, Selfridges, asked top celebrities to sign their "autograph window" using a diamond-pointed stylus. Cardini's signature took pride of place, appearing alongside the likes of Cary Grant, H. G. Wells, and the entire 1938 Australian cricket team. Television host and reporter Ed Sullivan once declared: "All card tricksters should leave the country after watching Cardini."

The early 1950s saw a dramatic rise in the popularity of nightclubs and acts often had to perform at several venues each night. Cardini's lack of large apparatus allowed him to hop between the clubs, and his skills meant that he could perform practically surrounded and just inches away from an audience. While other variety artists struggled to adapt to the nightclub scene, Cardini's star rose higher than ever.

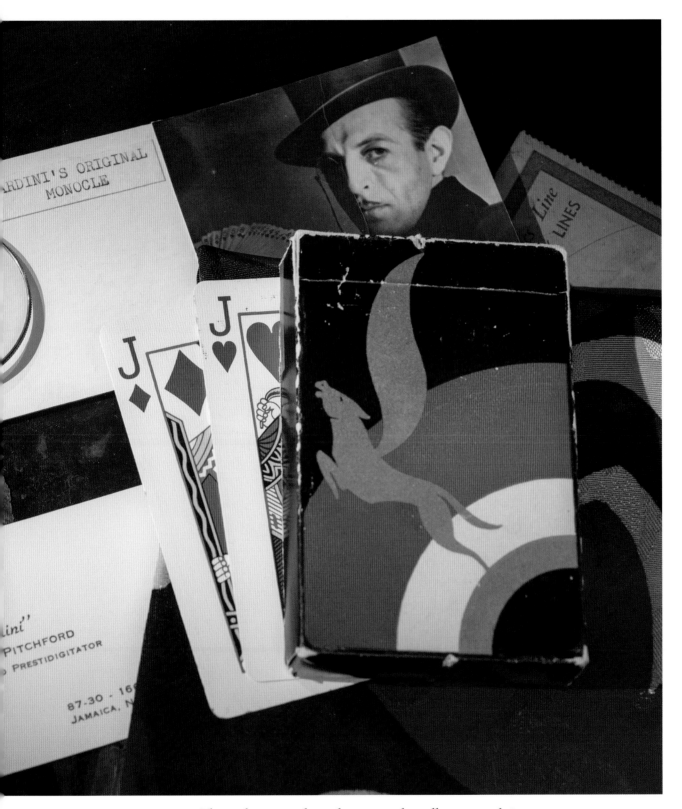

*These playing cards, and a seemingly endless array of cigarettes,
magically appeared at Cardini's fingertips.*

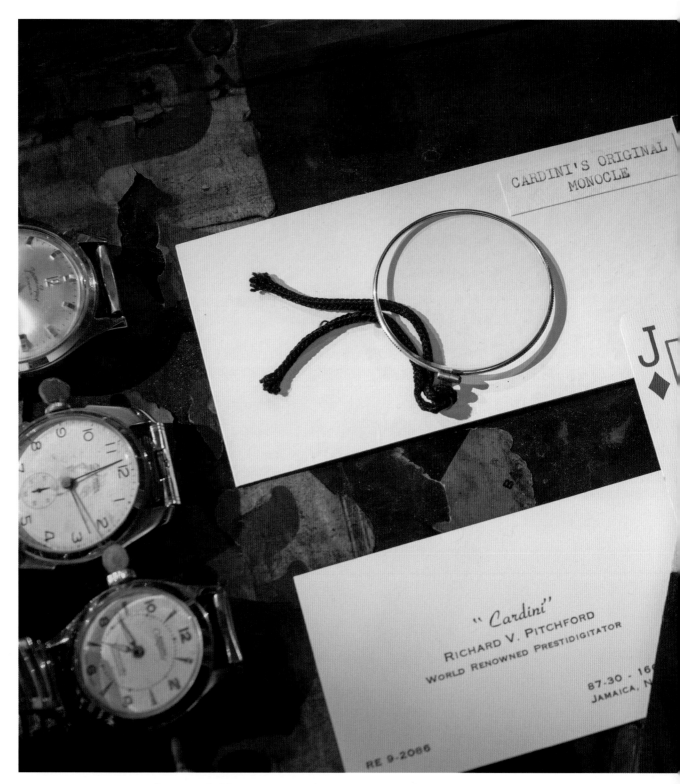

Cardini signaled his surprise at the strange events happening around him by having this monocle drop from his eye.

Cardini edged his way into retirement during the 1960s. His terrible experiences during World War I, combined with the stress of constant travel and heavy smoking (Cardini smoked around twenty cigarettes a day and a further thirty-five cigarettes during each show), took a toll on his health. He constantly suffered from ulcers and finally passed away from a stomach-related condition in 1973.

Cardini elevated the art of magical manipulation to an unprecedented level. He was adored by audiences and revered by magicians, devoted his life to magic, and never took the easy route. Other performers made single playing cards appear in their bare hands while Cardini produced fans of cards while wearing gloves. Others manipulated unlit cigarettes while Cardini chose to work with lit ones. However, the master manipulator paid the price for his perfectionism, and by the end of his career the endless cigarette manipulations had left his hands blistered, burnt, and scarred. According to Cardini's biographer, John Fisher, the world-famous sleight-of-hand artist wore these scars like badges of honor.

Great conjurors often make magic look easy, but these apparently effortless performances are perhaps their greatest illusion. In reality, amazing magic is often the result of intense dedication, perseverance, and pain. Cardini's tuxedo, monocle, and playing cards are an inspirational reminder of the heights that can be scaled by the small number of performers who are willing to truly suffer for their art.

The Human Index

∼ ARTHUR LLOYD'S GOWN, MORTARBOARD, AND CARDS ∼

For hundreds of years, conjurors have described the innermost workings of their illusions in books, pamphlets, and journals. However, a handful of secrets have managed to evade capture, with one of the strangest involving an academic gown.

een amassed by magician John Mulholland, and these now form
library. This library contains the solution to virtually every illu-
present-day performers to build upon the work of past masters.
hain unknown, and Lloyd's indexing system falls into that most
ies. How did he produce such a cornucopia of weird and won-
rent ease? Were the items filed away in a systematic way or did
emember where everything was? And if there was a system, were
cally, or according to category, size, or color?

Lloyd's gown stands as a testament to the notion that sometimes
up their hands and utter the phrase that they themselves love to
I have no idea how that was possible."

re
yd
ct.

rthur Lloyd was born in 1891 in Massachusetts, but moved to Britain at an
a child, Lloyd saw an amazing magic show in which spectators
e names of playing cards, and the conjuror immediately reached
ket and produced the requested cards. Lloyd became fascinated
ered the secret to the illusion, and started to perform it himself.
nces an audience member reportedly asked for the fourteen of
y unable to pull the nonexistent playing card from his pocket, but
ea. After the show, he created a fake playing card deck contain-
en arranged for a stooge to ask for the weird card during a show.
en he managed to fulfill this seemingly impossible request, and
ouraged him to take his performance to the extreme. In doing so,
bizarrely brilliant and utterly unique.

the early 1900s, Lloyd walked onstage dressed as a college pro-
tarboard and academic gown. After performing a few card tricks,
call out the name of any piece of printed card or paper, and then
s gown and produced the desired item. Billed as the "Human Card
astonishing range of items that included menus, driving licenses,
kets, receipts, banking bonds, union cards, signs ("Free Lunch,"
Grass"), birth certificates, burial permits, advertising flyers, and
able productions were frequently punctuated with cleverly con-
s. If, for instance, an audience member requested a dry cleaning
gh his pockets and appear stumped, only to undo his top button
s attached to the inside of his shirt. Lloyd's astonishing act, com-
nial personality, ensured that he became a tremendous hit, and for
ured America and Europe to rave reviews.

gths to ensure that his performances were as impressive as possi-
e continually added to his vast collection of cards in order to deal
sts. He also developed specific collections of cards that came into
particular audiences, such as lawyers or doctors.

around forty pockets distributed among his gown, a waistcoat,
n. Fully loaded, the pockets apparently held hundreds of items

and weighed more than forty pounds. Lloyd appeared to have a complex indexing system that allowed him to locate items with ease, but the exact nature of this secret arrangement remained a complete mystery to the magic fraternity. In one interview, he suggested that those trying to figure out the system were focusing their attention in the wrong place, noting that while locating the cards was tricky, the really difficult bit was putting them back.

Many years after Lloyd's death, I acquired his props and was looking forward to trying on the gown and finally discovering the secret to the human card index. However, the

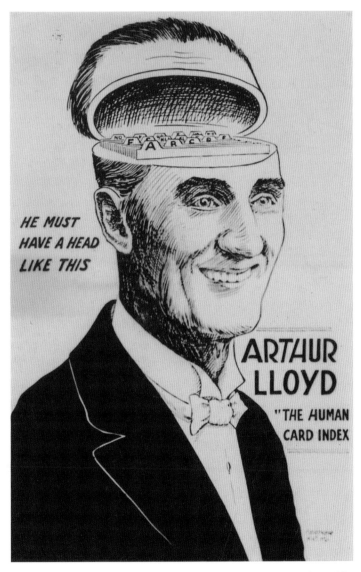

Audiences were astounded by the range of items produced by Arthur Lloyd, billed as the "Human Card Index."

Audience members called out the names of cards and tickets, and Arthur Lloyd produced them from his pockets.

props arrived in two separate packages, with one containing Lloyd's academic gown and the other containing all of the printed matter that he produced on a nightly basis. A note from the sender explained that they didn't want to send me a dusty old gown, and so had had it dry-cleaned. It was a kind thought, but it meant that all of the cards and papers had been removed from the gown prior to the dry cleaning. I suspect the mystery will never be solved. In my mind I can see a smiling Lloyd looking down from heaven, happy that his secret will probably now never be discovered!

For hundreds of years, generations of magicians have carefully devised and documented the secrets to their illusions. Over the years, a handful of conjurors, and several magic organizations, have collected this material together in vast libraries containing millions of pages of text, photographs, plans, and illustrations. In the 1990s, for instance, I purchased several

If They Don't Know You, They Can't Book You

❧ DELL O'DELL'S GUILLOTINE ❧

Hundreds of volunteers have nervously placed their head into these stocks, and each time the guillotine blade has been slammed down and magically penetrated through their neck. Unlike most of the items in my museum, this apparatus isn't associated with an internationally renowned illusionist, but instead belonged to a remarkable performer who helped reveal a very different side to the world of magic.

Odella Newton had show business and sawdust in her veins. She was born into a circus family in the Midwest of America in 1897. Her father, William Newton, had originally worked on a cattle farm until one of his cows gave birth to a calf with multiple tails. Realizing that people were prepared to pay good money to see this biological oddity, William took the calf on tour and eventually started his own circus. When his wife ran away with the circus strongman, William was forced to bring up Odella and her five older brothers on his own. During circus season she was sent to a boarding school run by nuns, but was always attracted back to the glitz and glamour of show business. By the time she was a teenager, Odella had perfected her own strongwoman act and could climb up one side of a ladder and down the other with a sofa balanced on her chin.

Odella moved from circus to vaudeville, adopted the stage name Dell O'Dell, realized that her true talent lay in making people laugh, and at age thirty-two started to work as a comedy magician. She was a loud and brash performer, slamming her way through tricks with a huge amount of energy and slapstick humor. In 1930, O'Dell met a talented juggler named Charles Carrer. She had found her perfect partner in both show business and in life. They were married within a month and stayed together for the next thirty years.

Throughout the late 1930s and 1940s, O'Dell performed wherever and whenever she could. During the day she appeared at children's parties, schools, and department stores. In the evenings she entertained at colleges, private events, hotel dinners, and nightclubs. O'Dell often played several nightclubs in a single evening by having assistants set up her apparatus at one venue while she was finishing at another. And she took advantage of the intimacy of the nightclub venues by mingling with the guests after the show, performing tabletop magic. In addition, she often appeared at trade shows and conventions, and was one of the first conjurors to use magic to help sell products and services. Although O'Dell was prepared to travel across the country for work, most of her bookings were in New York and included regular appearances at Macy's department store.

Throughout it all, O'Dell entertained audiences with her trademark rhyming patter. Specially written for her, the good-natured rhymes were packed with terrible puns and silly humor. Many magicians were critical of O'Dell's rhymes, but the unusual approach stuck in spectators' minds and helped her to stand out from the crowd.

Dell O'Dell was a brash performer who often employed bawdy humor to capture spectators' attention.

O'Dell was a relentless one-woman marketing machine. ("If they don't know you, they can't book you.") She placed advertisements in trade magazines, ran "Dell O'Dell Friends of Magic Club" (attracting 10,000 junior members and over 7,000 adults), and published several magic books for the public, including the curiously titled *A Book of Entertainment by Dell O'Dell World's Leading Lady Magician 77370-0-77370—There's Magic in These Numbers*. When readers turned the book upside down they discovered that the numbers formed the word "Dell-O-Dell." She also designed and distributed tens of thousands of

The museum houses scrapbooks containing hundreds of pages of
Dell O'Dell's trademark rhyming patter.

self-branded puzzles and novelties. In perhaps her most effective marketing stunt, O'Dell showed people a pencil with a loop of string attached and then quickly looped the pencil through their buttonhole. It was almost impossible to remove without cutting the string, and so the person was forced to wander around with the pencil hanging from their clothing. It's estimated that O'Dell gave away over half a million of these pencil puzzles and all of them were embossed with her name.

While many magicians spend a lifetime perfecting an act that lasts just a few minutes, O'Dell frequently performed for repeat customers and so needed a constant supply of new illusions. She consumed the content of magic store catalogs and often purchased several duplicates of her favorite items. Carrer, her husband, was not only an accomplished juggler but also a wonderful mechanic. He rebuilt many of O'Dell's tricks and illusions to suit her

specific requirements, including the guillotine in my collection. In most guillotine illusions the volunteer is asked to sit or kneel down on the floor, and so when it's performed on a nightclub floor, spectators toward the rear of the room often struggle to see what's happening. Carrer cleverly redesigned O'Dell's guillotine to ensure that the illusion could be performed with the volunteer standing up, and therefore greatly improved its visibility.

Struggling to accommodate this vast amount of equipment, O'Dell eventually bought two adjacent houses in Queens and filled one of them floor to ceiling with her apparatus. The house next door was home to O'Dell and her husband, along with their menagerie of rabbits, doves, goldfish, cats, dogs, ducks, and even a skunk. A huge animal lover, O'Dell let her ducks and goldfish enjoy their own outdoor pool, housed her rabbits in a heated hutch, and kept her doves in large and clean cages. Throughout her life, she had a special affinity for rabbits, creating a rabbit-shaped swimming pool and claiming to have collected more than ten thousand rabbit-themed figures and novelties.

O'Dell was popular among her magical peers. She was a good cook and wonderful hostess, her house parties frequently attended by leading magicians of the day, including legendary card manipulator Cardini and illusionist Harry Blackstone. O'Dell also put on a great show when journalists came visiting, with reporters describing a madhouse of magic containing a thousand and one surprises. She loved mischievous pranks and gags, including books that exploded and chairs that collapsed. Sometimes her husband juggled eggs in the kitchen and O'Dell caught them in a pan before transforming them into a chicken.

When television came along in the 1950s, many magicians mourned the loss of live entertainment, but O'Dell saw the new medium as an incredible opportunity to reach large numbers of people. In 1951, she moved across the country and was given her own series on the first commercially licensed station in Los Angeles. Set in what appeared to be her home, the weekly show ran for two years and O'Dell became one of the best-known magicians in California. She received thousands of letters from fans and insisted on answering them all personally.

In O'Dell's later years, the popularity of nightclubs declined and she struggled to get bookings. Ever the trouper, she switched to performing at county fairs and drove around in a golf cart plying her magic. Eager to catch people's attention, she was frequently found performing with a squirrel monkey on her shoulder. But in her final years O'Dell kept one secret

*Dell O'Dell gave away thousands of self-branded
novelties, including this dancing doll.*

from her audiences. She had been diagnosed with cancer. Despite undergoing agonizing
radiation treatments, O'Dell insisted on continuing to perform, and even though she was in
considerable pain before a show, she still managed to step out onstage with a smile on her
face. O'Dell gave her final performance just two days before her death in 1962.

Although few modern-day magicians can match O'Dell's incredible work ethic, most still
perform at the same variety of venues, including private parties, corporate events, weddings,
and restaurants. Often, it isn't an especially glamorous life, and they may never achieve
fame and fortune. Nevertheless, they are out there, day after day, night after night, putting a

smile on people's faces and bringing some much-needed wonder into the world. My museum houses hundreds of pages of O'Dell's rhyming patter and several fascinating scrapbooks. However, her guillotine takes pride of place. Like O'Dell herself, the guillotine had a tough life, but was well loved, and carried on working through all of the ups and downs. As such, it's a fitting tribute to a talented magician who worked incredibly hard, kept going when the going got tough, achieved commercial success, and constantly adapted her magic to an ever-changing world.

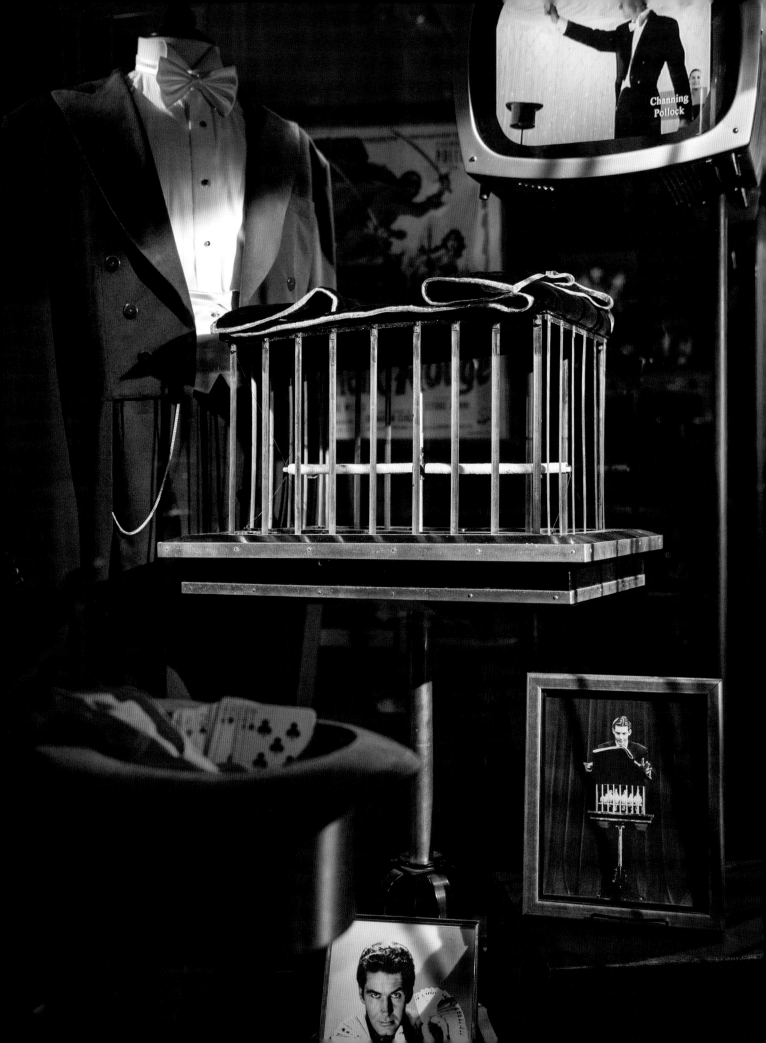

Channing
Pollock

In Pursuit of Perfection

Channing Pollock was one of the most gifted magicians of his generation. Tall, suave, charismatic, and remarkably handsome, he changed the face of conjuring and played a pivotal role in my life.

orn in 1926, Channing Pollock first stepped into the limelight when a magician visited his school in Sacramento and invited him to help out during his act. Curious about conjuring, Pollock visited a local library in his early twenties and came across a classic Victorian book on illusion: Professor Hoffmann's *Modern Magic*. Hoffmann's book contained many beautiful illustrations of ornate and intricate apparatus, but at the time Pollock was a man of modest means and realized that the elaborate equipment was outside his price range. Instead, he purchased a pack of playing cards and began to practice manipulation and sleight of hand.

Bitten by the magic bug, Pollock relocated to Los Angeles and enrolled at what was then America's only accredited course on conjuring, the Chavez School of Magic. Practicing for five hours a day, for five days a week, Pollock graduated in record time and was promptly hired to teach the course.

Determined to take magic to a new level, Pollock wanted to create a stripped-back and deceptively simple act that was as elegant as it was fooling. He worked with Naomi, his offstage wife and onstage assistant, and the two of them focused on the magical production of playing cards and doves. Pollock had a clear vision from the very start; no suspicious-looking apparatus, no unusually thick tabletops, no bulging suits, just two beautifully attired people performing one miracle after another. The young couple used their life savings to buy an expensive tuxedo and evening dress, put together the beginnings of an act, and toured America's West Coast in search of work. Struggling to make ends meet, they were forced to perform anywhere and everywhere, including run-down restaurants, cheap nightclubs, and burlesque houses. Through it all, Pollock was innovating and experimenting, adapting and evolving; mile by mile, show by show, iteration by iteration, the act slowly took shape.

After several years on the road, in 1954 Pollock was invited to perform on *The Ed Sullivan Show,* and that night the American public saw something they had never seen before. Elegantly dressed in a close-fitting tuxedo, Pollock made playing cards appear at his fingertips, again and again. Entire fans of cards were plucked from thin air and thrown into an upturned top hat then, seconds later, another fan instantly appeared. Pollock plucked a small silk scarf from Naomi's stylish cocktail dress, slowly gathered it up between his hands, and made a dove materialize from the center of the silk, not once, but several times. At the end of the act, Naomi brought on a large cage containing several doves sitting on a perch. Pollock unfolded a

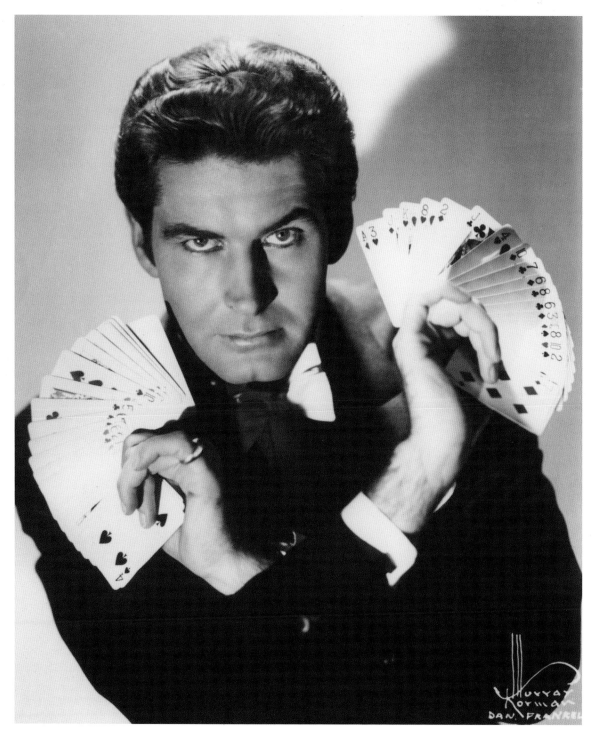

Suave, handsome, and sophisticated, Channing Pollock
was the personification of perfection.

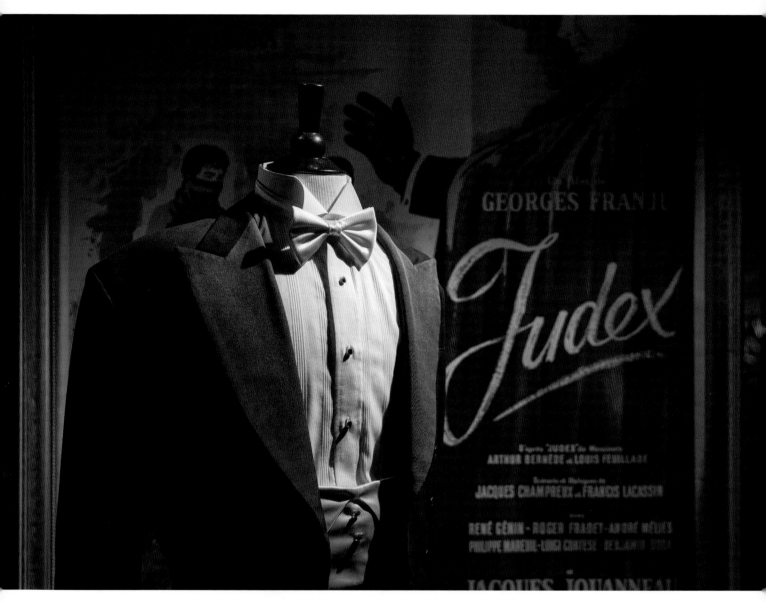

Dressed in this elegant tuxedo, Pollock effortlessly
made playing cards and doves appear at his fingertips.

black velvet cloth over the cage, picked it up, and carried it forward. Moments later he flicked the cloth, and both the cage and the doves had completely disappeared. Throughout it all the chisel-jawed, steely-eyed master magician stared down the barrel of the camera, nonchalant and aloof. Only at the end of the act, when the audience burst into wild applause, did he allow himself the luxury of a smoldering half smile.

Pollock and Naomi had created a masterpiece of magic and became an overnight

sensation. Taking one high-profile booking after another, they worked in the top theatres and nightclubs across America and Europe, and during the 1950s Pollock entertained the Queen in Britain, performed at the wedding of Prince Rainier and Grace Kelly, and went to the White House to conjure for President Eisenhower. Afterward the president remarked that if Pollock were in his cabinet he would have to be investigated for deception. Ironically, Richard Nixon was standing directly behind the president as he spoke.

Pollock eventually separated from Naomi but continued to perform the act with his second wife, Jozy, a former British hula hoop champion. Having created such a remarkable act, many magicians would be content to receive standing ovations for the rest of their career, but not Pollock. He had achieved his dream against the odds, and now it was time to move on to new challenges. When he was working in Britain, his driver was a keen amateur magician named Frank Brooker, and during the late 1950s he taught Brooker how to perform his act, after which Pollock promptly vanished from the world of magic and became a movie star. Brooker successfully performed Pollock's act for several years, although he never managed to replicate the technique and presentational panache of his masterful tutor.

As an actor, Pollock was touted as the new Errol Flynn. He moved from stage to screen and spent a decade playing lead roles in several European movies, including swashbuckling adventures, historical dramas, and crime thrillers.

Then, once again, Pollock quit while he was ahead. In 1969 he abandoned the movies, married his third wife, Cori, and began to explore spiritual matters. Pollock was fascinated with the multitude of religions around the world, and was especially interested in Hinduism and Zen Buddhism. Cori and Pollock moved to California's Pacific coast, and set up both an organic farm and a ranch where they bred and sold earthworms. He became a magnificent gourmet chef, was the perfect host, and frequently invited magicians to enjoy a spectacular 180-degree view of the ocean. Always humble about his achievements, Pollock made a point of never putting down other performers, and was a friend and mentor to many aspiring magicians. He died from complications due to cancer in 2006, at the age of seventy-nine.

I was lucky enough to know Pollock and was hugely impressed by his work. When I staged my show *The Magic Man,* the program thanked two people who had inspired my work: Gene Kelly and Channing Pollock. And when my star on the Hollywood Walk of Fame was unveiled, Channing was kind enough to come along to the ceremony. My

museum proudly houses his tuxedo, playing cards, diaries, and, of course, his wonderful vanishing dove cage.

To me, Pollock was the James Bond of magic. Suave and sophisticated, his astonishing act is a tribute to the power of pursuing perfection. With a Zen-like mentality, he demonstrated how growth comes from always looking ahead, setting the bar high, and working hard to overcome challenges. Perhaps most important of all, he was about giving not taking, and about nurturing not neglecting. Pollock was a perfect gentleman who fathered lots of magicians, and I'm proud to be one of his sons.

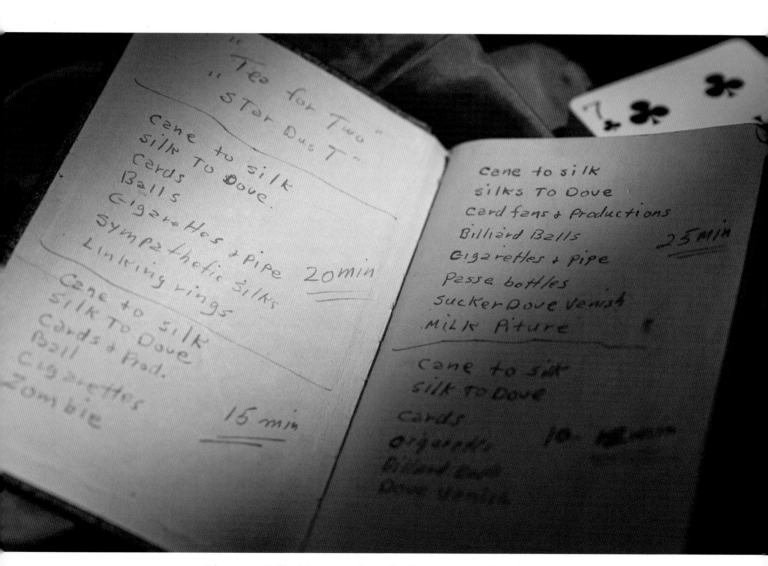

Channing Pollock's personal notebooks are an invaluable resource to historians researching this remarkable performer.

⇝ *The Vanishing Bird Cage* ⇜

Recently I was watching the film of Channing performing the vanishing bird cage and I realized that it was the best recording of it that I had ever seen. Channing unfolded the cloth over the bird cage, placed his hands on the sides of the covered cage, and lifted the cage off the table, pressing on the sides of the cage with his palms. A few moments later, Channing threw the cloth into the air, and the cage and doves had vanished. In a final gesture he held the corner of the cloth in one hand and drew the cloth through his other hand to show that it was truly empty. It was a stunning version of the illusion, and I was moved and inspired.

A little while later I contacted my friend and an expert on Channing Pollock, James Dimmare, and we chatted about the vanishing bird cage. He asked me if I knew the details of Channing's handling of the bird cage and I managed to guess correctly. The following day I was strolling through the museum and saw it in Channing's display cabinet. Did I dare try it myself to see if it would work the same way? I opened the cabinet and carefully took the apparatus over to a mirror so I could see how the illusion looked from the audience's point of view.

I mimicked Channing's handling and technique, and miraculously it worked in my hands exactly as Channing had intended. It was an unbelievable experience thanks to Channing's brilliant mechanical design and handling.

It was a rare and remarkable experience that I will never forget.

CHAPTER 23

Blood on the Curtain

☙ RICHIARDI'S BUZZ SAW ❧

In the Buzz Saw illusion a person appears to be sliced in half by a razor-sharp rotating blade. This gruesome-looking apparatus was used to thrill and terrify audiences the world over. It belonged to a performer who was praised for having the soul of a poet, and whose artistry and grace lifted magic to new heights.

Magic was in Aldo Izquierdo Colosi's blood. He was born in Peru in 1923, and his father was a magician and ventriloquist who appeared as The Great Richiardi. During his childhood, Aldo toured with his family and first trod the boards when he was just four years old. The Great Richiardi was always searching for new magic, and obtained one of his most famous illusions under somewhat strange circumstances. In 1934, a magician named Kasfikis was driving a truck full of illusions to a show in Spain. Kasfikis was suddenly forced to swerve and unfortunately the crate containing the Buzz Saw illusion slid forward, hit the back of his head, and decapitated him. The Great Richiardi purchased the apparatus and regularly used it to appear to saw his assistant in half. Audiences were thrilled by the spectacle, unaware that the equipment had been involved in a genuine fatality.

In 1937, The Great Richiardi contracted an acute infection while he was performing in North America and suddenly passed away. Aldo wasn't especially keen on becoming a professional magician. He was a talented singer and dancer, had dabbled in bullfighting, and had even considered becoming a physician. However, there was considerable pressure on him to continue the family tradition, and so in the early 1940s Aldo adopted the stage name Richiardi Jr. and launched his own magic show. For the next thirty years, he toured across South America, North America, and Europe. Traveling with a large cast and overcoming language barriers by performing mainly to music, his shows proved extremely popular. In 1956, his performance on *The Ed Sullivan Show* caused a sensation and over the years he made over fifteen additional appearances.

Wearing high-waisted trousers and a flamenco jacket, Richiardi Jr. was a charismatic and electric performer who brought a sense of theatricality to everything he touched. He developed a series of signature illusions, including the sudden disappearance of an assistant from under a cloth, the suspension of an assistant on an upright broomstick, and the buzz saw. All of these items had a long pedigree. The vanishing assistant illusion is the work of the brilliant Victorian inventor Buatier de Kolta, the suspension illusion was invented by French magician Robert-Houdin during the late 1840s, and the Buzz Saw was created by American illusionist Horace Goldin in the 1930s. However, Richiardi Jr.'s presentation of these classic illusions was both groundbreaking and breathtaking.

For instance, while other magicians might make a dove vanish by placing it into a box and then slowly taking the box apart, Richiardi Jr. performed the illusion at breakneck speed, and used two boxes and four doves. As he ripped both boxes apart, Richiardi Jr. threw the sides, tops, and bottoms across the full width of the stage, where each piece was caught with astonishing accuracy by his assistants. Similarly, many magicians have their assistant sit in a chair, cover them with a cloth, and then remove the cloth to reveal that their assistant has vanished. When Richiardi Jr. performed this classic illusion he took it to a new level by making his

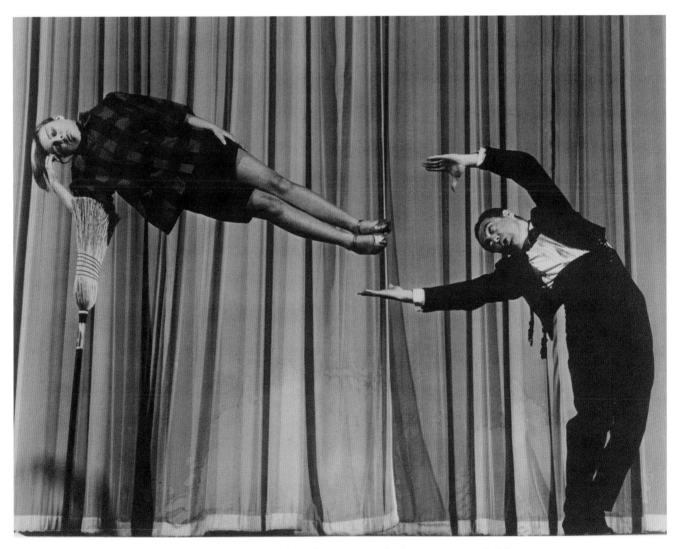

Richiardi Jr.'s powerful performances relied upon a remarkable understanding of movement and choreography.

assistant suddenly vanish and then instantly reappear in a raised trunk on the other side of the stage. Combining speed and grace, Richiardi Jr. could plunge a sword through a box, or whip away a cloth, with artistry and precision like no other performer.

Richiardi Jr.'s background in dance and bullfighting resulted in a remarkable understanding of movement and choreography. Every facial expression was thought through and every gesture was timed to perfection. Take, for instance, his presentation of the classic broomstick illusion. Performed to soulful music, it had the feel of a strange, brooding relationship between a woman suspended in midair and Richiardi Jr. with his feet firmly on the ground. Mesmerizing spectators with both his magic and movements, Richiardi Jr. convinced audiences that the suspension had nothing to do with hidden strings or concealed mirrors. Instead, the laws of physics no longer applied simply because he commanded it so.

Richiardi Jr. also understood how to create highly dramatic presentations. Most magicians perform a bloodless and somewhat sanitized version of the Buzz Saw illusion. Not Richiardi Jr. At the start of the performance Richiardi Jr. announced that he was about to present an illusion that some spectators might find upsetting, and advised those with a delicate disposition to leave the auditorium. The curtains then parted to reveal a sterile-looking medical scene, complete with assistants clad in white surgical gowns and a huge buzz saw suspended high above an operating table. A woman dressed in a patient's smock had a handkerchief apparently dosed in anesthetic held to her face. Once unconscious, she was placed on the operating table. Richiardi Jr. set the blade in motion and sawed straight through the woman, creating a gruesome scene that wouldn't have been out of place in a horror film. Blood spattered onto the white gowns and up the white plastic curtain behind him. Then the woman's innards appeared to spew out onto the operating table and, perhaps most important of all, there was no restoration. Instead, Richiardi Jr. invited the audience to come onstage and inspect the bloodied corpse.

A long line of curious onlookers shuffled up to take a close look and Richiardi Jr. waited patiently until everyone had had their fill of the bloody spectacle. Breaking the tension, the master magician assured audiences that they had witnessed an illusion (noting that he couldn't afford to kill a woman every night), and posed one final question: "All I ask you, is the illusion well done?" As the audience applauded, the unconscious woman was carried off and Richiardi Jr. took his final bow. It was an unsettling drama that spectators never forgot.

*Richiardi Jr.'s version of the Buzz Saw illusion was
an unsettling experience that stunned his audience.*

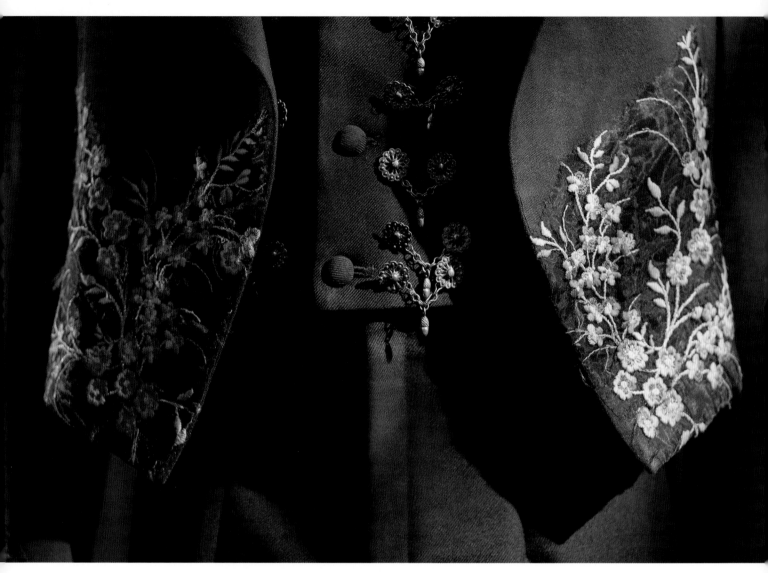

*Richiardi Jr. was one of the finest performers I have seen, and
I am proud to have his costumes and apparatus in my museum.*

Richiardi Jr. poured his heart into his work and his love of magic flowed over the foot-lights. Audiences knew that they were in the presence of a master illusionist.

In 1970, I saw Richiardi Jr. perform in New York and I was completely blown away. I had studied dance at college because my role models were the likes of Gene Kelly and Fred Astaire. I believed that movement had a vital role to play in the presentation of magic, and Richiardi Jr. was living confirmation of this idea. He was an inspiration and demonstrated what magic could be. Then, early on in my career, I both appeared in and coproduced a CBS

television show called *Magic with the Stars*. I invited Richiardi Jr. to perform and I can still remember how honored I felt to be sharing the bill with one of my inspirations.

In 1985, Richiardi Jr. injured his foot. Unfortunately, complications set in after several operations, and he died at the age of sixty-two. His show was placed into storage in Brazil, and I was worried that over time these historic artifacts might decay or become damaged. I was therefore delighted when Richiardi Jr.'s family agreed to let them have a safe and secure home in my museum.

My Richiardi Jr. collection contains his costumes and several illusions, including his famous version of de Kolta's vanishing assistant. However, Richiardi Jr.'s Buzz Saw sits at the center of the collection. To most visitors it appears to be a gruesome and terrifying piece of equipment. To me it represents a performer of intense artistry and beauty. Richiardi Jr. understood that conjuring shouldn't stand apart from other performing arts, and he elevated magic to a new level by incorporating elements of dance, movement, music, lighting, acting, and drama. I consider him to be one of the finest magicians I have ever seen, and his work continues to inspire and lift me. A reviewer once declared that Richiardi Jr. had the soul of a poet, and I am delighted to help preserve his apparatus, legacy, and lasting contribution to the art of magic.

Coleman

England
Price

Fitzgerald
Ferguson
Fortune
Fleming

Galvin
Guyon
Gray
Glaser
Gordon
Goldin
Goldin
George
Cyril Divodemont
Green
Giltin
Houdini
Hardeen Waubecker
Harvee
Horwitz
Harrison
Hoffman
+ Hellstrom
Mullins Helluid
Howell
Hopkins
Hingard
Winkler

The Man Who Fooled Houdini

➣ DAI VERNON'S DEAD LIST ➣

This piece of paper contains the names of more than two hundred magicians and belonged to a man whose dedication, passion, and deceptively simple thinking changed the art of sleight of hand.

Born in Canada in 1894, David Frederick Wingfield Verner became hooked on conjuring when he was seven years old (later quipping that he had wasted the first six years of his life). He became fascinated with sleight of hand and was especially attracted to the wily ways of crooked gamblers. When he was around eight years old, Verner came across an obscure book that changed his life. Published in 1902, *The Expert at the Card Table* described the complex techniques used by card cheats, and while many of his fellow conjurors found the complicated descriptions impenetrable, Verner mastered the moves and thought the book a work of genius. At the time, most professional magicians focused on stage magic. Inspired by Erdnase and crooked gamblers, Verner preferred to spend his time at the card table and was especially attracted to the idea of performing small-scale magic a short distance away from spectators. This genre of conjuring, now known as "close-up magic," was to play a major role in his career. When he was in his twenties, Verner adopted the name Dai Vernon.

Harry Houdini had declared that no illusion could fool him if he saw it three times in a row. At a banquet, Vernon was introduced to Houdini and put the master magician's claim to the test. Vernon asked Houdini to sign the face of a playing card. The card was then placed underneath the top card of the deck, Vernon snapped his fingers, and Houdini's signed card was back on top. Houdini asked to see the illusion a second time and Vernon did it again, and again, and again. Vernon eventually performed the illusion eight times and Houdini had no idea how it was achieved, and from then on Vernon became known as "The Man Who Fooled Houdini."

In the 1920s and '30s, many of America's greatest magicians gathered in the back rooms of New York's magic shops and shared their secrets with a select few. Vernon's impeccable sleight of hand ensured that he was soon ushered into these inner sanctums of secret knowledge. Rubbing shoulders with America's most famous magicians, including Harry Kellar and the king of impromptu magic, Max Malini, Vernon quickly gained a reputation as an impressive close-up wonderworker.

Young, charming, and skillful, Vernon made his living performing close-up magic for New York's high society, and by cutting silhouettes at fairs and street shows. However, his true passion lay in the search for magical perfection. For Vernon, magic was like a fever that

Vernon's immense knowledge about sleight of hand resulted
in him becoming known as "The Professor."

he could never shake off. Desperate to take his beloved art of close-up magic to new levels, his life became a never-ending quest to seek out the most skilled sleight-of-hand artists and absorb their knowledge.

Vernon spent much of his life traveling across America in pursuit of expert card sharps. In the 1930s, for instance, he heard a rumor that a crooked gambler could perform the "holy grail" of card cheating and deal playing cards from the center of the deck. According to the rumor, the gambler was called Kennedy and lived in Kansas City, so Vernon spent months

visiting gambling joints and pool bars there, eventually discovering that Kennedy actually lived in a small city in Missouri called Pleasant Hill. Vernon traveled there but still couldn't track down his elusive quarry. One day he saw a young girl in the street and, in desperation, asked her if she had heard of someone called Kennedy. Remarkably, the girl nodded and calmly directed the magician to Kennedy's house (although not a religious man, when Vernon recalled the story he always said that the incident reminded him of the biblical phrase "a little child shall lead them"). Kennedy was a farmer and card cheat, and had spent more than five years learning how to perfect the seemingly impossible center deal. Vernon persuaded him to explain the intricate mechanics of the move and eventually passed it on to his fellow magicians.

Vernon's fascination with both close-up magic and crooked gambling paid off. At the time, the sleight of hand used by conjurors performing close-up magic often appeared somewhat unnatural. Spectators might not know exactly what was happening, but they knew that something was afoot. In contrast, crooked gamblers were eager to avoid being caught cheating and so they had more natural ways of concealing their sleights. It wasn't just a case of what they were doing, but also when they were doing it: these gamblers had perfected the art of misdirecting a spectator's attention and then executing a sleight at the moment of distraction. These tiny changes meant that even the most suspicious spectators were unable to detect any signs of trickery. Vernon's simple but brilliant idea was to apply the naturalness of crooked gambling to the performance of close-up magic.

Vernon worked his way through one piece of magic after another and rendered them beautiful. Focusing mainly on sleight of hand, he provided a purpose for every action, eliminated suspicious moments, and streamlined routines until only the magic remained. His versions of two classic illusions—the Linking Rings and the Cups and Balls—were studied and admired by many magicians, and continue to inspire modern-day performers.

In 1963, the Magic Castle opened in Hollywood. Billed as "the most unusual private club in the world," the Castle was a nightclub for magicians and those interested in the deceptive arts. Vernon was invited to visit and had intended to stay for just two weeks, but ended up spending the rest of his life there. Magicians flocked to see him, and several of his acolytes uprooted their lives and moved to Los Angeles to be near him. Most nights he could be found sitting on a Victorian love seat close to the Castle's main bar, a Partagas cigar in one

The museum houses some of the everyday objects that
Vernon used to astonish and bewilder spectators.

hand and a deck of cards in the other. He dispensed invaluable advice to fellow performers, and regaled visitors with stories of his time with the magical greats. Vernon likened himself to Ishmael in the novel *Moby-Dick*, as he alone was left alive to tell the tale. A continuous font of knowledge, he eventually became known simply as "The Professor."

During the 1970s Vernon compiled a list of more than two hundred magicians he had known, with everyone on the list sharing three traits—they were all well known in magic, they were all friends of Vernon's, and they were all dead. He'd outlived them all. To some, the list

Dai Vernon was a superb close-up magician and a talented silhouette artist.

seemed somewhat morbid, but Vernon always saw the funny side of it. Once, when Vernon's elderly magician friend Hy Berg came to the Magic Castle, Vernon pulled out the list and said, "There's still a space on it for you!" Berg and Vernon had known each other for over fifty years, and when Berg eventually died in 1982, Vernon sorrowfully entered his name on the list. Vernon himself passed away in 1992 at the age of ninety-eight.

I knew The Professor well and have many happy memories of spending time with him at the Magic Castle. My museum proudly houses many items associated with Vernon, including his scrapbooks containing newspaper cuttings, linking rings, silhouettes, playing cards, coins,

and other performing paraphernalia. Together they symbolize a long life well lived. His legendary "dead list" sits at the heart of the collection and illustrates how Vernon himself was a linking ring that connected the past masters with future generations. Modern-day magicians often strive to conceal their secrets under a cloak of naturalness, and so there is a piece of The Professor in each of their performances. As a young man, Vernon fooled Houdini. More than a century later, his deceptively simple idea about the importance of naturalness in magic continues to mystify the world.

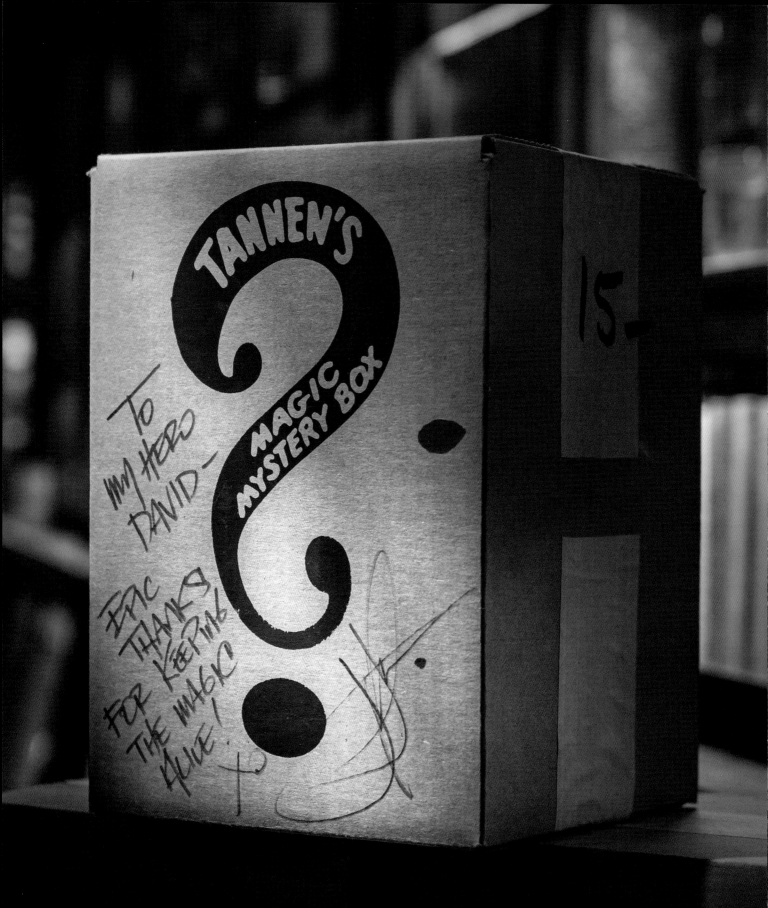

The Mystery Box

➣ TANNEN'S MAGIC STORE ➢

This is one of the most personal and meaningful exhibits in my museum. Filled floor to ceiling with hundreds of illusions, it represents, to me, a home away from home and is forever associated with feelings of friendship, support, and happiness.

I grew up in New Jersey and was fascinated by ventriloquism and magic from a young age. One day I convinced my parents that I needed a new ventriloquist figure, and they kindly offered to take me to New York City.

We headed to Macy's department store because at the time they had a small magic counter. The demonstrator there, Danny Tsukalis, was a friendly and highly skilled magician, and he showed me an illusion where he placed a coin on a small wooden board and suddenly made it vanish. He must have performed it for thousands of customers over the years and he had honed it to perfection. That little board was one of the first illusions that I ever acquired, and I can still remember the joy of making that coin disappear over and over again. Many years later, an elderly gentleman approached me after one of my shows and asked me to make an autograph out to "Danny." I didn't recognize him at first, but suddenly realized that he was the Macy's demonstrator who I had watched as a kid.

My memory instantly took to me back to that special visit to Macy's and to the man who had helped to ignite my passion for magic. I was delighted to see Danny again after so many years, and especially thrilled when he reached in his pocket and took out the small wooden board that meant so much to me. Danny asked if he could share his special illusion with my crew backstage and I gathered everyone together. Danny's muscle memory kicked in, and he gave a brilliant and masterful performance. My teammates saw amazing large-scale magic every night, and yet here they were blown away by the beauty and elegance of Danny's tiny vanishing coin illusion. The moment has always remained in my mind and vividly illustrates what can be achieved by a lifetime of dedication.

A few months after Danny passed away I received a large mystery crate from his family. I couldn't imagine what could be inside. We slowly opened the crate and I was stunned. It was Danny's actual counter from Macy's, where my passion began, and it now has pride of place in my museum. When visitors first arrive, I stand behind the special counter and show them the vanishing coin illusion that had made such an impression on me all those years ago.

Soon after visiting Macy's, I looked through the New York yellow pages phone book and I found "Louis Tannen Magic." Although I didn't realize it at the time, this small discovery would change the course of my life. Tannen's is a magical institution. Founded by Lou Tannen in 1925, it's still the oldest operating magic store in New York City.

I can still remember visiting Tannen's for the first time. The store was on the thirteenth

Tannen's counters were jammed full of cards and coins,
wooden boxes and brass tubes, and much, much more.

floor of the Wurlitzer Piano building. My parents and I made our way into the small elevator and the doors closed. Moments later they reopened and I found myself transported into an extraordinary Aladdin's cave of magic. I know that it sounds odd, but I knew that my life was changing. It was like walking into heaven. The walls were covered in posters and pictures of the magical greats, and the shelves were jammed full of mysterious silver tubes, strange-looking wooden boxes, and brightly colored apparatus. There was row upon row of books and pamphlets, and drawer after drawer of playing cards and coins. It seemed as if all of the apparatus that I had read about in magic books was now right in front of me, including wands, billiard balls, top hats, thin-topped tables, bottles, brass boxes, feather flowers, and wooden ducks.

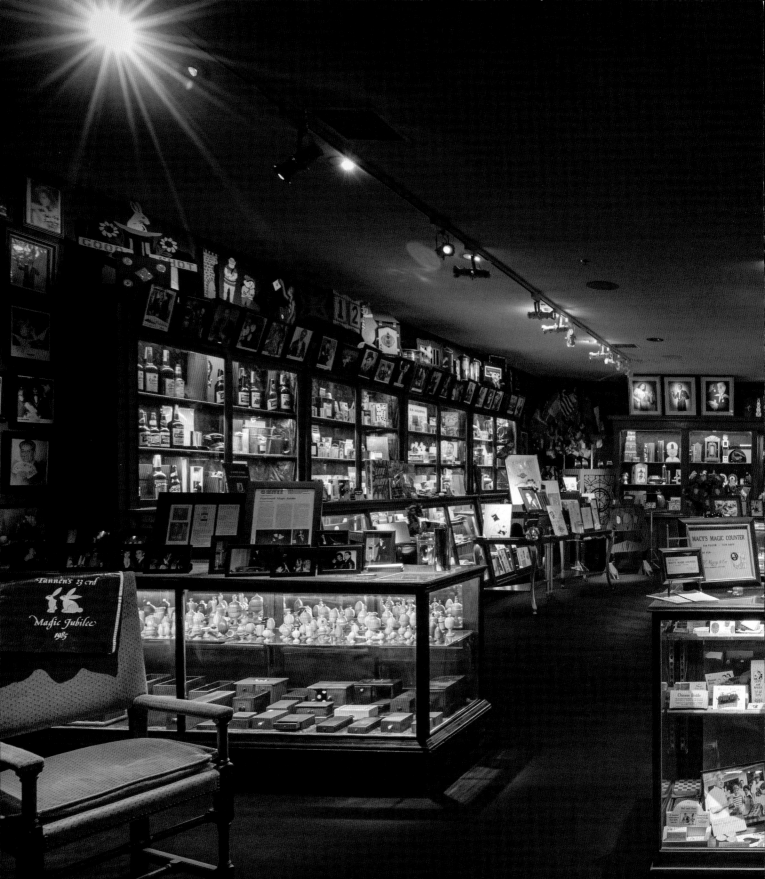

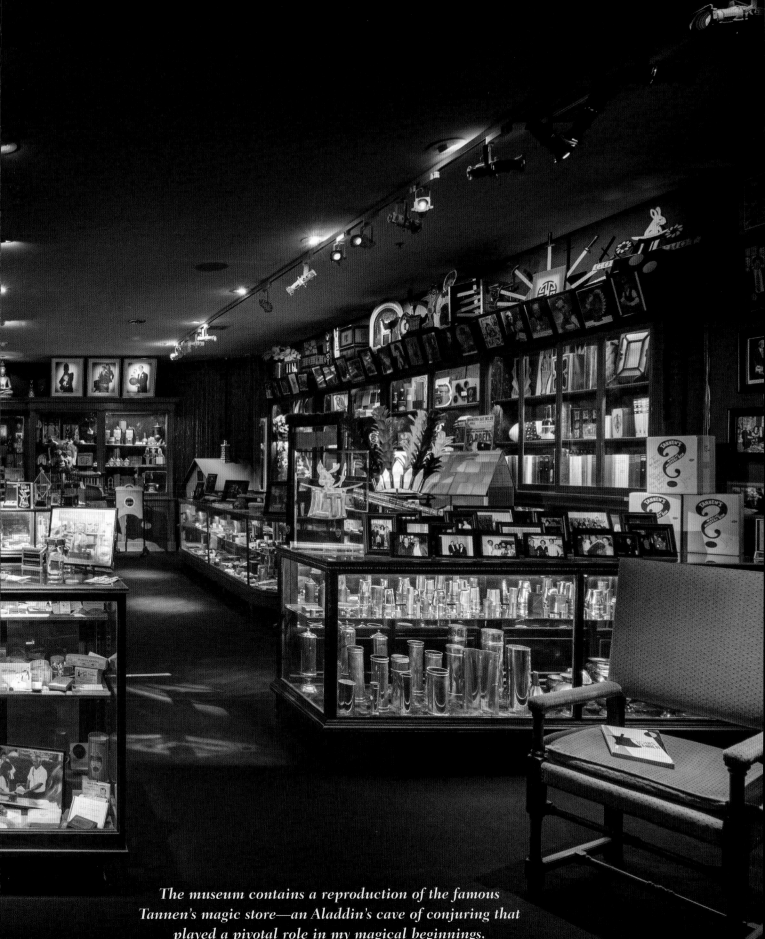

The museum contains a reproduction of the famous Tannen's magic store—an Aladdin's cave of conjuring that played a pivotal role in my magical beginnings.

The exhibit contains all the apparatus that I performed with in my youth, including one of my favorites, the Dancing Cane.

My mother was kind enough to let me go to Tannen's most Saturdays and it became the center of my world. I met Lou and his brother Irv Tannen, hung out with fellow magicians, watched their partner Tony Spina demonstrate illusions, and spent my somewhat limited funds on books and apparatus. The store had a wonderful sense of community and goodwill, and many magicians gave up their time to offer advice and encouragement.

Tony was a great guy and only sold an illusion to a customer if he thought it was within their skill set. One day I asked him if I could buy an illusion called the Dancing Cane, which is

a classic piece of magic, and involves a walking cane rising into the air and flying around. Tony knew that the Dancing Cane was very difficult to perform for a child and so tried to dissuade me from buying it. But I was certain that I could master the moves and insisted on making the purchase. When I returned home with the cane, I discovered that the illusion was indeed far from easy. Nevertheless, I put in hours and hours of practice, and a few weeks later my mother and I returned to Tannen's. I took out a portable cassette tape recorder, pressed Play, and as the music began I performed the illusion in the store. All these years later, I can still remember Irv Tannen being kind enough to tell me that my version of the Dancing Cane was one of the best that he had ever seen. He continued to be very supportive when I started to perform professionally, and recommended me for both television work and live appearances.

I wasn't the only person to find Tannen's a life-changing experience. J. J. Abrams has directed many hugely successful television shows and movies, including *Lost* and some of the best *Star Wars* films. In a recent TED talk, Abrams spoke about having an interest in magic as a kid, visiting Tannen's and buying a Magic Mystery Box. Advertised as "$50 worth of magic for $15," all of the boxes were sealed so that customers never knew what was inside them. The box still sits in Abrams's office and remains unopened. In his talk, Abrams explained that the unopened box has informed his storytelling by reminding him about the power of mystery and imagination.

My museum features a full-sized replica of Tannen's magic store, complete with several original, and, of course, still unopened, Magic Mystery Boxes.

When I am asked about my heroes, I conjure up famous names like Gene Kelly, Fred Astaire, and Frank Sinatra. These amazing artists certainly had a huge impact on my thinking and career. However, I am also enormously grateful to the not-so-well-known magicians who helped shape my formative years, such as the conjurors I met in Tannen's who were kind enough to share their experience and expertise. Similarly, Lou, Irv, Tony, and Danny dedicated their lives to serving both magic and magicians.

Young people are like miniature mystery boxes. Full of hope and possibilities, one day they may have their own show, make astonishing films, or change the world. My re-creation of Tannen's magic store, and Macy's magic counter, celebrates the people who nurture the next generation. The names of these inspirational heroes will probably never appear in lights, but they are deserving of our admiration and gratitude.

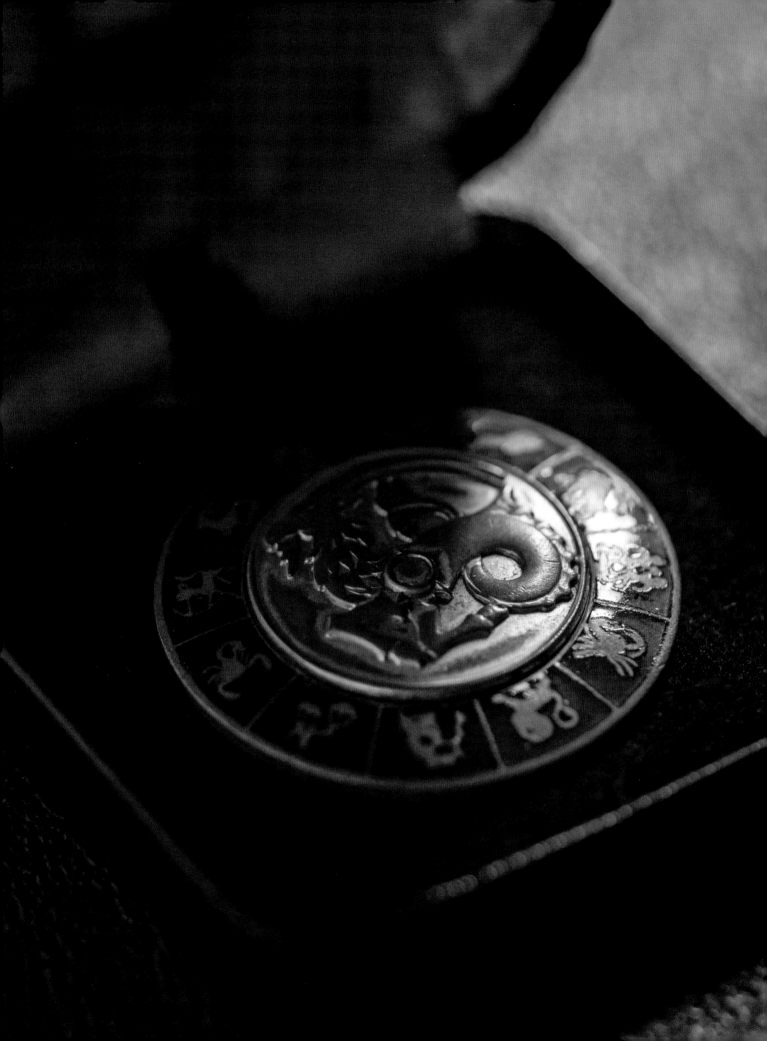

The Magic in Your Mind

�María AL KORAN'S MEDALLION ⬱

This small gold medallion is about two inches in diameter and, unlike many of the objects in my museum, has never appeared, levitated, or vanished. Instead it represents a very different approach to magic, one that involves a curious relationship between reality and illusion.

In 1964, Al Koran was invited to appear on *The Ed Sullivan Show*. Koran asked several members of the audience to help choose a year. The numbers 1, 8, 7, and 2 were selected. Next, he invited a woman onstage, reached into his pocket, and brought out a small medallion engraved on the face with the signs of the zodiac. Koran explained that it was also engraved on the back and asked the woman to read what was written there. The woman turned over the medallion and read out "1872." Koran had predicted the unpredictable and the audience burst into thunderous applause.

Koran's real name was Edward Doe and he was born in London's East End in 1914. Growing up in a working-class family, he first became involved in conjuring when he watched a local street magician, befriended him, and acted as his assistant. Fascinated by the experience, Koran borrowed magic books from his local library, became a skilled sleight-of-hand artist, and started to perform on an amateur basis. After World War II, he trained as a hairdresser and found work in an upmarket London barbershop, but after a few years Koran decided to swap the glamour of the salon for the glitz of show business, and become a professional magician.

In 1949, Koran injured his hand a few weeks before a big show, and so, unable to perform sleight of hand but eager not to lose the booking, he set about creating a completely different act. Striding onstage with his arm in a sling, Koran performed a type of magic that conjurors now refer to as "mentalism." Whereas most magicians conjure with objects, mentalists read minds, influence people, and predict the future. To Koran's total surprise, he obtained a standing ovation. Amazed by the reaction, he decided to carry on conjuring with people's minds.

With his newfound calling, Koran totally transformed his image. Out went the cockney accent and in came a much more measured delivery. Well dressed and neatly groomed, Koran even whitened his hair around the temples to add a touch of dignified mystery.

Deep down, audiences know that magicians can't actually defy the laws of physics. They might experience a moment of astonishment when a performer suddenly seems to perform the impossible, but they always know that they are watching an illusion. However, when people watch a mentalist they might well believe that they are seeing a genuine demonstration of mind power.

THE *Fantastic* KORAN

Al Koran specialized in reading minds and predicting the future.

Some mentalists play on this uncertainty by claiming to possess paranormal powers. However, in doing so, they are open to accusations of unethical behavior and possible exposure. Indeed, in the late 1940s, one of Koran's peers, British mentalist Maurice Fogel, claimed to possess genuine telepathic powers but had his career shattered when a skeptical journalist revealed that it was all trickery.

Other mentalists adopt a more ambiguous approach. For instance, whenever the great American mentalist Joseph Dunninger was asked to explain his astonishing feats, he would declare: "For those who believe, no explanation is necessary. For those who do not, none

will suffice." Koran adopted a similar stance by either avoiding the question ("this is the nearest approach to mind reading that you will ever witness in your life") or coming up with a pseudo-psychological explanation that might involve intuition, enhanced sensory acuity, or a deep understanding of human behavior. Often these explanations were bunkum, but they helped convince audiences that they were watching a genuine demonstration of the extraordinary.

Long before cell phones, Al Koran used this futuristic-looking spy communicator to reveal words chosen by spectators, including a twelve-year-old me.

Koran's first break came in 1954 when he appeared on BBC television. Asked to make a prediction, he paused, then wrote something on a five-pound note, folded the note up, and sealed it in a jar. A few days later the jar was opened and viewers discovered that he had predicted the outcome of a major horse race run earlier that day. When asked how he had managed to pick the winners, Koran claimed it was just a hunch. He quickly became one of the most sought-after mentalists of his era, touring British theatres and even having his own television series. Billed as "The World's Greatest Mind Reader," he performed for Winston Churchill, Queen Elizabeth, and Princess Grace of Monaco.

Throughout the history of magic, mentalists have produced books, pamphlets, and courses that claim to help people to improve their lives. In the mid-1960s, Koran upheld this long-standing tradition by lending his name to a self-help book. *Bring Out the Magic in Your Mind* extolled the virtues of positive thinking and visualization across a surprisingly wide range of topics, including health, wealth, love, friendship, change, fear, luck, and happiness. The book wasn't afraid to stretch the truth, such as claiming that Koran had exhibited "extra-sensory instincts" from a young age, had studied yoga under a Tibetan monk, and had baffled Albert Einstein (there is no evidence that he ever met the great physicist). Nevertheless, the public warmed to the idea of bringing out the magic in their minds and the book proved hugely successful.

I met Al Koran when I was just twelve years old. I attended a magic convention, went to see him perform, and he invited me up onstage to help out. I randomly chose a phrase from a newspaper and Koran then took a strange kind of futuristic communication device out of his pocket. At the time a popular television program called *The Man from U.N.C.L.E.* featured secret agents using tiny pocket radios concealed in cigarette packets and pens. Mimicking one of the well-known catchphrases from the show, Koran spoke into his communication device and asked to "Open Channel D." A mysterious voice answered and revealed my chosen phrase! I am delighted that Koran's mysterious communicator now sits in my museum.

In 1969, Koran moved to America but shortly afterward he became seriously ill. He was much loved within the magical community; his fellow conjurors raised funds to help cover his medical costs but sadly he died from cancer in 1972 at the age of just fifty-eight.

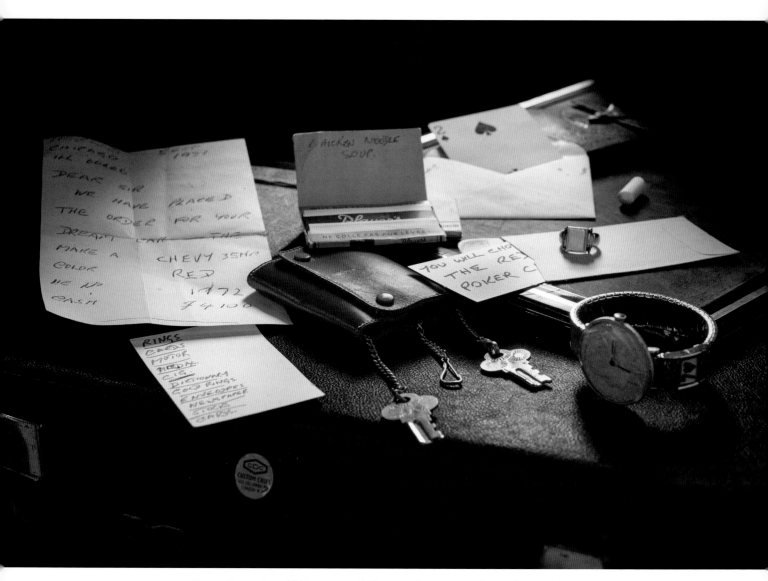

*Everything that Al Koran needed to perform a two-hour show of magic
and mind reading could be contained in a small briefcase.*

Koran had gone from a life of poverty in London's East End to international stardom, and appeared to genuinely believe in the power of positive thinking. He often carried with him a list of all the things he had yet to achieve in his career, and one of them was to appear onstage at the London Palladium. His friend the magician Billy McComb knew this and so when Koran was cremated he took some of the ashes with him to London and while there visited the famous theatre. He managed to get onstage and sprinkled some of the ashes there just before the curtain went up.

When I embark on a tour I take several trucks full of equipment with me. Amazingly, Koran could perform a two-hour show carrying everything in a small suitcase. That suitcase is now in my museum and contains the tools of his trade, including two school slates, a dictionary, a leather key case, and, of course, his gold medallion. Night after night Koran showed audiences the zodiac signs on the front of his medallion and then turned it around to reveal a miraculous prediction. Spectators may have believed that it was genuine precognition, amazing intuition, or psychology at work. As such, Koran's medallion symbolizes how mentalists differ from mainstream magicians. While mentalists hide illusions to create the experience of an extraordinary reality, magicians hide reality to create the experience of an extraordinary illusion.

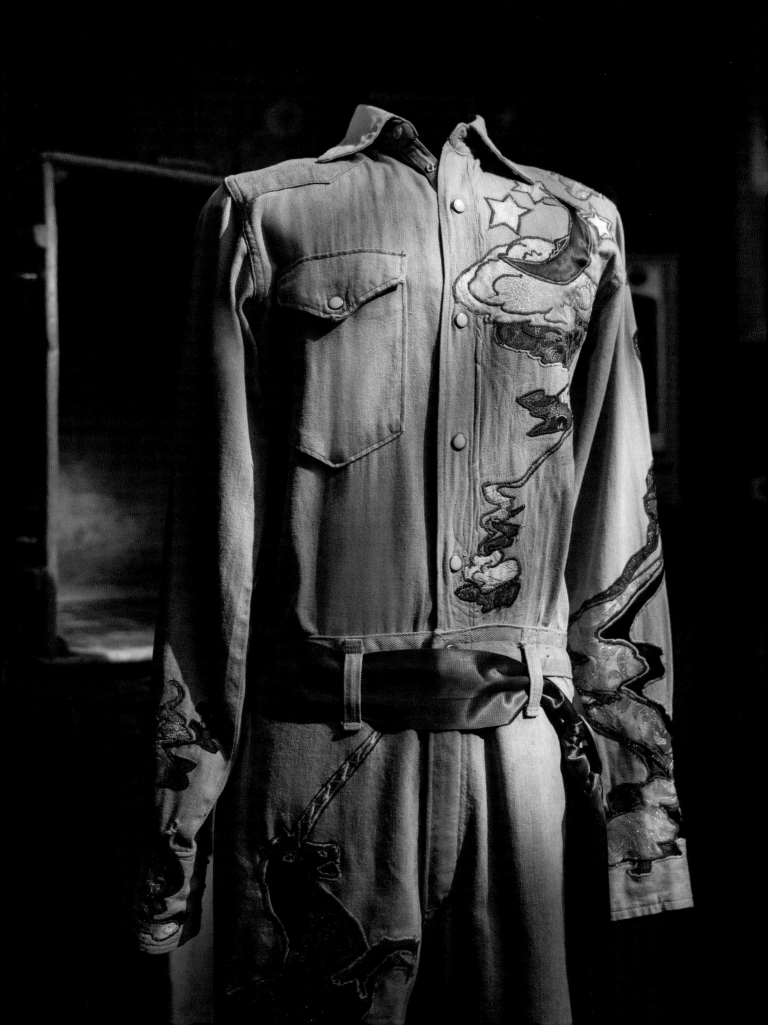

The Magician Who Believed in Real Magic

⋙ DOUG HENNING'S COSTUME AND METAMORPHOSIS TRUNK ⋘

This costume and trunk belonged to a magician who dedicated his life to sharing wonder. He developed a unique performing style, wove a powerful spell over the public, and desperately wanted everyone to experience the power of magic.

During the 1950s, *The Ed Sullivan Show* was a national institution. Every Sunday, families across America gathered around their television sets to watch the genial host introduce a colorful cast of musicians, comedians, circus acts, and magicians. Ed Sullivan had the power to propel performers on to fame and fortune, and in October 1956, Peruvian illusionist Richiardi Jr. appeared on the show. More than a thousand miles away in Ontario, a boy named Doug Henning watched the program and asked his mother how Richiardi was able to perform such incredible feats. Henning's mother explained that it was magic, and a few moments later her son asked whether he too could become a magician. Unbeknownst to everyone, *The Ed Sullivan Show* had just launched another performer on the pathway to stardom.

Inspired by Richiardi, Henning learned a handful of tricks, donned a magical cape (actually a bathrobe), and began performing shows for his relatives. Growing ever more confident, he rebranded himself "The Astounding Hendoo" and ran ads in local newspapers ("Magician: Have Rabbit, Will Travel"). In his early twenties, Henning moved to Toronto to study psychology and began performing in local coffee shops. Influenced by 1960s hippiedom, he flew in the face of formality and appeared onstage sporting shoulder-length hair, jeans, and a T-shirt.

Henning won a government award to pursue his passion for conjuring (Thesis: Magic + Theatre = Art) and studied with some of the world's greatest magicians, including the legendary Dai Vernon. Then, encouraged by the success of the Broadway hit *Hair,* he took the unconventional step of putting together a magic-based musical. *Spellbound* opened in Toronto in 1973 and was produced and directed by his college friend Ivan Reitman (*Ghostbusters*), written by David Cronenberg (*The Fly*), and included music by Howard Shore (*The Lord of the Rings*). Henning took the lead role, and appeared onstage in his trademark hippie garb and looking genuinely astonished at the magic that was happening around him. Audiences instantly warmed to his impish charm, childlike innocence, and look of wonder. The show featured a classic illusion known as Metamorphosis, in which an assistant ("Maya, the Goddess of Illusion") was locked in a trunk and magically changed places with him. The illusion became a key part of Henning's stage shows, and his costume and Metamorphosis trunk now take pride of place in my museum.

*Doug Henning was fascinated by the existence of
genuine magic. He studied Transcendental Meditation™
and intended to create a theme park dedicated to wonder.*

Spellbound formed the basis for Henning's follow-up musical, *The Magic Show,* and even
though many producers were convinced that the public wouldn't support a large-scale magic
show, he again defied convention by opening on Broadway and running for a remarkable four
and a half years. Henning also broke down barriers in the world of television. In the early
1970s, magicians appeared on the small screen in relatively short guest spots, but Henning's
success on Broadway led NBC to build an entire television special around him. In 1975
an unprecedented fifty million viewers tuned in to watch the long-haired hippie magician

perform live and risk his life escaping from Houdini's Water Torture Cell. Henning had hit the big time and he spent the next decade staging two more Broadway shows and presenting six more television specials. Then, everything suddenly changed.

Magicians produce miracles for a living and so often tend to be somewhat skeptical about the existence of the supernatural, but not so Henning. Throughout his life, he had been interested in mind power and was especially attracted to the writings of an Indian spiritual leader named Maharishi Mahesh Yogi. The Maharishi had developed a relaxation procedure known as Transcendental Meditation™ and claimed that the technique eventually led to enlightenment, levitation, and invisibility. Henning had frequently used the technique to calm himself down before performances and became a close associate of the mysterious Maharishi. In 1981, Henning and his partner Debby Douillard tied the knot in the "Golden Dome of Pure Knowledge" at the Maharishi International University in Iowa. A few years later, he sold most of his illusions and completely vanished from the world of magic and devoted himself to his spiritual teacher.

Together, Maharishi and Henning decided to create a theme park dedicated to the wonders of nature (working title: Veda Land). According to their ambitious plans, the park would represent Heaven on Earth and include a magic chariot ride that would allow visitors to explore the molecular structure of a rose petal, a corridor of time that would illustrate the entire history of the universe, and a huge forty-two-ton building that would appear to levitate above a lake. For the following decade Henning traveled the world in search of the multimillion-dollar investment needed to transform Veda Land into reality. Unfortunately, logistical problems, combined with a lack of potential donors, meant that Veda Land never materialized. Henning was diagnosed with liver cancer in 1999 and passed away in February 2000, at the age of just fifty-two.

I was fourteen years old when I first met Henning. At the time he was creating *The Magic Show* and we hung out together during rehearsals and discussed magic into the night. There's no doubt that the success of that show helped open the door for me to stage my own large-scale solo shows and television specials.

Throughout his life, Henning questioned what was possible. He swapped the traditional magician's tuxedo for flared trousers, took magic onto Broadway, and pioneered television

Doug Henning used this trunk to perform the classic
Metamorphosis illusion in his Broadway show.

*Doug Henning was noted for his colorful costumes and flower child persona—
all part of his mission to help spectators recapture their sense of wonder.*

specials, always working hard to inspire a sense of innocence and wonder. To some, Henning's shift to create his overly ambitious transcendental theme park appears inexplicable, but he was simply doing what he always did—stretching the boundaries and pursuing his passion. Henning's costume and Metamorphosis trunk are a tribute to a performer who had a deep understanding of illusion and yet still believed in real magic.

On the Shoulders of Giants

⋙ DAVID COPPERFIELD'S DEATH SAW ⋘

I have performed this illusion all around the world, and it embodies the motivation and thinking behind my entire museum.

It all begins as an escape.

I lie on a table, secured in place by two metal restraints around my torso and one around my neck. Then a box is locked around my body, with my hands reaching out from holes in one end and my feet reaching out from the other. My hands are placed in stocks and my feet are shackled. There appears to be no way to free myself.

The box, shackles, and locks are not all I have to contend with. High above the box is a large circular saw. A clock beside the apparatus begins to tick, the hand counting down the seconds as the rotating saw begins to slowly descend toward the box. I have exactly one minute to escape.

I manage to release my hands from the stocks. I break open the box and the sides fall open around me. Next, I manage to pick the lock that secures the neck stock, but the metal restraints around my body still pin me to the table. I turn to see that the large spinning blade is now inches away from my body. Suddenly, disaster strikes. Sparks fly as the saw malfunctions and quickly descends, severing my body in two. The audience is shocked as I lie motionless on the table.

I slowly regain consciousness. I raise my head, and my assistants slowly separate the two sections of the table and move them to opposite sides of the stage. The two halves of my body are still shackled but are now a considerable distance apart. Someone in the audience shouts "move your feet," and I look across the stage and wiggle each foot.

Clearly, I need to find a way out of this difficult situation. I gesture toward the clock. The hand on the clock moves backward and time begins to reverse itself. The two halves of the table come together and reunite my body, and the box reassembles itself around me. The saw begins to spin in reverse, then moves upward and returns to its start position. Soon everything is exactly as it was and I stand up on the table, whole and restored.

Like so many of my creations, The Death Saw was born from a desire to both elevate the art of magic and invent the greatest illusion possible. For me, this often involves focusing on the themes, symbolism, and situations that truly resonate with audiences. At one level, the Death Saw reflects humanity's enduring fascination with the possibility of returning from the dead. Perhaps most important of all, spectators can easily imagine themselves facing adversity, and so they develop an empathic and emotional connection with me as I perform each stage of the illusion.

Whenever I create a new illusion, I attempt to maximize the impact of every part of the performance. For decades magicians had sawed their assistants in half, but I believed that the illusion would be even more dramatic if I were the one subjected to the sawing. Also, the illusion often aroused suspicion because the assistant was usually placed into a box and the separation of two halves of the box post-sawing was often somewhat less than convincing. I wanted my version to be performed without the box, and my upper and lower torso to continue to move, despite being separated by several feet. In addition, many

My goal is to involve themes that resonate with audiences. The Death Saw reflects humanity's enduring fascination with immortality.

previous sawing illusions lacked drama because the plot and outcome were clear from the outset and the restoration felt like a predictable finale. To create a more dramatic scenario, the Death Saw is originally presented as an escape but suddenly transforms into the sawing in half when the giant steel blade unexpectedly comes crashing down. However, for a while I did not know how to resolve the story of the escape that goes wrong, and how to get from the accidental dissection to the restoration. Archimedes had his eureka moment

Magic can bring dreams to life. During my Flying illusion I defy gravity and glide through the air. It's a dream we have all shared.

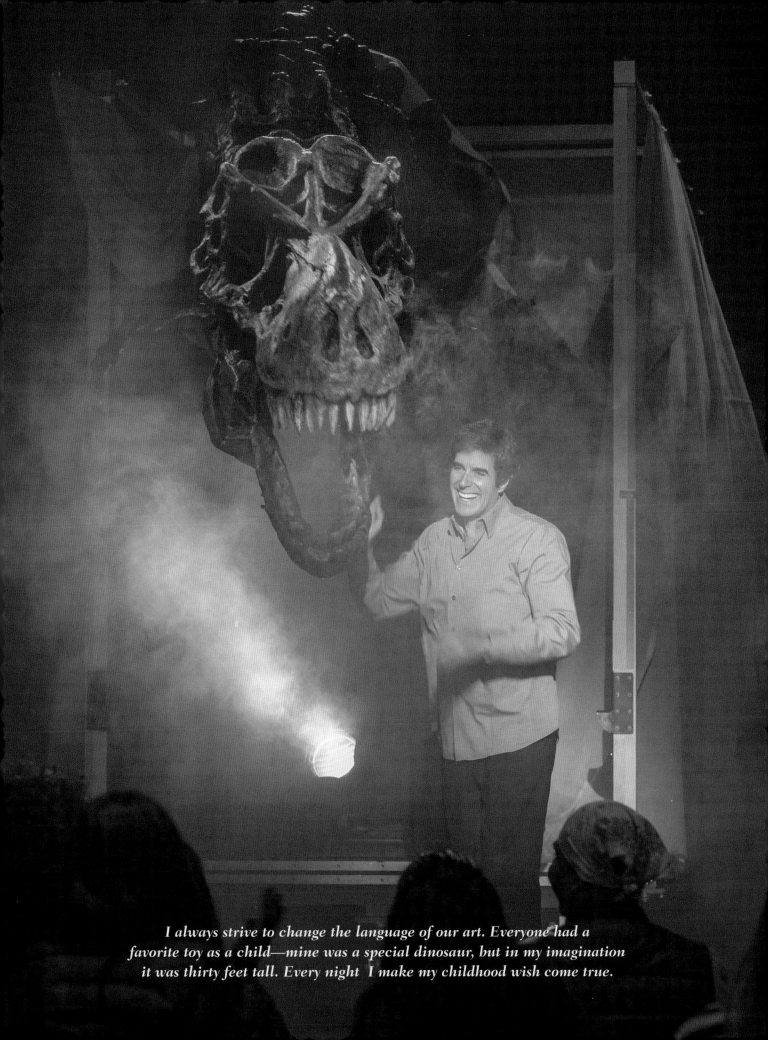

I always strive to change the language of our art. Everyone had a
favorite toy as a child—mine was a special dinosaur, but in my imagination
it was thirty feet tall. Every night I make my childhood wish come true.

in the bath; I had mine in the shower. That's when I realized that magically turning back time would be a unique way of adding one final layer and bringing the performance to a dramatic conclusion.

Transforming this magical dream into reality was far from easy. As a child I used to go to my local library, find the conjuring books, and read all the magical effects. Back then, I would try to figure out several ways in which the illusions could have been achieved before turning the page and discovering the method described in the book. All these years later, I still go through the same process whenever I create a new illusion. However, nowadays, it's a complex and time-consuming procedure that involves exploring many possible solutions, enduring the deep disappointment of dead ends, and overcoming endless obstacles.

During each journey, I collaborate with many wonderful engineers and experts, and often create new methods and technology in the process. I am especially honored be able to draw inspiration from a very special group of people. When asked about his astounding achievements, the great British scientist Sir Isaac Newton once famously remarked that he had seen so far because he had stood on the shoulders of giants. To Newton, every generation builds upon the work of their predecessors and exactly the same applies to magic.

Many past masters of magic devoted years of their lives to developing and performing versions of the sawing-in-half illusion. As we have discovered during our time together, Selbit's original version of the illusion was elegant, Dante popularized the idea of separating the two halves of the victim in a box, Goldin was the first to use a buzz saw, and Richiardi Jr. injected his trademark theatricality. I had to figure out how perform The Death Saw without boxes and with a convincing separation of my upper and lower torso, and I was inspired by the hard work and invaluable experience of these wonderful magicians. Similarly, when I had the idea to present The Death Saw as an escape, it was a tip of the hat to escape artists like Houdini. I have performed The Death Saw on stages around the world, and when the members of the Magic Circle were asked to vote on the greatest illusions of all time, The Death Saw took first place.

The same approach lies behind many of the illusions that I have developed over the years. Each time I have started with a blank piece of paper and worked hard to make the best possible version of whatever illusion I am trying to create.

Great magicians like John Nevil Maskelyne, Harry Kellar, and Howard Thurston had

Every night I share the stage with BLU32, a tech-savvy, time-traveling alien from outer space!

In this groundbreaking creation, a twenty-ton spaceship appears from nowhere over the heads of the audience and flies through the theatre.

levitated their assistants high into the air, and their work laid the foundation for my illusion—Flying. Whereas previous versions of the illusion have involved someone floating up and down, it was never something that really resonated with people's needs and desires. Although people rarely dream about a magician making them levitate, they frequently imagine how wonderful it would feel to fly through the air. I wanted to create an illusion that matched these amazing dreams and allowed people to witness a moment of magic that's been in their hearts since childhood. I believed that audience members watching such an illusion would picture themselves in the same situation and, in doing so, both fulfill a personal desire and feel inspired. During the illusion, I fly across the stage and even dance in midair. While other performers had passed a hoop over their levitating assistant, I have two spinning hoops placed around me when I am in airborne, and then continue to fly despite being placed into a sealed clear acrylic box. At the finale of the piece, I pick up an audience member and fly with her in my arms. Once again, the entire creation process was to invent something brand-new that would take the art of magic to the next level.

Magicians regularly go into boxes and disappear. However, in my Portal illusion I perform the vanish on an extremely thin platform, cantilevered high over the audience. Spectators can see above, below, and to the sides of the platform, and yet I still disappear over their heads in the blink of an eye. Not only that, but I then appear to teleport across continents to a Bahamas beach. It is a crazy idea that took my team and me more than three years to transform into reality.

For hundreds of years magicians have conjured up objects from thin air. Each night in my show I use new techniques and technology to elevate this aspect of the art, performing a series of amazing appearances that include a time-traveling alien, a flying spaceship that is half of the size of the theatre, and a giant thirty-foot *T. rex*.

Finally, all of my performances are also a tribute to the many people who have nurtured and inspired me over the years. When I first started out, the magicians frequenting Tannen's magic store were kind enough to share their wisdom, expertise, and companionship. Later on, legendary magicians like Channing Pollock encouraged me to set the bar high, work hard, and always strive for perfection. And throughout it all, I benefited from the tallest and most supportive giants of all, my parents. Each time I take visitors through the replica of my

father's clothing store I am reminded of how they nurtured my passion for magic and loved me into being.

Seen in this way, The Death Saw is perhaps the perfect symbol for the motivation behind my museum. Throughout history, a small band of mavericks, outsiders, and eccentrics have, by pursuing their passion, shaped the history of magic. During the 1800s, the great French conjuror Robert-Houdin helped to move magic away from the streets and into far more respectable venues. In 1876, the British writer Professor Hoffmann wrote his seminal book *Modern Magic* and gave birth to a new generation of conjurors. During America's golden age of magic, performers like Harry Kellar and Howard Thurston created large-scale touring shows. More recently, the likes of Cardini moved magic into nightclubs, and Doug Henning paved the way for Broadway and television specials.

All of these performers helped to build the foundations for modern-day magic, and their work has inspired me to elevate conjuring to new heights. Magic is a dynamic art form. It changes, adapts, and evolves. Each generation of magicians builds upon the work of their predecessors, and so it's absolutely vital to preserve, cherish, and celebrate the expertise of our past masters.

When I show visitors around the museum I imagine my magical heroes quietly standing in the shadows and listening to my tour. Jean-Eugène Robert-Houdin. John Nevil Maskelyne. Harry Kellar. Howard Thurston. Dante. Harry Houdini. Cardini. Channing Pollock. The list goes on. Through the magic of my museum they continue to help the new generations to conjure up a wonderful future for my beloved art.

I am honored to stand on their shoulders.

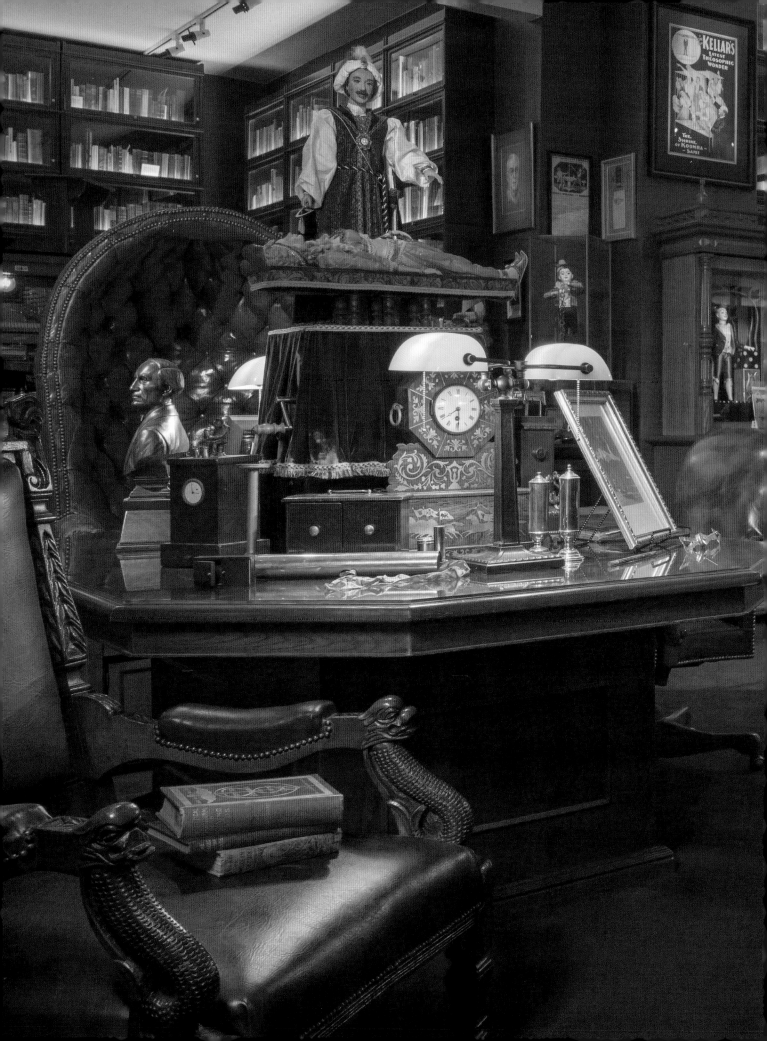

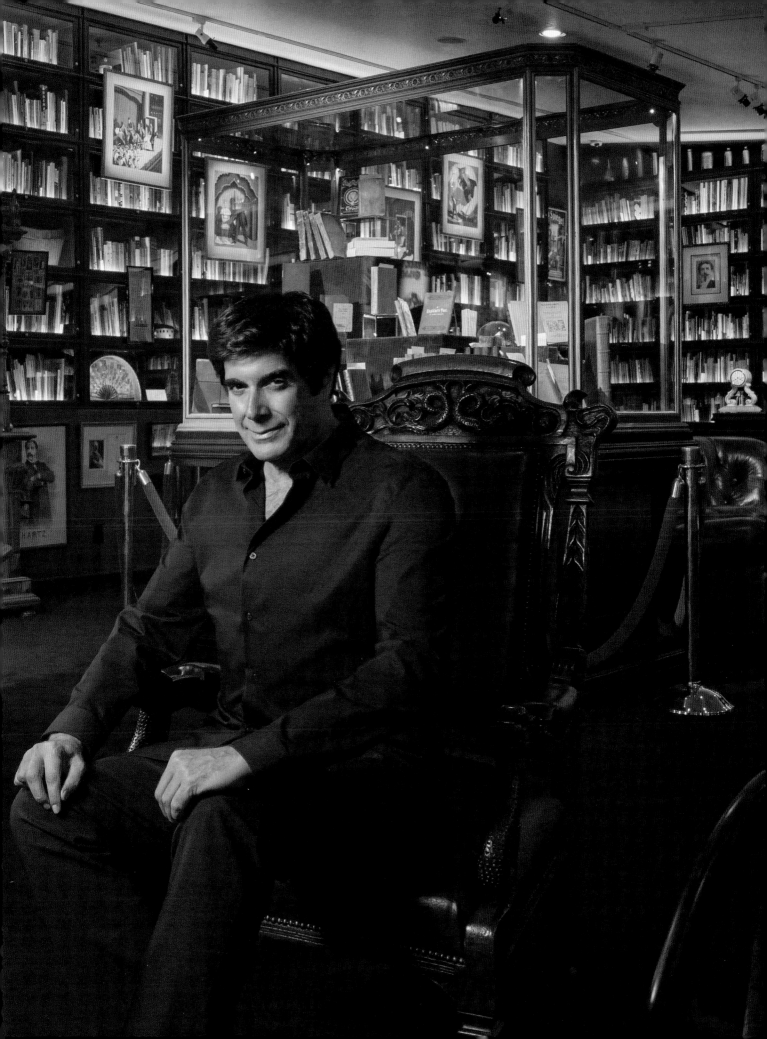

Sources and Further Reading

GENERAL BIBLIOGRAPHY

Alexander, D. (2002). Timeline of Magic and Magicians for the 19th and 20th Centuries. Retrieved from https://geniimagazine.com/timeline/timelineworking.htm.

Caveney, M. (2013). *Mike Caveney Wonders & The Conference Illusions.* Pasadena, CA: Mike Caveney's Magic Words.

Caveney, M., Steinmeyer, J., & Jay, R. (2013). *Magic: 1400s–1950s.* N. Daniel (Ed.). Cologne, Germany: Taschen.

Christopher, M. (1962). *Panorama of Magic.* New York, NY: Dover.

Christopher, M. (1973). *The Illustrated History of Magic.* New York, NY: Thomas Y. Crowell.

Clarke, S. W. (1924–28/1983). *The Annals of Conjuring: The Greatest Historical Work on Conjuring with a New Comprehensive Index by Bob Lund.* New York, NY: Magico Magazine.

Dawes, E. A. (1979). *The Great Illusionists.* Secaucus, NJ: Chartwell Books.

Fisher, J. (1987). *Paul Daniels and the Story of Magic.* London, England: Jonathan Cape.

Lamb, G. (1976). *Victorian Magic.* London, England: Routledge and Kegan Paul.

Lamont, P., & Steinmeyer, J. (2018). *The Secret History of Magic: The True Story of a Deceptive Art.* New York, NY: Tarcher Perigee.

Steinmeyer, J. (2003). *Hiding the Elephant: How Magicians Invented the Impossible and Learned to Disappear.* New York, NY: Carroll & Graf.

Whaley, B. (2007). *Encyclopedic Dictionary of Magic.* (3rd ed). Lybrary.com.

CHAPTER 1: SECRETS OF THE CONJURORS REVEALED

Information about Reginald Scot and *The Discoverie of Witchcraft* was drawn from various sources, including:

Almond, P. C. (2014). *England's First Demonologist: Reginald Scot and "The Discoverie of Witchcraft."* London, England: I. B. Tauris.

Bercovice, K. (2015). "Reginald Scot and King James I: The Influence of Skepticism." *Mount Royal Undergraduate Humanities Review 3*, doi:https://doi.org/10.29173/mruhr212.

Davies, S. F. (2013). "The Reception of Reginald Scot's Discovery of Witchcraft: Witchcraft, Magic, and Radical Religion." *Journal of the History of Ideas, 74*(3), 381–401.

Forrester, S. (2000). *The Annotated Discoverie of Witchcraft Booke XIII.* Alberta, Canada: Published by the author.

Additional comments and information were kindly provided by Professor Owen Davies.

CHAPTER 2: THE PASTRY CHEF

Robert-Houdin wrote a fascinating autobiography that details his remarkable life. Although the veracity of some of the stories in the book have been questioned by historians, it remains a fascinating read:

Robert-Houdin, J. E. (1860). *Memoirs of Robert-Houdin.* London, England: Chapman & Hall.

Many of the details in this section were drawn from two seminal texts about Robert-Houdin's remarkable life and inventions:

Fechner, C. (2002). *The Magic of Robert-Houdin: An Artist's Life.* Boulogne, France: Editions F.C.F. (distributed by Miracle Factory).

Karr, T. (Ed.). (2006). *Essential Robert-Houdin.* Los Angeles, CA: Miracle Factory.

Some of the details about the technology incorporated into Robert-Houdin's home are described in:

Smith, W. & Lewi, H. (2008). "The Magic of Machines in the House." *Journal of Architecture, 13*(5), 633–660.

Both Michael Start and Todd Karr also kindly provided additional information and comments.

CHAPTER 3: PRESTIDIGITATION AND THE PRESIDENCY

Information about the life and work of Wyman the Wizard was drawn from several sources, including:

Campbell, L. (1947). "Three Famous American Magicians." *Sphinx, 46*(3), 82.

Charvet, D., & Howard, A. (2008). "Presidential Prestidigitators." *Magic Magazine, 18*(3), 46–53.

Clarke, K. (1918). "The Story of the Gift Shows." *M.U.M., 7*(58), 1–8.

Evans, H. R. (1934). "From Puppetry to Prestidigitation." *Linking Ring, 8*, 649–652.

Houdini, H. (1919). "Wyman the Wizard: One of the Financially Successful Magicians of the Historic Gift Show Era." *M.U.M.*, 8(72), 1–2.

Mulholland, J. (1945). "Wyman the Wizard." *Sphinx*, 44(1), 11–16.

Information about the remarkable life of Harry Cooke was drawn from the following articles:

Cannon, M. (2005). "Harry Cooke: American's First Escape Artist?" *M.U.M.*, 94(9), 39, 46.

Cannon, M. (2006). "Harry Cooke: American Wizard." *M.U.M.*, 95(11), 63–69.

"Death of Magician Recalls War Tales." *New Castle News*, Pennsylvania, August 4, 1924, p. 11.

"Magician Who Knew Lincoln Dies in West." *Kokomo Tribune*, Indiana, July 18, 1924, p. 3.

For a more sceptical view of Harry Cooke's claims, see:

Perovich, M. A. (2019). "The Redoubtable Harry Cooke." *Ye Olde Magic Mag*, 5(4), 187–193.

Chapter 4: Will, the Witch, and the Watchman

Information about Maskelyne was drawn from several sources, including:

Barnouw, E. (1981). *The Magician and the Cinema*. Oxford, England: Oxford University Press.

Dawes, E. A. (1998). "England's Original Home of Mystery." *Magic Circular*, 92(986), 148–151.

Fisher, D. (1983). *The War Magician*. New York, NY: Coward-McCann.

Jenness, G. A. (1967). *Maskelyne and Cooke, Egyptian Hall London, 1873–1904*. London, England: Published by the author.

New, C. (2014). Hacking at the Royal Institution. Retrieved from https://www.rigb.org/blog/2014/november/hacking-at-the-royal-institution

Sharpe, S. (1976). *The Magic Play, including Will, The Witch, & The Watchman*. Chicago, IL: Magic Inc.

Steinmeyer, J. (2007). "The Language of Illusion: Will, the Witch, and the Watchman." *Genii*, 70(1), 46–47.

Stokes, R. (n.d.). "Jasper Maskelyne: The War Magician." Retrieved from https://www.maskelyne magic.com.

We would also like to thank John Davenport, Anne Goulden, Mike Caveney, and Richard Stokes for their invaluable comments.

Chapter 5: The Man Who Knows

Much of the information about the life and work of Alexander (including the visit to Alexander's dressing room, him encouraging his assistants to cut passages from library books, the creation of images for calendars, and various brushes with the law) was drawn from the following seminal text:

Charvet, D., & Pomeroy, J. (2004). *Alexander: The Man Who Knows*. Pasadena, CA: Mike Caveney's Magic Words.

We also drew on the following sources:

Alexander, C. (1921). *The Life and Mysteries of the Celebrated Dr. Q.* Los Angeles, CA: Alexander.

Beckmann, D. (1994). *The Life and Times of Alexander, the Man Who Knows.* Rolling Bay, WA: Rolling Bay Press.

Charvet, D. (2007). "Knowing More About 'The Man Who Knows.'" *Magic, 16*(10), 64–67.

Jefferson, V. (1920). "A Spook Party de Luxe." *Magical Bulletin, 8*(4), 54–55.

Nelson, B. (1954). "Claude Alexander Colin (Alexander, the Man Who Knows)." *Linking Ring, 34*(7), 45–47, 110.

Darryl Beckmann kindly supplied additional information.

CHAPTER 6: "P" IS FOR PRIVATE

Information about Hoffmann was based on several sources, including:

Hoffmann, Professor. (1876). *Modern Magic.* London, England: Routledge.

Houstoun, W. (2014). *Professor Hoffmann's Modern Magic: The Rise of Victorian Conjuring* (Doctoral dissertation). University of Essex, Colchester.

Houstoun, W. (2018). "The Grand Cycle of Conjuring Treatises: Modern Magic, More Magic, Later Magic and Latest Magic." *Early Popular Visual Culture, 16*(2), 123–145.

Knight, G. (1896). "Professor Hoffmann and Conjuring." *Windsor Magazine, 4*(4), 362–364.

Dr. Will Houstoun also kindly provided additional details.

CHAPTER 7: THIS IS MY WIFE

Details about the life and work of Buatier de Kolta were based on the following sources:

Braun, J. (1969). "Recollections of Buatier de Kolta." *Linking Ring, 49*(8), 23–27, 92–93.

Braun, J. (1969). "Recollections of Buatier de Kolta." *Linking Ring, 49*(9), 31–39.

Braun, J. (1969). "Recollections of Buatier de Kolta." *Linking Ring, 49*(10), 31–34.

Dawes, E. A. (1984). "The Demise of Buatier de Kolta." *Magic Circular, 78*(847), 125–126.

Findlay, J. B. (1952). *Buatier de Kolta Fourth Collectors Annual.* Isle of Wight, England: Published by the author.

Goldston, W. (1909). "Buatier de Kolta by One Who Knew Him." In, *Magician Annual 1909–1910.* London, England: A. W. Gamage.

Goldston, W. (1912). "Buatier de Kolta—The Expanding Cube Illusion." In, *Exclusive Magical Secrets.* London, England: Magician Ltd.

Lanconn, H. (1953). "Buatier de Kolta." *Magic Wand, 42*(239), 126–129.

Warlock, P. (1993). *Buatier de Kolta, Genius of Illusion.* Pasadena, CA: Magical Publications.

Woolf, M. (2007). Interview with John Gaughan. *Magicana, 54*(323), 22–25.

Additional information and thoughts were kindly supplied by John Davenport, Mike Caveney, and Tom Stone.

CHAPTER 8: WE'RE OFF TO SEE THE WIZARD

For a comprehensive account of Harry Kellar's life, see Mike Caveney's seminal book:

Caveney, M., & Meisel, B. (2003). *Kellar's Wonders.* Pasadena, CA: Mike Caveney's Magic Words.

Additional details about Harry Kellar came from several other sources, including:

Caveney, M. (2003). "The Rise of Harry Kellar." *Magic Magazine, 13*(3), 58–63.

Jarrow, G. (2012). *The Amazing Harry Kellar: Great American Magician.* New York, NY: Calkins Creek.

Kellar, H. (1886). *A Magician's Tour.* Chicago, IL: Donohue, Henneberry.

Mulholland, J. (1939). (Ed.) Issue featuring various articles concerning Harry Kellar, including those by Nate Leipzig, Elmer Ransom, Grant Stuart, Dorny, and Harry Kellar. *Sphinx, 38*(1).

Additional information about the notion that Harry Kellar may have acted as the inspiration for the Wizard of Oz can be found in:

Brown, S. (1984). "Was This the Wizard Who Was the Wizard of Oz?" *Baum Bugle, 28*(1), 1–7.

Gibson, W. B. (1966). *The Master Magicians: Their Lives and Most Famous Tricks.* New York, NY: Doubleday.

Steinmeyer, J. (2003). *Hiding the Elephant: How Magicians Invented the Impossible and Learned to Disappear.* New York, NY: Carroll & Graf.

Our thanks to Mike Caveney, Sarah Crotzer, and Bill Kalush for their additional comments and information.

CHAPTER 9: THE QUEEN OF MAGIC

Many of the details about the life and work of Adelaide Herrmann were drawn from the following:

Henderson, J. (2013). "The Female Illusionist Revealed: Adelaide Herrmann's Expression of Womanhood Through Material Culture, 1869–1928." *Journal of American Drama and Theatre, 25*(2), 37–58.

Herrmann, A. (2011). *Adelaide Herrmann Queen of Magic: Memoirs, Published Writings and Collected Ephemera.* M. B. Steele (Ed.). Putney, VT: Bramble Books.

Steele, M. (2011). "Adelaide Herrmann and the American Society of Magicians." *M.U.M., 100*(12), 44–47.

Our thanks to Margaret Steele for additional comments.

Chapter 10: The Palace of Magic

This section drew on various sources, including:

Brown, G. (1996). "Al Flosso: The Coney Island Fakir." *Magicana, 44*(259), 10–13.

Caveney, M. (2015). "Classic Correspondence from Egyptian Hall Museum: Francis J. Martinka to Clinton Burgess." *Magic Magazine, 24*(10), 12–15.

Evans, H. R. (1931). "A House of a Thousand Memories." *Sphinx, 30*(1), 7–10.

Fajuri, G. (2001). "Martinka's: Much More than a Century." *Magic Magazine, 10*(5), 54–59.

Goodsell, D. (2001). "Founding the S.A.M." *M.U.M., 91*(7), 27–30.

Ransom, E. P., & Mulholland, J. (1935). "The Birthplace of the Society of American Magicians." *Sphinx, 34*(10), 274.

Steinmeyer, J. (2005). *The Glorious Deception: The Double Life of William Robinson, aka Chung Ling Soo, the "Marvelous Chinese Conjurer."* New York, NY: Carroll & Graf.

Vernon, D. (2006). *The Vernon Touch: Writings of Dai Vernon in Genii, The Conjurors' Magazine from 1968 to 1990.* New York, NY: Genii.

William Sargent's lovely poem about Martinka's shop first appeared in:

Sargent, W. (1902). "Martinka's Little Back Shop." *Mahatma, 5*(8), 83.

Our thanks to Gabe Fajuri for additional comments.

Chapter 11: Author Unknown

The literature on Erdnase is vast, and we drew on the following books and articles:

Alexander, D. (2000). "The Magician as Detective: New Light on Erdnase." *Genii, 63*(1), 16–26.

Britland, D., & Gazzo. (2003). *Phantoms of the Card Table.* London, England: High Stakes.

Hatch, R. (1999). "Searching for Erdnase." *Magic Magazine, 9*(4), 67–73.

McDermott, H. (2012). "Artifice, Ruse & Erdnase: The Search for One Who May Not Want to Be Found." Lybrary.com.

Vernon, D. (1984). *Revelations.* Pasadena, California: Magical Publications.

Whaley, B., Gardner, M., & Busby, J. (1991). *The Man Who Was Erdnase.* Oakland, CA: Jeff Busby Magic.

Wiseman, R., & Holmes, D. (2011). "Stylometry and the Search for S. W. Erdnase." *Genii, 74*(2), 70–73.

Our thanks to Richard Hatch for kindly providing additional information and comments.

CHAPTER 12: NOTES ON STEAM ENGINES, PUMPS, BOILERS HYDRAULIC, AND OTHER MACHINERY

Information about Malini's wonderful life and work was drawn from several sources, including:

Ben, D. (2012). "Max Malini: Bigger Than Life." *Genii*, 75(10), 48–71.

Kaufman, R. (Ed.). (1999). "Focus on Malini" (various contributors). *Genii*, 62(11), 23–52.

Vernon, D. (1962). *Malini and His Magic*. L. Ganson (Ed.). London, England: Harry Stanley.

Our thanks to Steve Cohen for kindly providing additional thoughts and comments.

CHAPTER 13: CONDEMNED TO DEATH BY THE BOXERS

For a comprehensive, and wonderful, account of Chung Ling Soo's life, see the seminal book:

Steinmeyer, J. (2005). *The Glorious Deception: The Double Life of William Robinson, aka Chung Ling Soo, the "Marvelous Chinese Conjurer."* New York, NY: Carroll & Graf.

We also drew upon the following sources:

Dexter, W. (1955). *The Riddle of Chung Ling Soo*. London, England: Arco.

Karr, T. (2001). *The Silence of Chung Ling Soo*. Seattle, WA: Miracle Factory.

Lead, B. (2018). "A Deadly Way to Make a Living; The Lamentable Fate of Chung Ling Soo, Marvellous Chinese Conjuror." Thirteen monthly articles in the *Magic Circular*, March 2018 to March 2019.

For a comprehensive discussion of Chung Ling Soo and Orientalism, see:

Goto-Jones, C. (2016). *Conjuring Asia: Magic, Orientalism and the Making of the Modern World*. Cambridge, England: Cambridge University Press.

For additional information about those who have lost their lives to magic, see:

Jay, J. (2010). "Tragic Magic." *Gibeciere*, 5(2), 71–129.

Robinson, B. (1986). *Twelve Have Died*. Watertown, MA: Ray Goulet Magic Art Book Company.

Brian Lead, Mike Caveney, and Chris Goto-Jones kindly provided additional information and comments.

CHAPTER 14: ESCAPING MORTALITY

Houdini's life and work have been described in a large number of books, including the following seminal texts:

Kalush, W., & Sloman, L. (2006). *The Secret Life of Houdini: The Making of America's First Superhero*. New York, NY: Atria Books.

Posnanski, J. (2019). *The Life and Afterlife of Harry Houdini*. New York, NY: Avid Reader Press.

Silverman, K. (1996). *Houdini!!! The Career of Ehrich Weiss*. New York, NY: HarperCollins.

Houdini's life and work are comprehensively covered on John Cox's wonderful website: https://www.wildabouthoudini.com.

In addition to these sources, we also drew upon:

Brandon, R. (1993). *The Life and Many Deaths of Harry Houdini*. New York, NY: Random House.

Gresham, W. L. (1959). *Houdini: The Man Who Walked Through Walls*. New York, NY: Henry Holt.

Tait, D. (2017). *Houdini: The British Tours*. Barnsley, England: Pen & Sword Books.

Taylor, R. P. (1985). *The Death and Resurrection Show: From Shaman to Superstar*. London, England: Anthony Blond.

John Cox, Derek Tait, and Bill Kalush also kindly provided additional information and comments.

Chapter 15: The Magician Who Made Himself Disappear

Thurston's work is wonderfully described in the following seminal text:

Steinmeyer, J. (2011). *The Last Greatest Magician in the World: Howard Thurston Versus Houdini & the Battles of the American Wizards*. New York, NY: Penguin.

We also drew on the following sources:

Caveney, M. (2011). "Classic Correspondence from Egyptian Hall Museum: Floyd Thayer to Howard Thurston." *Magic Magazine, 20*(12), 12–15.

Steinmeyer, J. (1991–1992). *Howard Thurston Illusion Show Workbooks Volumes 1 & 2*. Pasadena, CA: Magical Publications.

Steinmeyer, J. (2005). "The Language of Illusion: The Disembodied Princess." *Genii, 68*(11), 26–27

Temple, P. (1981). *Thurston and Dante—The Written Word*. [N.p.]: Phil Temple.

Thurston, H., Shepherd, J. T., Temple, P., & Olson, R. E. (1989). *Our Life of Magic*. [N.p.]: Phil Temple.

The wonderful story of Thurston cueing the boy during his levitation illusion is described in:

Steinmeyer, J. (2003). *Hiding the Elephant: How Magicians Invented the Impossible and Learned to Disappear*. New York, NY: Carroll & Graf.

Mike Caveney also kindly supplied additional comments and information.

Chapter 16: Lighter Than Air

Information about Okito was drawn from several sources, including:

Albo, R., Lewis, E., & Bamberg, D. (1973). *Oriental Magic of the Bambergs*. San Francisco, CA: San Francisco Book Company.

Bamberg, D. (1988). *Illusion Show: A Life in Magic*. Glenwood, IL: David Meyer Magic Books.

Okito. (1921). *Quality Magic*. London, England: Will Goldston.

Okito. (1952). *Okito on Magic: Reminiscences and Selected Tricks*. Chicago, IL: Edward O. Drane.

Okito. (1955). "A Short Autobiography," *M.U.M.*, 45(4), 152–55.

Teale, O. (1909). "The Bambergs: Six Generations of Magicians." *Sphinx*, 8(6), 112–115.

Information about David Abbott's life and thinking can be found in the following seminal work:

Teller, R., & Karr, T. (2005). *House of Mystery: The Magic Science of David P. Abbott*. (Vol. 2.) Los Angeles, CA: The Miracle Factory.

Chapter 17: Divided

For a detailed analysis of Selbit's sawing illusion, including the historical context, see:

Steinmeyer, J. (2006). *Art and Artifice: And Other Essays of Illusion*. New York, NY: Carroll & Graf.

Additional information about Selbit was drawn from the following sources:

Lewis, E., & Warlock, P. (1989). *P. T. Selbit: Magical Innovator*. Pasadena, CA: Magical Publications.

Steinmeyer, J. (2003). *Hiding the Elephant: How Magicians Invented the Impossible and Learned to Disappear*. New York, NY: Carroll & Graf.

The section about the life and work of Dante was based on several sources, including:

Andrews, V. (1978). *Goodnight Mr Dante*. Bromsgrove, England: Goodliffe.

Furst, A. (1957). "Dante: A Review of His Show at the Biltmore Theatre, 1941." *Famous Magicians of the World*. Los Angeles, CA: Genii.

Dante Memorial Issue, with contributions by Arnold Furst, Ray Muse, and David Price., 21(3).

Ray, J. (1993). *We Remember Dante*. Madison, WI: Northpointe.

Temple, P. (1981). *Thurston and Dante—The Written Word*. [N.p.]: Phil Temple.

Trikosko, M. S. (2006). *Trouping with Dante: Travels with Dante's Sim Sala Bim in the Golden Age of Big Illusion Shows*. Chicago, IL: Squash.

The information concerning Moi-Yo Miller asking potential assistants about their head size was based on information from Stan Jarin.

Mike Caveney, Stan Jarin, and Charisse Kininmonth also kindly supplied additional comments and information.

Chapter 18: Free Rabbits

The information in this section was drawn from several sources, including:

Furst, A. (1957). "Blackstone: A Review of His Show at the Biltmore Theatre, 1947." In *Famous Magicians of the World*. Los Angeles, CA: Genii.

Johnstone, G. (1965). "The Great Blackstone." *New Tops*, 5(12), 8–9.

Johnstone, G. (1993). "The Story behind the Story." *Magic Magazine*, 2(4), 40–42.

Lund, R. (1965). (Ed.). "An Affectionate Salute to Harry Blackstone" (various contributors). *Genii, 30*(1), 18–35.

Waldron, D. (1999/2013). *Blackstone: A Magician's Life*. Chicago, IL: David Meyer Magic Books.

Our thanks to Gabe Fajuri for additional comments.

CHAPTER 19: THE SUAVE DECEIVER

A comprehensive and fascinating account of Cardini's life is described in the seminal book:

Fisher, J. (2007). *Cardini: The Suave Deceiver*. Los Angeles, CA: Miracle Factory.

In addition, we also drew on the following sources:

Ball, B. (1995). "Paging . . . Mr Cardini!" *Magic Magazine, 5*(4), 56–70.

Zolotow, M. (1945). "Richard Cardini." *Conjurors' Magazine, 1*(9), 9–11.

John Fisher kindly supplied additional information and comments.

CHAPTER 20: THE HUMAN INDEX

The information in this section was drawn from several sources, including:

Anon. (1920). "Arthur Lloyd: The Human Card Index." *Magic World, 4*, 91.

Jay, R. (1986). *Learned Pigs & Fireproof Women: A History of Unique, Eccentric & Amazing Entertainers*. London, England: Robert Hale.

Miller, C., & Wilson, R. (n.d.). *Charlie Miller and Ron Wilson Proudly Present Their Card Index*. Chicago, IL: Magic Inc.

CHAPTER 21: IF THEY DON'T KNOW YOU, THEY CAN'T BOOK YOU

Dell O'Dell's life and work are comprehensively described in the seminal text:

Claxton, M. (2014). *Don't Fool Yourself: The Magical Life of Dell O'Dell*. Chicago, IL: Squash.

In addition, we drew on the following sources:

Claxton, M. (2014). "Rethinking Dell O'Dell." *Magic Magazine, 24*(3), 46–51.

O'Dell, D. (c. 1940s). *Dell O'Dell: An Interesting Glimpse at What Takes Place Behind the Curtain*. Advertising brochure published by Dell O'Dell.

O'Dell, D. (c. 1940s). *Presenting Dell O'Dell Queen of Magic*. Advertising brochure published by Dell O'Dell.

O'Dell, D. (1940–). "The Lady Looks Around." Columns by Dell O'Dell in *Tops* magazine. First column in 5(8).

O'Dell, D. (1942–). "Dell-Lightfully." Columns by Dell O'Dell in *Linking Ring* magazine. First column in 22(5).

Sobanski, J. (2007). "Dell O'Dell, 'The Queen of Magic.'" *M.U.M.,* 97(3), 68–71.

Michael Claxton and Chuck Jones also kindly provided additional information and comments.

CHAPTER 22: IN PURSUIT OF PERFECTION

The information about Channing Pollock was drawn from the following sources:

Burton, L., & Pollock, C. (2006). "Channing Pollock . . . in His Words." *Magic Magazine, 15*(9), 51–53.

Morrall, J. (2007). "The Channing Pollock Story." Retrieved from http://www.halfmoonbaymemories.com/2007/02/16/the-channing-pollock-story/.

Nielsen, N., et al. (2006). Channing Pollock . . . In His Friends' Words." *Magic Magazine, 15*(9), 54–57.

Thompson, J., et al. (2006). "Channing Pollock Remembered 1926–2006." *Genii, 69*(5), 51–73.

James Dimmare kindly provided additional comments.

CHAPTER 23: BLOOD ON THE CURTAIN

The information about Richiardi was drawn from the following sources:

Levent. (2016). "The Legendary Richiardi Jr." *Magic Magazine, 25*(6), 44–51.

Pit, P. (1985). "Richiardi—The Man—His Magic." *Genii, 49*(4), 245–250.

Levent Cimkentli kindly provided additional comments and information.

CHAPTER 24: THE MAN WHO FOOLED HOUDINI

A large amount of literature has been written about Vernon, and we drew on the following sources:

Cervon, B., & Burns, K. (1992). *The Vernon Chronicles Vol IV—He Fooled Houdini.* [N.p.]: L & L.

Ganson, L. (1956). *The Dai Vernon Book of Magic.* London, England: Harry Stanley.

Kaufman, R. (2006). *The Vernon Touch.* Genii Corporation.

Minch, S. (1987–92). *The Vernon Chronicles.* Vols. 1 to 4. [N.p.]: L&L.

Perovich, M. A. (2018). *The Vernon Companion.* Seattle, WA: Hermetic Press.

Max Maven kindly provided additional information and comments.

CHAPTER 26: THE MAGIC IN YOUR MIND

This section was based on the following sources:

Breese, M. (Ed.) (1985). *The Magic of Al Koran*. London, England: Martin Breese.

Forzoni, R. "Al Koran, (1914–1972)" Retrieved from http://forzonimagic.com/mindreaders-history /al-koran/.

Grimshaw, B. (1972). "Al Koran Loses the Last Trick." *New Tops, 12*, 28–29.

Koran, A. (1964). *Bring Out the Magic in Your Mind*. London, England: HarperCollins.

Mackay, C. (1979). "Show and Lecture Reports: A Tribute to Al Koran." *Magic Circular, 73*(793), 11–13.

McComb, B. (1988). *The Professional Touch*. London, England: Martin Breese.

CHAPTER 27: THE MAGICIAN WHO BELIEVED IN REAL MAGIC

For a comprehensive account of Henning's work, see the seminal text:

Harrison, J. (2009). *Spellbound: The Wonder-filled Life of Doug Henning*. New York, NY: BoxOffice Books.

Henning's life and work are comprehensively covered on Neil McNally's wonderful website: www .doughenningproject.com.

In addition, we drew on the following sources:

Gerard, T. (2015). "Doug Henning's World of Magic." *Magic Magazine, 25*(4), 44–53.

Henning, D., & Charvet, D. (1999). "Doug Henning in His Words." *Magic Magazine, 9*, 22–29.

Larson, B. (1976). "Doug Henning's World of Magic." *Genii, 40*(2), 97–102.

Neil McNally kindly provided additional information and comments.

Acknowledgments

This book wouldn't have happened without the assistance and support of many people. First, we are hugely grateful to our brilliant agent, Patrick Walsh, and fabulous editor, Priscilla Painton. Also, many thanks to our readers who kindly supplied feedback on earlier drafts: Caroline Watt and Jeff Sanford. Special thanks to Helen Keen for additional comments. We would also like to thank Chris Kenner, Ron Hebler, and Rene Nadeau. Finally, our thanks to everyone who helped supply information, advice, and magical suggestions: Todd Karr, Will Houstoun, Steve Cohen, Bill Smith, Sarah Crotzer, Chuck Jones, Michael Claxton, James Dimmare, Levent Cimkentli, Richard Hatch, Tiago Hirth, Chris Goto-Jones, John Cox, Max Maven, Richard Kaufman, Derek Tait, John Davenport, Anne Goulden, Massimo Polidoro, Neil McNally, Tom Stone, Bill Kalush, Darryl Beckmann, Jim Steinmeyer, Peter Lamont, Brian Lead, Margaret Steele, John Fisher, Stan Jarin, Charisse Kininmonth, Richard Stokes, Michael Start, and Owen Davies. Finally, our special thanks to Mike Caveney and Gabe Fajuri, who kindly commented, and provided expert advice, on several sections.

Image Credits

PAGE CREDIT

12 The Conjuring Arts Research Center
29 Mike Caveney's Egyptian Hall Museum
30 Mike Caveney's Egyptian Hall Museum
147 Reproduced with kind permission by Gay Blackstone
150 Reproduced with kind permission by Gay Blackstone
177 Murray Korman
185 Photograph by Irving Desfor, Courtesy of the American Museum of Magic, Marshall, MI
193 Meir Yedid
209 Rubin Bolber
217 Nathan Sternfeld and David Collier

Index

Page numbers in *italics* refer to images.

Abbott, David P., 132–34

Abbott, Percy, 151

Abbott's Get Together, 151

Abbott's Magic Co., 151

Abrams, J. J., 205

A-Haunting We Will Go, 143

Alexander: The Man Who
 Knows (Claude Alexander
 Conlin), 43–49, *45*, 55
 calendar business of, 49
 criminal activities of, 48–49
 death of, 49
 early life of, 44
 mail-order book business of,
 45–48
 paraphernalia of, *46–47*, 48
 "spirit" paintings of, 44, *45*
 turban of, *42*, 44, *45*, 49

American Occupational
 Therapy Association, 154

Andrews, Edwin Summer, 93

Andrews, E. S., 93

Andrews, James, 93

Andrews, James DeWitt, 93

Andrews, James M., 93

Andrews, Milton Franklin, 93

Andrews, William Symes, 93

Archimedes, 226–28

*Art of Juggling or Legerdemain,
 The* (Rid), 13

Astaire, Fred, 2, 188, 205

automata, 16, 23
 The Marvellous Orange Tree,
 19, 22, 82
 The Pastrycook of Palais
 Royale, 15–23, *20–21*
 The Singing Lesson, 16, 22

Bamberg, David (Fu Manchu),
 135

Bamberg, Tobias, *see* Okito

Bamberg magical dynasty, 131,
 132, *133*, 135

Barker, Betty, 138

Barnum, P. T., 68

Baum, L. Frank, 68

Benny, Jack, 156

Berg, Hy, 196

Bertinelli, Valerie, 41

Binet, Alfred, 1

bird cage, vanishing
 of Blackstone, 148, *149*, 151
 of Pollock, *174*, 175–78, 180,
 181

Blackstone, Harry, *144*, 145–51,
 147, *150*
 background and early life of,
 146
 bird cage illusion of, 148, *149*,
 151
 Blackstone's Island, 150–51
 death of, 150
 Dunninger and, 149–50
 fire and, 148
 O'Dell and, 171
 tire illusion of, *144*, 147, 151

Blackstone, Harry, Jr., 151

Booth, John Wilkes, 31

Boxer Rebellion, 107–8

boxes
 of Kellar, *64*, 65, 66
 of Maskelyne, 38–39, *38*, *40*, 41

*Bring Out the Magic in Your
 Mind* (Koran), 211

Brooker, Frank, 179

Bullet Catch, 109–11
 de Linsky and, 109
 Epstein and, 109–10
 Herrmann and, 74, 77
 Houdini and, 110
 Soo and, 108, *109*, 111

Bush, George W., 33
Buzz Saw illusions, *see* sawing-in-half illusions

Cane, Dancing, 204–5, *204*
cannonball, human, 75
Capone, Al, 98, 156
Capra, Frank, 2, 40
Cardini (Richard Pitchford), 33, *152*, 153–59, *155, 157*, 233
　death of, 159
　early life of, 154
　Houdini and, 154, 156
　lit cigarette manipulations of, 154, 156, 159
　monocle of, 153, 156, *158*, 159
　O'Dell and, 171
　in World War I, 154–55, 159
Carnegie, Dale, 125–28
Carrer, Charles, 168, 170–71
Carter, Charles (Carter the Great), 86
Caruso, Enrico, *102*
Caveney, Mike, 3
Charvet, David, 48–49
Chavez School of Magic, 176
chest-stabbing illusion, 13
China
　Boxer Rebellion in, 107–8
　Great Wall of, 3, 121
Chung Ling Soo (William Robinson), 55, 106, *107*, 132
Churchill, Winston, 211
CIA, 3
cigarette manipulations, 154, 156, 159
Civil War, 30, 31
Clinton, Bill, 33
clocks, mystery, 15, 16, *18*, 22
close-up magic, 192–94
Collins, Thomas, 79

Colon, Mich., 150–51, *150*
Columbo, 93
Conjuring Arts Research Center, 90
Cooke, George, *34*, 36, 38
Cooke, Horatio "Harry," 30–31, *30*
　Lincoln and, 30–31, *30*
Coolidge, Calvin, 31–33
Copperfield, David, 2–3
　background and early life of, 2, 129
　dangerous illusions performed by, 111
　Death Saw of, 222, 223–33, *225*
　dinosaur of, 227, 232
　Flying illusion of, *226*, 232
　Great Wall illusion of, 3, 121
　The Magic Man show of, 2, 179
　Magic with the Stars show of, 188–89
　mirror ball levitation of, 135
　museum of, 4, 6, 233
　name change of, 2
　Portal illusion of, 232
　presidents and, 33
　Project Magic founded by, 154
　Society of American Magicians and, 2, 86
　spaceship of, *230–31*, 232
　Statue of Liberty illusion of, 3, 121
　time-traveling alien of, 229, *231*, 232
Cronenberg, David, 216
cutting off head illusion, 12, *12*

Daily Illustrated Mirror, 118
dancing cane, 204–5, *204*

Dante (Harry Jansen), 139–43, *139, 142*, 233
　Miller and, 139, 140, 142–43
　sawing illusion of, *136*, 139, *140–41*, 143, 228
　Thurston and, 139–42
Davenport Brothers, 36, 66
Death Saw, 222, 223–33, *225*
de Kolta, Buatier, 59–63, *61*
　Expanding Die illusion of, 59, 60, 62–63, *62*
　Martinka's and, 83
　vanishing assistant illusion of, 62, 184, 189
de Linsky, Louis, 109
Denslow, William, 68
Dimmare, James, 181
Discoverie of Witchcraft, The (Scot), 8, 9–13, *11, 12*, 52
Disembodied Princess, The, 124, *125*, 128, *128*, 129
Douillard, Debby, 218
Dunninger, Joseph, 149–50, 209–10

Eden Musée, 60
Edison, Thomas, 68
Ed Sullivan Show, The, 156, 176, 184, 208, 216
Egyptian Hall, 35, 36
Einstein, Albert, 211
Eisenhower, Dwight, 179
Elizabeth II, Queen, 179, 211
Ellison, Saram, 86
Epstein, Adam, 109–10
Erdnase, S. W., 90, 92–95
　The Expert at the Card Table, 88, 89–95, *91, 92, 94*, 192
　Malini's disguised copy of *The Expert at the Card Table*, 96, 97, *100*, 103

ether, 24

Ethereal Suspension, The, 24–25, 25

Expanding Die illusion
 of de Kolta, 59, 60, 62–63, 62
 of Houdini, 58, 63, 63

Expert at the Card Table, The (Erdnase), 88, 89–95, 91, 92, 94, 192
 Malini's disguised copy of, 96, 97, 100, 103

FBI, 49

Fillmore, Millard, 28

film, 1, 39–40

Fisher, John, 159

Flosso, Al (The Coney Island Fakir), 86

Flosso, Jackie, 86

Flying illusion, 226, 232

Fogel, Maurice, 209

Foo, Ching Ling, 106, 110

Ford's Theatre, 31, 33

Fox, Karrell, 151

Fredrik, 146

Fu Manchu (David Bamberg), 135

Gallaway, Edward, 93

gamblers, 193–94

Gardner, Martin, 93

gift shows, 28, 29

Ginsburg, Ruth Bader, 121

Goldin, Horace, 138–39, 143, 184, 228
 Martinka's and, 82

Goto-Jones, Chris, 107

Grace, Princess, 179, 211

Grant, Cary, 156

Great Richiardi, 184

guillotine illusions, 171
 of O'Dell, 166, 167, 171, 173

Hair, 216

Hancock, Winfield Scott, 31

Hand-Book of Magic (Wyman), 32

Hanna, Mark, 98

Harris, Neil Patrick, 94

Henning, Doug, 33, 215–21, 217, 233
 costumes of, 214, 215, 216, 220
 death of, 218
 early life of, 216
 Magic Show musical of, 217, 218
 Maharishi Mahesh Yogi and, 218
 Metamorphosis trunk of, 214, 215, 216, 219
 Spellbound musical of, 216–17
 theme park planned by, 218, 221

Herrmann, Adelaide, 73–79, 75, 77
 death of, 79
 dress of, 72, 78, 79
 early life of, 74
 Martinka's and, 82, 83
 in vaudeville, 76

Herrmann, Alexander, 74–77
 Martinka's and, 86–87
 Robinson and, 106

Hippodrome Theatre, 118

Hocus Pocus Junior: The Anatomie of Legerdemain, 13

Hoffmann, Professor (Angelo Lewis), 52, 53, 55–57

The Expert at the Card Table
 and, 90
 letters and notebook of, 51, 53–54, 54

Modern Magic, 50, 51–57, 53, 56, 106, 124–25, 176, 233

Hollywood Walk of Fame, 179

Houdin, Josèphe Cecile, 16

Houdini, Bess, 101, 114

Houdini, Harry, 31, 113–21, 115, 116–17, 119, 228, 233
 Bullet Catch and, 110
 Cardini and, 154, 156
 death of, 118–20
 early life of, 114, 129
 Expanding Die illusion of, 58, 63, 63
 Hoffmann and, 55, 56
 in jail cell, 115
 Kellar and, 69–71, 70, 110
 Martinka's and, 82, 86
 Milk Can escape of, 112, 116, 118, 121
 sea creature escape of, 115–18
 stage name adopted by, 114
 straitjackets of, 120, 121
 in vaudeville, 114
 Vernon and, 192
 Water Torture Cell of, 118, 119, 121, 218

Houstoun, Will, 53

How to Win Friends and Influence People (Carnegie), 125–28

Hughes, Isaiah Harris, 66

human cannonball, 75

Human Card Index, 162–65, 163, 164, 165

International Museum and Library of the Conjuring Arts, 4, 6, 233

James VI, King of Scotland, 13
Jansen, Harry, *see* Dante
Jastrow, Joseph, 1
John the Baptist, 12, *12*
Jones, Little Johnny, 151

Kalush, William, 121
Kellar, Harry, 65–71, *67*, 129, 228, 233
 Bullet Catch and, 110
 death of, 71
 early life of, 66, 129
 Houdini and, 69–71, *70*, 110
 Kellar's Wonder Book, 69
 Martinka's and, 82, 83
 Maskelyne and, 68–69
 nesting boxes of, *64*, 65, 66
 Robinson and, 106
 Thurston and, 125
 Vernon and, 192
 Wizard of Oz compared to, 68, 71
Kelly, Gene, 2, 179, 188, 205
Kelly, Grace, 179, 211
knife through arm illusion, 12, *12*
Koran, Al, 207–13, *209*
 ashes of, 212
 briefcase of, *212*, 213
 Bring Out the Magic in Your Mind, 211
 communicator of, *210*, 211
 death of, 211
 early life of, 208
 medallion of, *206*, 207, 208, 213
 mentalism of, 208–11, 213

Lakeside Cemetery, 151
Laurel and Hardy, 143
Leonardo da Vinci, 1
levitations, 134, 228–32
 Copperfield's mirror ball, 135
 Copperfield's Flying illusion, 226, 232
 Okito's floating ball, *130*, 131, 134, *135*
 Thurston's assistant, 129
L'Homme Masque, 93
Lincoln, Abraham
 assassination of, *30*, 31
 Cooke and, 30–31, *30*
 Wyman and, 28
Lloyd, Arthur, 161–65
 academic gown of, *160*, 161–65
 early life of, 162
 as Human Card Index, 162–65, *163*, *164*, *165*
 in vaudeville, 162
London Palladium, 212
Lumière brothers, 39
Lund, Robert, 151

Macy's, 168, 200
Magic Castle, 194–96
Magic Circle, 56, 228
Magic Man, The, 2, 179
Magic Mystery Box, *198*, 205
Magic Show, 217, 218
Magic with the Stars, 188–89
Maharishi Mahesh Yogi, 218
Malini, Max, 31, 97–103, *99*
 Caruso's drawing of, *102*
 death of, 102
 disguised copy of *The Expert at the Card Table*, 96, 97, *100*, 103

early life of, 98
 opera gloves, shoes, and egg bag of, 97, *100*
 Vernon and, 101, 192
Marconi, Guglielmo, 39
Martinka, Antonio, 82
Martinka, Francis, 82, 83, 86
Martinka, Pauline, 82
"Martinka's Little Back Shop" (Sargent), 87
Martinka's Palace of Magic, *80*, 81–87, *83*, *84–85*
Marvellous Orange Tree, The, 15, 19, 22, 82
Marx Brothers, 156
Maskelyne, Jasper, 39
Maskelyne, John Nevil, 34, 35–41, *37*, 129, 228, 233
 box of, 38–39, *38*, *40*, 41
 Cooke and, 34, *36*, 38
 death of, 39
 early life of, 36
 Kellar and, 68–69
 Will, the Witch, and the Watchman, 35–41
Maskelyne, Nevil, 39
McComb, Billy, 212
Méliès, Georges, 1, 39–40
mentalism, 208–11, 213
Metropolitan Opera House, 74
Milk Can escape, *112*, *116*, 118, 121
Miller, Moi-Yo, *139*, *140*, 142–43
Mission: Impossible, 93
Modern Magic (Hoffmann), 50, 51–57, *53*, 56, 106, 124–25, 176, 233
motion pictures, 1, 39–40
Mulholland, John, 3, 165
 archive of, 3–6

National Museum of American
 Jewish History, 121
needle through head illusion,
 12–13
Newton, Isaac, 228
Newton, William, 168
New York Prison Association,
 124
New York Times, 142
New York University, 2
Nixon, Richard, 179
Noah's Ark, 76, 77

O'Dell, Dell, 167–73, *169*
 animals of, 171
 background and early life of,
 168
 dancing doll novelty of, *172*
 death of, 172
 guillotine of, *166*, 167, 171,
 173
 pencil puzzles of, 170
 rhyming patter of, 168, *170*,
 173
Okito (Tobias Bamberg),
 131–35, *133*
 Abbott and, 132–34
 death of, 135
 floating ball of, *130*, 131, 134,
 135
 Thurston and, 132

Pacioli, Luca, 1
Palace Theatre, 124
Pastrycook of Palais Royale, The,
 14, 15–23, *20–21*
pennies and small leather cap,
 26, 27, 28
Pitchford, Richard, *see* Cardini
Pollock, Channing, 175–81,
 177, *178*, 232, 233

acting career of, 179
bird cage illusion of, *174*,
 175–78, 180, 181
death of, 179
early life of, 176
notebooks of, *180*
Pollock, Cori, 179
Pollock, Jozy, 179
Pollock, Naomi, 176–79
Portal illusion, 232
presidents and White House
 performances, 27–33, 98,
 179
Professor Brown's Lady
 Velocipede Troupe, 74
Project Magic, 154
Psycho, 41
psychology, 1

Rainier, Prince, 179
Reagan, Ronald, 33
Reitman, Ivan, 216
Richiardi Jr., 183–89, *185*, *188*,
 216
 background and early life of,
 184
 Buzz Saw illusion of, *182*,
 183, 184, 186, *187*, 189,
 228
 death of, 189
Robert-Houdin, Eugène, 22, 24,
 25
Robert-Houdin, Jean-Eugène,
 15–25, *17*, 114, 184, 233
 early years of, 16
 The Ethereal Suspension,
 24–25, *25*
 The Marvellous Orange Tree,
 15, 19, 22, 82
 mystery clocks of, 15, 16, *18*,
 22

The Pastrycook of Palais
 Royale, *14*, 15, 19–22,
 20–21
The Singing Lesson, 16, 22
theatre of, 19
Robinson, William, *see* Soo,
 Chung Ling
Rockefeller, John D., 98
Roosevelt, Ethel, 66
Roosevelt, Franklin, 33, 98, 156
Roosevelt, Kermit, 66
Roosevelt, Theodore, 31, 66, 67

Sanders, Wilbur Edgerton, 93
Sargent, John William (The
 Merry Wizard), 87
sawing-in-half illusions, 137–39,
 143, 184, 186, 228
 Copperfield's Death Saw, *222*,
 223–33, *225*
 of Dante, *136*, 139, *140–41*,
 143, 228
 of Richiardi, *182*, 183, 184,
 186, *187*, 189, 228
Scot, Reginald, 10
 The Discoverie of Witchcraft,
 8, 9–13, *11*, *12*, 52
Seiden, "Professor" Frank, 98
Selbit, P. T., 56, 138, 143, 228
Selfridges, 156
Shore, Howard, 216
Sinatra, Frank, 40, 205
Singing Lesson, The, 16, 22
Society of American Magicians,
 52, 86, 87
 Copperfield and, 2, 86
 founding of, 86
Sondheim, Stephen, 121
Soo, Chung Ling (William
 Robinson), 55, 105–111,
 107, *110*, 132

Soo, Chung Ling (*continued*)
 Boxer Rebellion story line of,
 107–8
 death of, 108–9
 early life of, 106
 Foo and, 106
 guns of, *104*, 105, 108–9,
 109, 111
Spellbound, 216–17
Spielberg, Steven, 121
Spina, Tony, 204–5
Stanton, Edwin, 31
Statue of Liberty, 3, 121
Straight and Crooked Magic,
 146
straitjackets, *120*, 121
Sullivan, Ed, 156, 176, 184,
 208, 216

Tannen, Irv, 204, 205
Tannen, Lou, 200, 204, 205
Tannen's Magic Shop, 199–205,
 201, *202–3*, *204*, 232
 Magic Mystery Boxes of, *198*,
 205
Tarbell Course in Magic, 2
television, 171, 217
Thurston, Howard, 31–33, 55,
 122, 123–29, *126–27*, 228,
 233
 background and early life of,
 124
 Dante and, 139–42
 The Disembodied Princess,
 124, *125*, 128, *128*, 129
 early life of, 124

Kellar and, 125
levitation act of, 129
Okito and, 132
Modern Magic and, 55, 56,
 124–25
Thurston, Jane, 128
tire illusion, *144*, 147, 151
Transcendental Meditation, 218
Truman, Harry, 156
Tsukalis, Danny, 200, 205

Valadon, Paul, 69
Van Buren, Martin, 28
vanishing illusions
 Blackstone's bird cage, 148,
 149, 151
 Blackstone's tire illusion, *144*,
 147, 151
 Copperfield's Portal, 232
 de Kolta's assistant, 62, 184,
 189
 Pollock's bird cage, *174*,
 175–78, 180, 181
 Thurston's The Disembodied
 Princess, 124, *125*, 128,
 128, 129
vaudeville
 Herrmann in, 76
 Houdini in, 114
 Lloyd in, 162
velocipedes, 74
Vernon, Dai, 57, 90, 191–97,
 193, *195*, 216
 close-up magic of, 192–94
 "dead list" of, *190*, 191,
 195–97

death of, 196
early life of, 192
Houdini and, 192, 197
Kennedy and, 193–94
at Magic Castle, 194–96
Malini and, 101, 192
as silhouette artist, *196*
Victoria, Queen, 22

Walker, Swan, 156
Water Torture Cell, 118, *119*,
 121, 218
Weekly Dispatch, 106
Welles, Orson, 2, 40
Wells, H. G., 156
White House, 27–33, 98, 179
*Will, the Witch, and the
 Watchman*, 37–39
William II, King of the
 Netherlands, 132
Winchell, Paul, 2
witchcraft, 10, 13
*Wonderful Wizard of Oz,
 The* (Baum and Denslow),
 68
Woodfield, Bill, 93
World War I, 108, 138, 146
 Pitchford (Cardini) in,
 154–55, 159
World War II, 39, 143, 148
Wyman, John, Jr., 28
 gift shows of, 28, 29
 Hand-Book of Magic, 32
 Lincoln and, 28
 pennies and small leather cap
 of, *26*, 27, 28

About the Authors

David Copperfield has been hailed by critics as the greatest illusionist of our time. In addition to decades of network television specials, ten world tours, and a critically acclaimed Broadway show, Copperfield has won twenty-one Emmy awards. He was the first living magician to be given a star on the Hollywood Walk of Fame, was knighted by the French government, and has been named a Living Legend by the United States Library of Congress. Copperfield's live shows have sold in excess of four billion dollars in ticket sales and he has been described by *Forbes* magazine as the most commercially successful magician in history.

Richard Wiseman is a professor of psychology, author, and magician. He holds Britain's only Professorship in the Public Understanding of Psychology at the University of Hertfordshire, where he has gained an international reputation for research into luck, illusion, magic, and belief. Wiseman has had a lifelong interest in magic, is a member of the Inner Magic Circle, and his illusion-based YouTube Channel has received more than 500 million views. He has written several bestselling books that have been translated into more than thirty languages, including *The Luck Factor, Quirkology,* and *59 Seconds.*

David Britland is a writer, researcher, and consultant specializing in deception. He has authored numerous articles and books on magic including *Phantoms of the Card Table, Chan Canasta: A Remarkable Man,* and *The Mind and Magic of David Berglas.* He has consulted for and helped develop many television shows, from the scams of *The Real Hustle* to the mind-bending mysteries of Derren Brown. He holds special and literary fellowships at the Academy of Magical Arts in Los Angeles.

Homer Liwag is an acclaimed visual designer, photographer, cinematographer, artist, and magician. For almost three decades he has codirected David Copperfield's live and television work, and collaborated as his design director. Highly regarded within the magic community, he has created sleight-of-hand illusions and pioneered an innovative series of highly visual instructional videos. A geek at heart, Homer's favorite color is Pantone 1235c.